ESSENTIAL

History of British Art

ESSENTIAL

History of British Art

Isabella Steer

p

This is a Parragon Book
First published in 2001

Parragon
Queen Street House
4 Queen Street
Bath BA1 1HE, UK

ISBN: 0-75255-348-8

A copy of the CIP data for this book is available from
the British Library upon request.

The right of Isabella Steer to be identified as the
author of this work has been asserted in accordance
with Section 77 of the Copyright, Designs and Patents
Act of 1988.

Editorial, design and layout by Essential Books,
7 Stucley Place, London NW1 8NS

Picture research: Image Select International
Printed and bound in China

CONTENTS

INTRODUCTION

The very idea of a British art is intriguing, given the constant flow of outside influences on the arts of the British Isles. Painting is the principal concern of this book, but the decorative arts and architecture are equally rich in evidence of the ebb and flow of international influence and insularity. A narrative approach to art in Britain often considers it in terms of the nation's history, but this is reductive and neglects the regional and national traditions of Scotland, Wales and Ireland. It can also imply in artistic practice that innovation and conservatism do not go hand in hand; the assembling of a 'best of' can create an unrealistic impression of uniform and unilateral 'progress'.

At one point the British Isles was believed to lie on the edge of the world – its meaning varies enormously depending on the point of view from which you consider it. Beyond the isles, the rulers of England at various times owned Anjou, Aquitaine, Brittany, Ireland and Normandy. Wales came under the thumb of the English king after much fighting, most significantly during the reign of Edward I, with the declaration of the Statute of Wales in 1284. Scotland and England came under one crown only in 1603 with the accession of James VI of Scotland and I of England. This union was further ratified in 1707 by the Act of Union. Art in Britain, its form and function, like Britain itself has always been in a state of flux.

The paucity of religious or cultural heritage in Britain is conveniently explained by Henry VIII's self-appointment as Supreme Head of the Church of England in 1531. The subsequent dissolution of the monasteries and redistribution of their wealth and property left them powerless. The Church had been the most significant, if not sole, patron of the arts. Vestments, stained glass, candlesticks, prayer-books, altarpieces, wall-paintings, fonts and churches depended on the patronage of the Church or on local benefactors, anxious to commemorate certain events, preserve their memory for posterity and

reserve their place in the afterlife. Both the Castle Frome font (see page 18) and Richard II's portable altarpiece (see page 22) are the culmination of various artistic traditions and the result of influence through travel. The Wilton Diptych, like the Bayeux Tapestry, could have been made in England or in France, by English craftsmen or French, or by both. Despite the ban on religious imagery, condemned as idolatry in the Reformation, England would not be a Protestant power until well into Elizabeth I's reign – anti-Papal propaganda, such as the National Portrait Gallery's *Allegory of the Reformation* (see page 32), still had a role to play.

Portraiture has been the dominant art form in Britain for centuries and much of it has also played a part in propaganda. Portraits were valued in inventories, not for their artistic merit or human likeness, but in terms of their sheer size and the expense of materials used. During the sixteenth and seventeenth centuries portraiture was one of many art forms patronised by the ruling classes, tapestries and furnishings being equally in demand. Portraits were commissioned for a variety of reasons and were intended for private display. Like *The Ambassadors* (see page 24), portraits were commissioned to catch the royal eye, or to commemorate official appointments or achievements of rank, marriages or other types of familial allegiance and alliance. Painters in England occupied a lowly status – in 1563 the Painter–Stainers Company recommended that their members earn £4 a year, half the sum received by goldsmiths, and they often had to turn their hand to heraldry and decoration to make a decent living.

Holbein came to England imbued with Italian and European influences, and his early paintings for the English court have a monumentality and solidity to them that had not been seen in British portraiture prior to his arrival. It is a measure of Hans Holbein's success that he maintained his position principally as a painter at the court of Henry VIII, and was thus considerably better off than his colleagues.

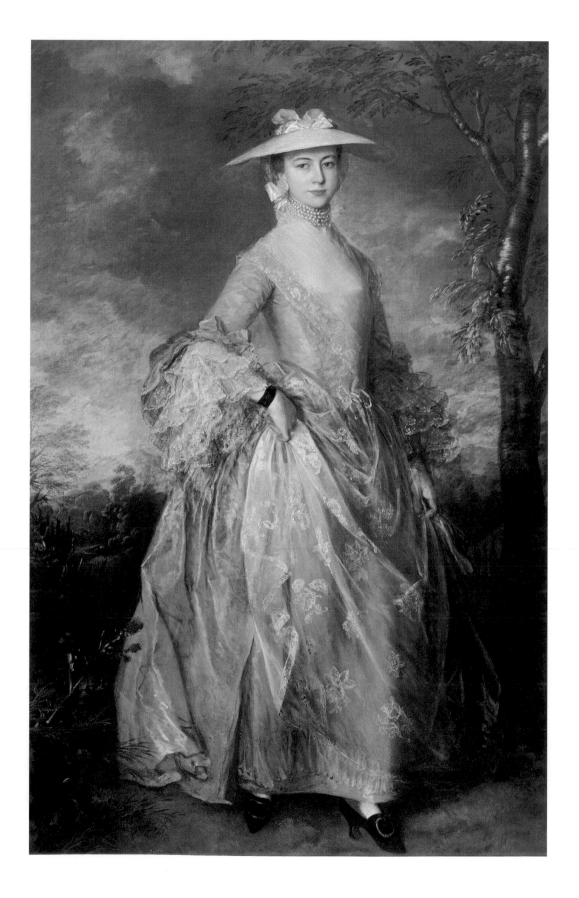

The North European technique of oil painting on wood panel would dominate until the seventeenth century. This was a technique that demanded much preparation and precision, including the use of stencils and underdrawing. The flamboyance and bravado seen in *The Ambassadors* would be toned down to adapt to his patrons' tastes, who perhaps feared that too convincing a portrait would result in charges of idolatry.

Holbein left no stylistic successors in Britain, and the court's next principal painters to emulate his legacy came from abroad. Hans Eworth, Anthonis Mor, Daniel Mytens, van Dyck, Peter Lely, Godfrey Kneller, who were all to find success in portraying the ruling class, were just some of those who surpassed rival native painters such as Gower and Segar. In the midst of this exoticism coexisted images more reminiscent of past heraldry, costume pieces and tomb decoration; Des Granges's *The Saltonstall Family* (see page 44), even though it was painted in the early seventeenth century, retains an old-fashioned, flat, linear quality, while expressing Cornelius Johnson's emotion.

The miniature as a genre was the height of fashion and Nicholas Hilliard's jewels owed as much to his training as a goldsmith in Geneva and travels to Paris as they did to the chivalric English royal court. Elizabeth I, more than any monarch, knew the power of the regal image and kept tight control over its dissemination, to the extent that she stipulated that no shadow should fall upon her face in Hilliard's miniatures. Rarely could an image of the Queen be made public without her royal approval, whether an iconic image of her as ruler, such as 'the Ditchley portrait' (see page 30), or as the Virgin Queen, clad in white and wedded only to her people, clasping symbols of chastity, such as the sieve, the phoenix and the rose.

If the Tudor image was one that shored up claims of legitimacy, inheritance and leadership, the Stuart portrait was of the palace born. With the union of Scotland and England under one Protestant crown in 1603, the concept of 'Magna Britannia' was born, and in the National

Gallery's portrait of Charles I on horseback the writing is not so much on the wall as on the oak tree. In the Stuart portrait, van Dyck evoked an effortless sense of royalty and aristocracy, innate in pose and gesture, and which did not need elaborate gold leaf, and pattern or heraldic symbols. Van Dyck eclipsed his foreign predecessors and the speed and delicacy with which he executed his work, his facility with oil and canvas and his eye, well informed by travel, revolutionised British portraiture. Figures became fully three-dimensional for the first time, placed in a real space with articulated movement emphasised by the beauty of colour and play of light on exquisite fabrics. Flickers of van Dyck's genius can be seen in the almond-eyed beauties painted by Lely, another foreigner who would have enormous success in London shortly after van Dyck, as well as in Gainsborough's idealised paintings of society women a century later.

The events of 1688, followed by the accession of William of Orange to the English throne and the accompanying shake-up of the old order, wrought irrevocable change to the status of the Crown in Britain, its power and role. The burgeoning middle classes broadened the art-buying constituency considerably and changed the nature and mood of British painting. Hogarth beat the national contemporary drum and helped in the formation of the Royal Academy and in the establishment of a British School of Painting, with history painting at the pinnacle of the genres. Free tuition and public exhibitions served both to educate artists in a homegrown tradition to rival those on the Continent and to school patrons in the art of supporting contemporary British artists in genres other than portraiture. As a history painter himself, Hogarth failed to win acclaim, but Reynolds adapted the historical genre to the portrait, as ever in high demand, elevating it to the Grand Style by clothing his sitters in classical robes and casting them in idealised poses. Stubbs and Wright of Derby would similarly combine the Grand Style with their genres. Stubbs married the painting of sporting scenes with ground-breaking anatomical observation while Wright of Derby sought the same tone for

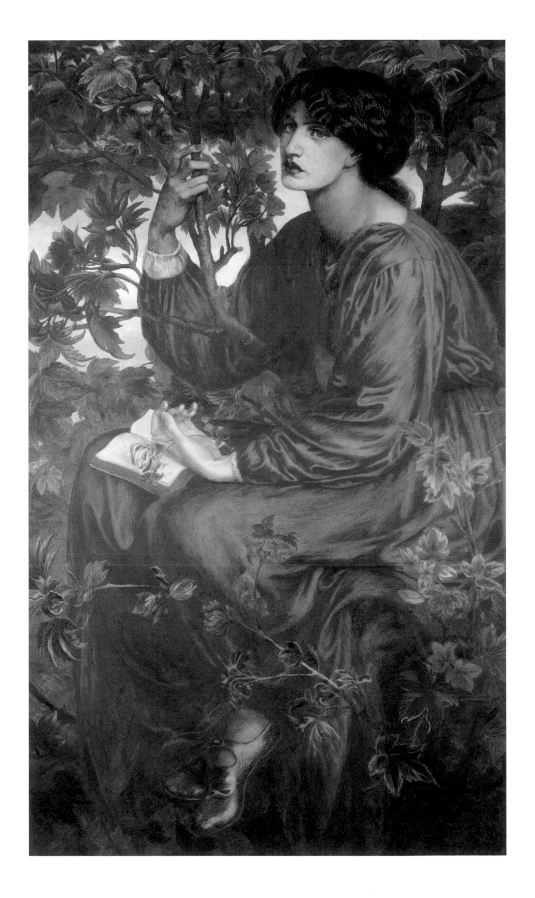

his innovative genre paintings of scientific and industrial practices. His portrait of Sir Brooke Boothby (see page 78) is a pivotal work, commemorating, in both the literal and the figurative sense, the translation into English of Rousseau's emphasis on the natural and the emotional over reason. Turner's drama, Fuseli's nightmares and Lear's images of nature red in tooth and claw stem from prolonged relations with German and French art and literature at the turn of the nineteenth century, and from a Romantic reaction against the classical formal principles of the Royal Academy.

While Lear's animal paintings were high drama, his landscape and work as a naturalist took their lead from topographical paintings of the seventeenth century and the analytical work of botanists such as Banks, and industrial innovators such as Wedgwood. The roots of landscape lay in portraiture. Records of gardens first appeared as inserts in portraits in the sixteenth century, but with little regard for scale. Siberechts's view of Longleat House (see page 60) was a statement of ownership and of record as much as an exterior view. Topographical record was transported on to international scenery, epitomised by artists accompanying their patrons on the Grand Tour. The work of Sandby, Girtin and Cozens brought the gravitas of oil painting to the watercolour, and Turner showed that the medium was capable of rendering the sublime.

Along with the myth of a British School of Painting, taking root in the eighteenth century, landscape painting was considered a British tradition, if not invention, with Constable as its father figure. The Pre-Raphaelites sought to depict the high moral ground through painstaking observation, in marked contrast, for example, to Steer's Impressionist works. The early twentieth century and the interwar years saw a return to landscape, as if capturing the essence of British artistic effort. Illustrations of everyday life are a constant feature, from the marginal miniatures in the Luttrell Psalter (see page 20) to Francis Hayman's pastimes, such as *Cricket in Marylebone Fields*, Rowlandson's commentary and Bewick's vignettes. As images of a constant, if softly

spoken, theme, they are countered by the powerful illustrations of medieval and classical literature, Arthurian romances, Chaucer and Shakespeare, the Bible and Dante's *Divine Comedy*, as in the work of William Blake and Samuel Palmer.

British and foreign painters alike painted some of the greatest art in Britain. As a tradition, British art pivots between two positions – insular and self-perpetuating on the one hand, eager to embrace foreign ideas on the other. Recognising the importance of native painters and of foreign traditions does not detract from the significance of art in Britain. The coexistence, often conflicting, of influences and styles precludes a neat and tidy definition or recipe for the essential and enduring vibrancy of British art.

THE MAPPA MUNDI

Hereford Cathedral/Courtesy of the Bridgeman Art Library

THIS is a thirteenth-century map of the world, or *mappa mundi*, and is one of the most interesting works from medieval Britain to survive. While presenting a geographical picture of the known world it also maps thirteenth-century Christianity. Jerusalem is seen in the middle, at the centre of the world. Mount Calvary, the site of Christ's crucifixion, and Bethlehem are represented by drawings of the crucifixion and a stable. The east is at the top of the circle; the three known continents, Europe, Asia and Africa, are bottom left, top and bottom right; and the world is surrounded by ocean. Around the circle, the letters spelling the Latin word for death, MORS, can be picked out, the suggestion being that all within the ocean is subject to mortality. Beyond the rim, the scene of the Last Judgment is at the very top, with the Garden of Eden directly below: to the right Adam and Eve are expelled.

The British Isles can be seen at the bottom left, or northwest of the map, at the edge of the known world, with only the limitless ocean beyond – the discovery of America would change all that. Rivers, cathedral cities and major towns can also be picked out. Although the rivers and seas appear brown, they were originally blue and green.

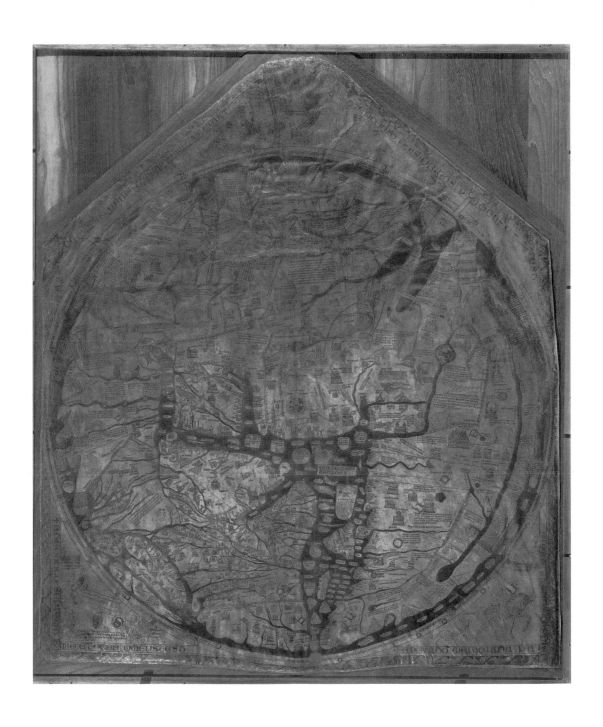

FONT, ST MICHAEL'S CHURCH, CASTLE FROME c.1140

Courtesy of Herefordshire Libraries Service

THIS baptismal font was carved in the manner of a distinct school of stone sculpture, the Kilpeck School, that emerged in Herefordshire in the 1130s, some seventy years after the Norman Conquest. Pilgrimages to Jerusalem, Rome and also to the shrine of St James the Greater, in Santiago de Compostela, northwest Spain, were of great importance at this time, and there were several fixed pilgrim routes. Travel, through trade, war and pilgrimage, was the main source of exchange of information and artistic influence, and the influences of French and Spanish art may well have been brought back along one of the routes through northern Spain, western France and Paris.

Oliver de Merlimond, the founder of Shobdon Church near Kilpeck, is recorded as having undertaken just such a pilgrimage to Santiago de Compostela, via France, and there are remarkable similarities between the figures on the font, the sculptured tympana remains of Shobdon Church, and cathedral sculpture at Compostela. For those who could not afford pilgrimages abroad, Glastonbury, Canterbury, Peterborough, St Andrew's and St David's were just a few of the British sites that were visited. Chaucer offers his readers a merry romp along the pilgrim route: pilgrims' offerings made up a sizeable part of the medieval Church's coffers.

Shobdon Church was destroyed in the eighteenth century by the Georgian antiquary Lord Bateman, who then recycled the chancel arch and door tympanum for a folly on a hill nearby. A plaster cast of the tympanum is in the Victoria and Albert Museum; other examples of the Kilpeck School are to be found in the churches of St Mary and St David, Kilpeck, and St Mary's, Eardisley. The central scene on the body of the font is the baptism of Christ. John the Baptist is seen to the left and above Christ's head the Holy Spirit, represented by a dove, and the hand of God descend. In trying to show Christ immersed in the River Jordan, the artist has ingeniously evoked the effect of ripples on the surface, and, in case there was any doubt, fish have also been carved swimming in the water.

The image of the baptism of Christ is encircled by the four evangelists, who are traditionally represented in art by the winged man (St Matthew), the winged lion (St Mark), the winged ox (St Luke) and the eagle (St John), and they are joined by two other birds to the right of the Baptism scene, possibly two doves. The base and the rim of the font are further decorated by two distinct lattice patterns and supported by the remains of three sculpted figures particularly reminiscent of those seen at the foot of the baptismal font in the Cathedral at Santiago de Compostela. Until the middle of the thirteenth century, when Anglo-Norman came increasingly into use, *litteratus* still referred to a person able to read and write in Latin, which remained

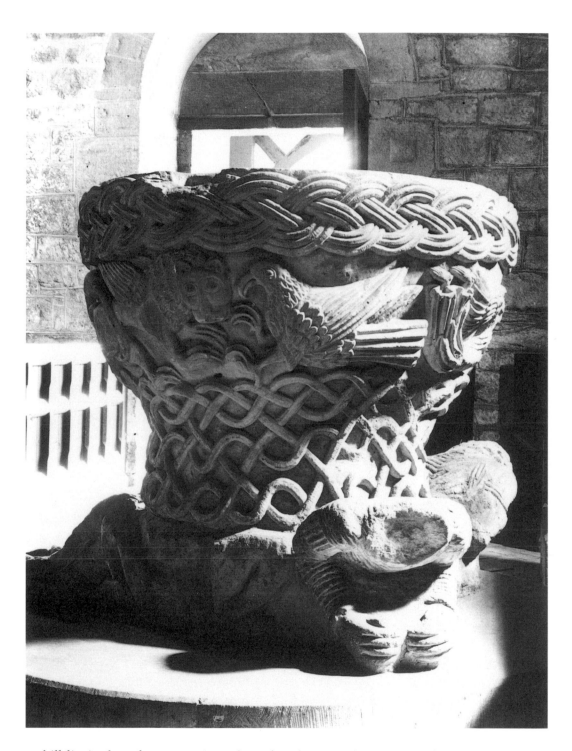

a skill limited to the monastic orders, the clergy and some members of the ruling nobility. Images such as these reminded the people of the teachings of the Church, symbolically linked that first Baptism and all those that followed, and decorated and enlivened the churches in the glory of God.

THE LUTTRELL PSALTER

British Library, London / Courtesy of the Bridgeman Art Library

THIS psalter was written and illuminated in England for Sir Geoffrey Luttrell of Irnham, Lincolnshire, in the first half of the fourteenth century. The psalter contained the Book of Psalms and canonical calendars, and was used both in private devotion and church ceremonies although its use declined in the thirteenth century as a consequence of the introduction of the Book of Hours. The Luttrell Psalter is renowned for its miniatures and marginal decoration; biblical scenes and fantasy figures intermingle with exquisite vignettes of everyday life. Farming scenes, such as ploughing, pushing the harvest cart up the hill, a hunting animal entering a rabbit warren and a young boy stealing cherries are found on the folios (or pages) of the psalms of thanksgiving for the bounty of God. Elsewhere, a woman beats her husband with a distaff (shown here), and scenes of gaming are found, including a lord and lady playing backgammon, she dressed in the latest fashion.

The dedicatory miniature depicts Sir Geoffrey Luttrell as a mounted knight, with the words 'Dominus Galfridus Louterell me fieri fecit' ('The Lord Geoffrey Luttrell caused me to be made'). He is equipped with the Luttrell coat of arms, the martlet bird. His wife, Agnes Sutton, hands him his plumed helmet, wearing a heraldic gown bearing both his coat of arms and her own, which features a lion. A younger woman is similarly identifiable by her dress as their daughter-in-law, Beatrice le Scrope.

The reasons behind the commissioning of this manuscript are unclear, but it is likely to have been to commemorate the marriage of one of Sir Geoffrey's sons and his eventual heir, Andrew, to Beatrice le Scrope. Sir Geoffrey and his wife were remote cousins, although it appears they were unaware of this at the time of their marriage. The Church had recently decreed against the marriage of cousins of certain degrees, and records reveal intense efforts on the part of the Luttrell family to regularise their union: failure to do so would have risked the confiscation of their properties by the Church and the disinheritance of their son. 1340, the year it is thought the manuscript was commissioned, was also the year of their son's wedding and Sir Geoffrey's receipt of papal approval. Although there are stylistic similarities between the master hand of the Luttrell Psalter and elements of the East Anglian school of illumination, little is known about the origins of this manuscript. It was certainly costly, and personally commissioned by Sir Geoffrey, who would have been closely involved in its design and illumination. Unusually, he is not pictured in the dedicatory miniature on his knees before the Virgin or patron saint, as was the practice, and the detail in which rural customs are recorded, coupled with his efforts throughout his life to consolidate both his properties and his children's inheritance, suggest possible reasons behind this commission.

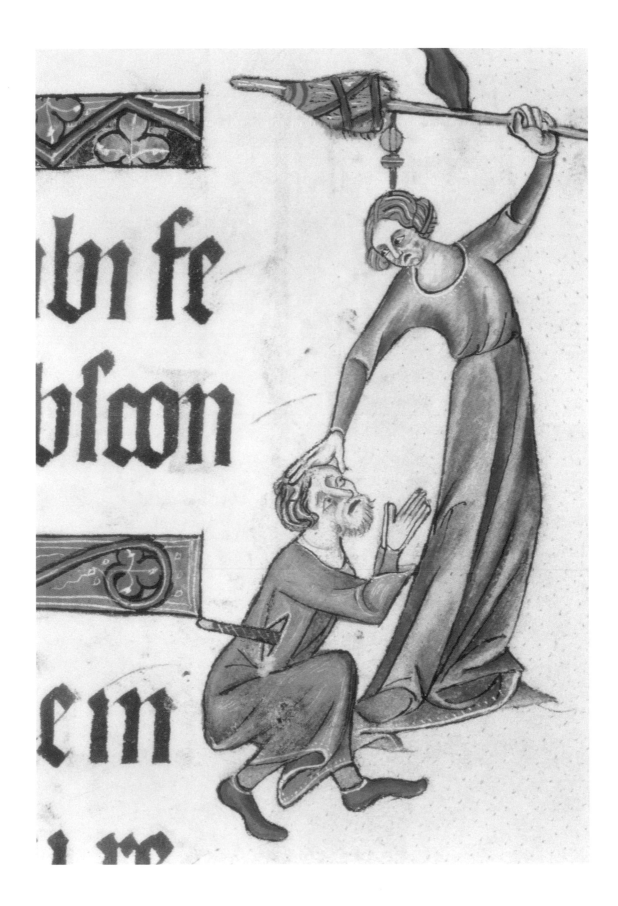

THE WILTON DIPTYCH c. 1395–9

National Gallery, London / Courtesy of the Bridgeman Art Library

THIS is a portable altarpiece, probably commissioned by Richard II, King of England at the age of nine, for his own private use. The level of craftsmanship is extremely high, and the materials and technique used point to several influences. It is painted on oak panels, commonly used in England at the time. However, the binding material and certain painterly techniques suggest Italian influences. When the altarpiece is opened up, figures are revealed whose styles also point to diverse influences. Their slender elegance is reminiscent of Gothic French art, whilst the Virgin holding the Christ Child's foot in this way is found in Bohemian art of the period. When so little is known about a work, style, materials, symbols and history all combine to provide the clues.

The painted exterior shows the French and English royal coats of arms intertwined (the fleur-de-lys and the leaping lion) and combined with that of Edward the Confessor. A mysterious white hart is seen on the opposite panel. Inside the diptych, Richard II, accompanied by three saints with glowing haloes, kneels before the Virgin and Child and a throng of angels. Two of the three angels are also kings, and the third, dressed in animal skins, is St John the Baptist, holding the Lamb of God in his arms. Furthest to the left is St Edmund, King of the East Angles, killed by Nordic invaders in 869 for refusing to renounce his Christian faith. Like Richard, he came to leadership at a young age, and in the fourteenth century was considered the patron saint of England. Deemed a martyr, he holds an arrow, the instrument of his martyrdom.

It was because St Edward the Confessor, who ruled England from 1042 to 1066, was so renowned for his piety that from 1395 Richard allied his arms with those of the dead king. St John the Baptist, from under whose protective arm Richard emerges, was the young king's patron saint – Richard was born on his feast-day and crowned on the eve of his vigil, supposedly wearing the same crown and coat that Edward the Confessor had worn at his coronation. The meaning is far from clear, but Richard seems to be claiming the protection of these illustrious forebears upon his own coronation, as if they epitomised the ideals of kingship that he too would bring to bear. Richard II is known to have begun using the device of the broom-cod as his personal insignia from the 1390s onwards, another detail that helps to date the diptych. His marriage by proxy to the young Isabella, daughter of Charles VI of

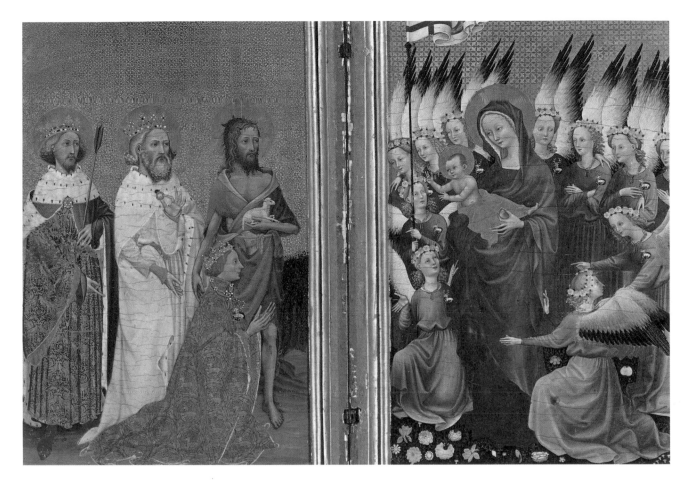

France, took place in 1396, and the arms of France and England were combined at her coronation. The broom-cod, or *planta genesta*, was a verbal pun on his family name, Plantagenet, just as the white hart when pronounced in the vernacular became 'Wichard'. Since classical times, the white hart had connotations with longevity. If the diptych was created after 1395 it may portray the young king in a strengthened position and in one of divine authority, having survived an attempt to depose him by his nobles, as well as the Peasants' Revolt, led by Wat Tyler.

The Virgin and Child return the herald, which represents England, to Richard II. It bears the flag of St George, and in the silver orb at the top, an island, a turreted gateway and a boat at sea can be singled out. References to England as 'this precious stone set in the silver sea' and 'this scepter'd isle' are found in Shakespeare's *Richard II*. The king was a known devotee of the cult of Mary; his position, asserted here, as ruler by divine right gave him alone the power to invoke her blessing for England.

HANS HOLBEIN THE YOUNGER *1497/8–1543*

THE AMBASSADORS 1533

National Gallery, London/Courtesy of the Bridgeman Art Library

HANS Holbein was born and raised in Augsburg, southern Germany, which he was forced to leave on account of the Reformation. The Church had always been a faithful patron, but religious painting could no longer be relied upon to provide a regular source of income and the Church was to be replaced as a patron by the royal courts, the nobility and the merchant class. Holbein came to England in 1532, where he would succeed primarily as a portrait painter, firstly to envoys and resident German merchants, then to the King and his family and the royal court, creating a tradition of portraiture unlike anything seen in England before.

This picture is painted on wood panel, a common material before the use of canvas became prevalent. The technique demanded a certain preparation, and there are some wonderful preliminary drawings by Holbein in the Royal Collection. Some carry his notes about the colour of his sitter's clothes, as he would work from these drawings in the studio. The magnificent picture hanging in the National Gallery of Christina of Denmark, Duchess of Milan, commissioned as part of marital negotiations with Henry VIII – never to come to fruition – was painted after three hours of her sitting for him.

The Ambassadors is similarly laden with purpose. It must have been expensive, as it is a full-length double portrait and contains all manner of intricacy and flamboyancy of technique. The gentlemen are evidently wealthy and educated, judging by the sumptuous clothing and the array of books and objects. The gentleman on the left, Jean de Dinteville, was the French Ambassador to England in 1533, the year the picture was painted; his friend the Bishop of Lavaur stands on his left. The clutter of instruments includes a polyhedral sundial, a celestial globe and other instruments for telling the time and reading the heavens. On the shelf below, the trappings of worldly pursuits such as a case of flutes, a lute, a book of arithmetic and a hymn book, are proudly displayed. In the foreground a distorted skull can be seen, a reminder of mortality: this comes into focus from a certain viewpoint to the right of the picture. Along with its dazzling display of perspective, this is a painting that shows off both its sitters and its painter at the height of their powers.

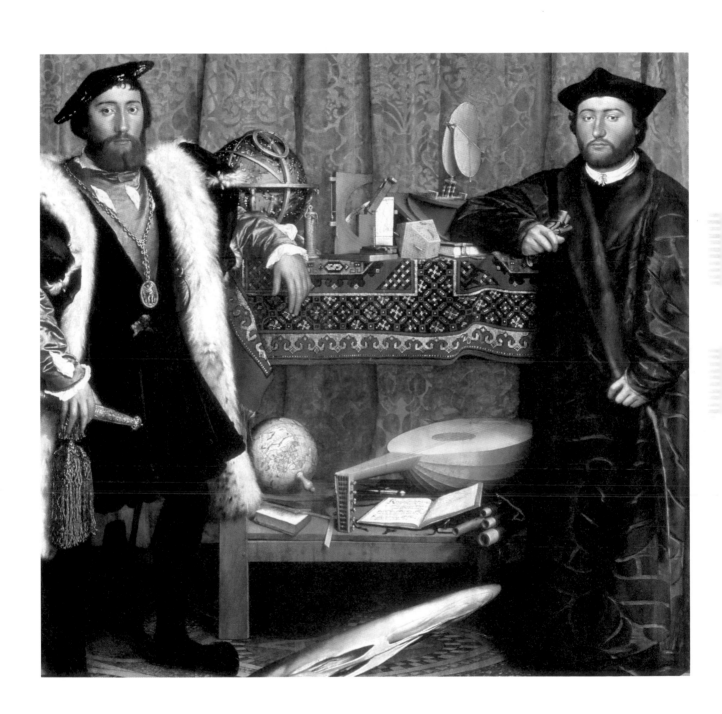

MASTER JOHN

CATHERINE PARR C. 1545

National Portrait Gallery, London / Courtesy of the Bridgeman Art Library

HOLBEIN the Younger wrought dramatic changes on British painting, but it is unclear why there are so few examples of independent work by English artists after his death in 1543 that bear his influence. Resentment against foreign-born artists ebbed and flowed and was particularly high in the second half of the sixteenth century, in part due to the influx of refugees from the religious wars in the Netherlands, who were forbidden to live within the confines of the City of London.

There are some existing copies of Holbein's portraits (for example, the portrait of Henry VIII in the Walker Art Gallery, Liverpool). Little is known of his working habits – that he was a foreigner may have restricted him in establishing a studio but it is not too far-fetched to presume that these copies were painted by assistants, who would later become independent painters in their own right. *A Man in a Black Cap* (Tate), for instance, was painted by John Bettes, about whom little is known except his signature and his status of low-paid craftsman for the royal court during 1531–3. Yet this portrait is executed in the manner of Holbein, a craft he must have learnt.

The rare, refined full-length portrait opposite was first identified as that of Lady Jane Grey, but the crown-shaped brooch the sitter holds was listed among Catherine Parr's possessions in an inventory. Catherine was the last of Henry VIII's six wives, outliving him by a year. The portrait is attributed to Master John, who may also have been an assistant to Holbein.

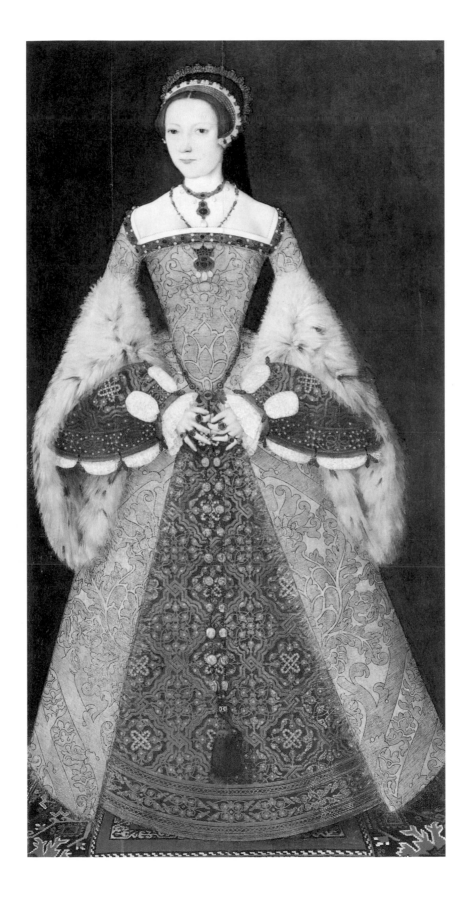

HANS EWORTH *1520–73*

TURK ON HORSEBACK 1549

Private collection / Courtesy of the Bridgeman Art Library

HOLBEIN'S successors came from abroad. Painters of international repute such as Guillim Scrots from the Netherlands and Gerlach Flicke from Osnabrück in Germany painted in England under Henry VIII, both adapting their manner to absorb the Holbein legacy.

Hans Eworth was born in Antwerp in 1520 and is first recorded in England in 1549. He came to prominence during the reign of Mary I, who had remained a Roman Catholic despite her father's dissolution of the monasteries and her half-brother's Protestant succession. A certain amount of religious painting was revived but the shortness of her reign, five years, defied the re-establishment of the Church as a significant patron. By 1553 Eworth had achieved court patronage, and painted portraits of Queen Mary and the English nobility, although he fell from royal favour for the first few years of the Protestant Queen Elizabeth I's reign – his patronage during this time was garnered mostly from the Catholic nobility. The main body of his work is British portraiture, but he is best known for two unconventional pictures painted shortly after his arrival, one of which is the magnificent *Turk on Horseback* of 1549.

The rider is glorious – he impresses with the severity of his profile and the purpose with which he moves through the landscape. The viewer's eye is immediately drawn to his impossibly large turban that winds around his head in regular swathes. Whilst the women and children in the background appear agitated and soldiers are seen running down the hill, he proceeds at a measured pace, bedecked in jewels and ermine finery, astride a mount almost as proud as he. The viewer's eye is encouraged to move from right to left by the horse's impatient stride, unusual in a culture that habitually reads narrative, whether in pictorial or written form, from left to right. The rocky landscape on the horizon and the path in the mid-foreground all sweep downwards from right to left in the direction dictated by the horseman's gaze. Amongst the group of women and children, the folds of their dresses and their linked arms reinforce this sensation of movement from one side of the canvas to the other.

Hans Eworth also painted a double portrait (1559) of Lady Neville and her son Gregory Fiennes, 10th Baron Dacre, whose name suggests that he may well have owned property and land in Acre, possibly as the result of one of the Crusade campaigns. From the late eleventh century crusading armies from the West attacked and counterattacked the East. Motives for joining the Crusades were mixed: for some it was the promise of salvation in return for protecting the Holy Lands from the 'infidel', for others it offered the opportunity to enrich their earthly existence, for others still it was an obligation, a consequence of titled and landed rank.

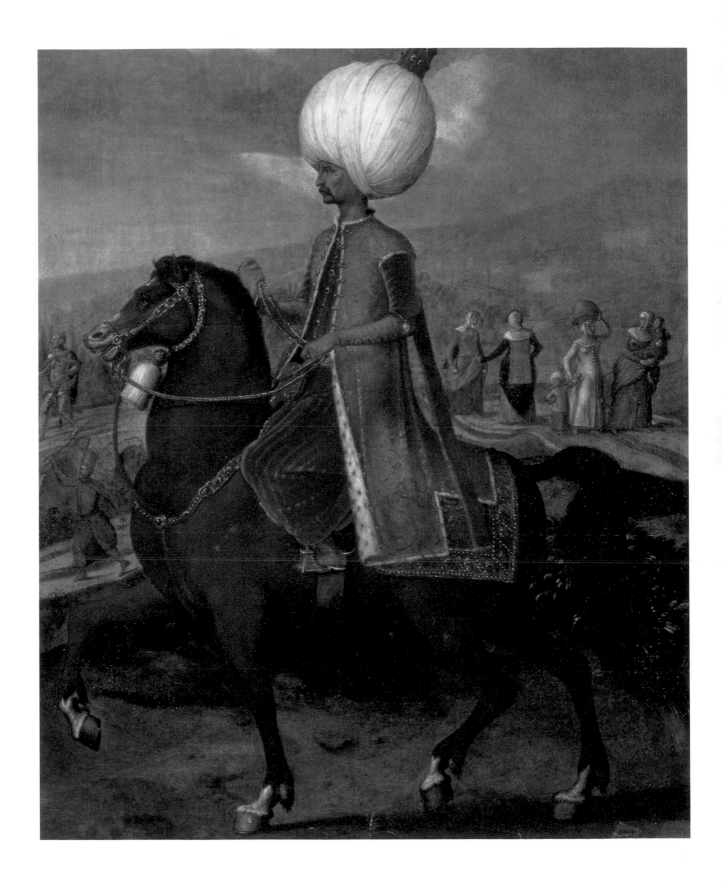

ANTHONIS MOR

SIR HENRY LEE C. 1568

National Portrait Gallery, London / Courtesy of the Bridgeman Art Library

ANOTHER foreign painter who came to England was the Dutchman Anthonis Mor, born in Utrecht around 1517/20. An accomplished painter to the Habsburg Spanish court, he came briefly to England at the behest of Philip II of Spain in 1554, at the time of his marriage to Mary I. Mor's portrait of her (three originals survive, one in the collection of Castle Ashby in Northamptonshire) is in the Habsburg court style, formal and devoid of character other than the strictly regal.

Mor probably painted the portrait opposite when Lee visited Antwerp in 1568. Lee was a courtier of Elizabeth I and the Queen's Champion, responsible for organising annual chivalric events in her honour and tilting for her in jousts. He is also thought to have commissioned a portrait of the Queen from Marcus Gheeraerts the Younger in 1592, and the same artist would paint Lee's nephew, Captain Thomas Lee, in 1594. Known as 'the Ditchley portrait', the painting of Elizabeth shows the monarch, dressed in all her majesty and jewels, standing on the globe, with her feet in Oxfordshire. The clouds darken over her left shoulder and the sun brightens over her right. It has been suggested that Lee commissioned this in commemoration of celebrations at Ditchley that the Queen attended, or in gratitude for her forgiveness: he had resigned from court life and taken up residence with his mistress Anne Vavasour.

This formidable portrait of Lee shows him with his left thumb inserted in a ring, perhaps a token of his love for the Queen. Other portraits by Anthonis Mor have his sitters in a similar pose but their meaning is not entirely clear. The celestial spheres on Lee's sleeves are a reference to his loyalty to Elizabeth, a symbol that can also be seen in the Ditchley portrait. Portraits of contemporary courtiers share similar characteristics. Sitters such as Robert Dudley, Earl of Leicester, and Sir Francis Drake appear suitably manly and proud, either in three-quarter or full-length pose, one hand on hip, the other often resting on an instrument of their success. In Drake's case his right hand rests on a globe, symbolising his circumnavigation of the world, and both he and Dudley are identified by their coats of arms in the top right-hand corners of their portraits. However, none of these portraits share the sophistication evident in Mor's image of Lee. The same confidence and poise can be seen, but here it is Sir Henry's own personality that rings out. The sitter has not been placed in front of a random backdrop or interior scene and there is no heraldry to distract the eye. His right arm is cut off at the edge of the picture, and although it is not inconceivable that the artist wished to continue here the illusion of three-dimensionality, it is more likely that the picture has been cut down in size at some point in its lifetime.

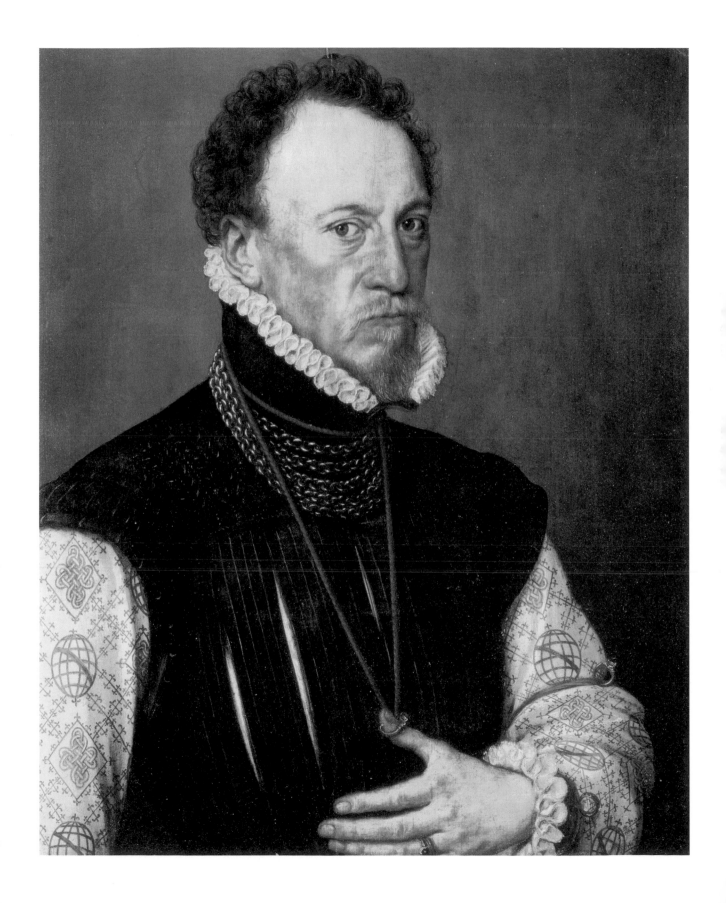

ALLEGORY OF THE REFORMATION c.1568–71

National Portrait Gallery, London / Courtesy of the Bridgeman Art Library

HENRY VIII is seen here on his deathbed, indicating his son and heir, Edward, protector of the Protestant faith. Edward VI came to the throne as a young boy and the gentlemen to the right of the picture are the Privy Councillors, his advisers. At his feet the Pope crumples, bearing the words ALL FLESHE IS GRASSE on his chest, and monks are seen fleeing, driven from their monastic orders. In the top right-hand corner of the picture, soldiers are seen destroying religious imagery; idolatry, the worship of the Lord through images, was forbidden. The white squares were left incomplete; they would have contained text and their unfinished state suggests either that the commission was abandoned or even that the painting was undertaken before the commission was sought.

For some time this picture was believed to date from Edward VI's reign but parts of it recall later imagery. The falling building in the top right-hand corner, symbolising the collapse of the old Church, and the bed in which Henry VIII lies have been traced to Flemish prints of the 1560s. Although most of the country was still Catholic, either actively or passively, under Elizabeth I England became a Protestant power and the spread of the Protestant doctrine was considerably aided by the great printing presses of Northern Europe. Not only texts but also narrative art in the form of prints confirmed the new religious line. Paintings such as *Allegory of the Reformation* served as affirmations and reinforcements of the new faith at a time of English isolation from the Catholic Netherlands and from Spain, and of English fears of a Franco-Scottish alliance embodied in the person of Mary Queen of Scots. Woodcut illustrations to John Foxe's *Acts and Monuments* (1563) depicted the deaths of Protestant martyrs in a necessarily gruesome manner during the Catholic reign of Mary I and Philip II of Spain.

In the new Church the congregation throngs not around the altar but around the pulpit, a triumph of word over image. Pictures such as the *Allegory of Man* (c.1570) firmly linked the deeds of this life with the hereafter and depicted the levelling power of death. Whilst previously the soul awaiting the Last Judgment in purgatory could be saved by the recital of daily masses on its behalf, the Protestant faith denied the power of any intercessionary act. Tomb decoration of this period also reflects the shift in emphasis. The prominent position held by the member of the nobility or local gentry whilst alive was maintained by the physical prominence of his or her family's tomb in the parish church. Instead of bearing images of saints or of Christ, the tomb would bear long texts prominently displayed, listing the deceased's valiant deeds and virtuous life.

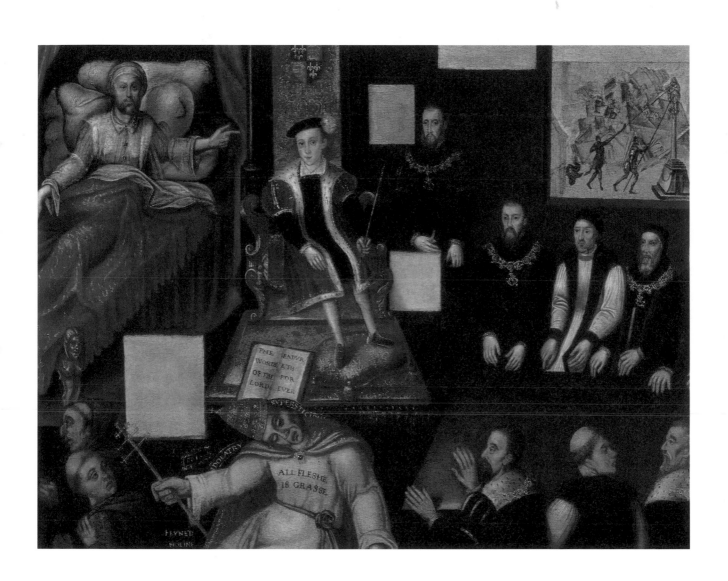

NICHOLAS HILLIARD *1547–1619*

WALTER RALEGH C. 1585

Courtesy of the National Portrait Gallery, London

HILLIARD was one of England's greatest miniaturists and author of *Treatise on the Art of Limning* (published only in the first half of the twentieth century). He was the son of an Exeter goldsmith but grew up in Geneva, returning to England at the age of fifteen and apprenticed to Queen Elizabeth I's jeweller and goldsmith, Robert Brandon. Hilliard came quickly to be renowned as a miniature portraitist, and by the 1570s was the most fashionable in London and de facto 'limner' to the Queen. His earliest surviving portrait miniature of her dates from 1572. True to the Queen's wishes, Hilliard ensured that no shadow would fall upon her face – nor did it in any other portrait of her. The result is iconic, goddess-like and stylised; decorative forms are favoured over the illusion of three-dimensionality.

Miniature painting as a technique has its origins in manuscript illumination and became popular at the court of Henry VIII. It was first introduced by Lucas Horenbout, and it was he who instructed Hans Holbein the Younger in the art of the miniature. Miniature painting gained its name not from the dimensions of its portraits but because of the minium or white lead ground on to which the pigments were applied. Limners, as portrait-painters were originally known, usually applied the white lead to card or vellum – treated animal skin – and then worked in gouache. In his treatise on limning Hilliard emphasised the importance of clean working conditions and a dust-free atmosphere. Along with the Italian Cennino Cennini's *Libro dell'Arte*, first published in the 1390s and concerned with every aspect of the painter's methods and materials, Hilliard's treatise offers a rare insight into the workings and aesthetics of the miniature.

Queen Elizabeth's court was one of music and literature, as well as intrigue. This was the age of Ben Jonson, William Shakespeare, Edmund Spenser and the explorers Francis Drake and Walter Ralegh, who named Virginia in deference to his Queen. Although the portrait opposite is tiny (48 x 41 mm), Hilliard has created an image of a personality so strong that he jumps out at the viewer. His lace ruff fills most of the surface, and the daintiness of his moustache and drastically pointed beard are cunningly silhouetted against the light background, creating a sense of depth without the use of shading. There is a sense of haughtiness but also one of knowing humour – it is the portrait of the explorer in his prime, secure in the Queen's favour.

In contrast, a full-length portrait by an unknown artist of Ralegh and his eight-year-old son Walter hangs in the National Portrait Gallery. As was the fashion, both strike manly poses, their left hands on their hips, their facial expressions composed, as they stand against a silken drapery. Yet the figures are devoid of the energy palpable in Hilliard's miniature.

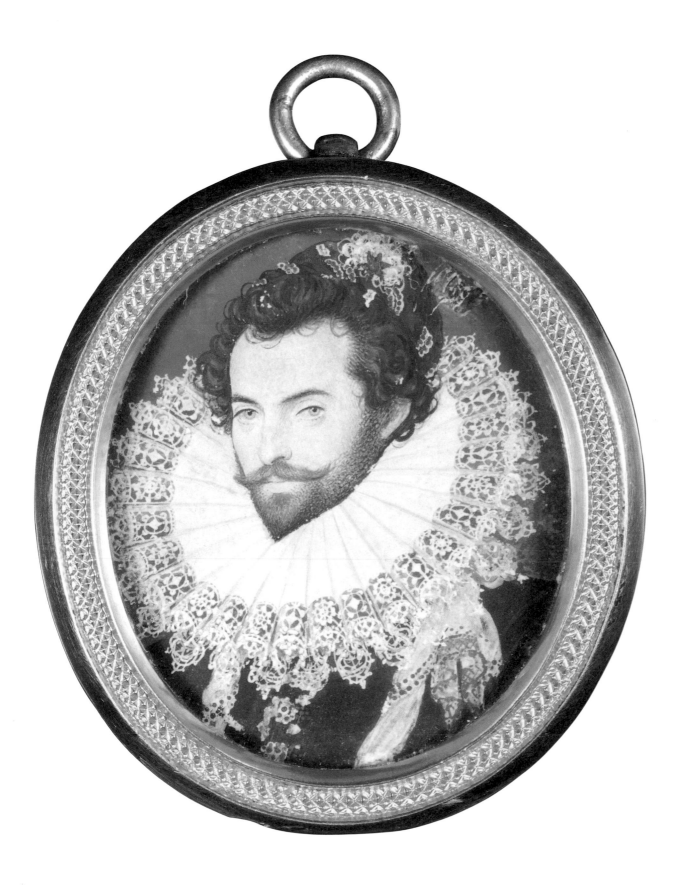

NICHOLAS HILLIARD *1547–1619*

YOUNG MAN AMONG ROSES C. 1587

Courtesy of the Victoria & Albert Museum, London

THE young man epitomises the age of Shakespeare and the love sonnets of Sir Philip Sidney. Languid, pining, effortlessly elegant, a fur slung over his shoulders, long, slim legs tapering into fine shoes, he leans against the tree, his right hand on his heart. The Latin inscription at the top of the miniature, 'Dat poenas laudata fides' ('My praised faith procures my pain'), is typical of the time, when foppish young men were expected to make great shows of suffering and unrequited love. Miniature portraits were in many ways a more private art form than large-scale portraiture – perhaps the young man gave this to the lady of his affections, part of the game of wooing which was always accompanied with the utmost artistry. Queen Elizabeth is said to have kept a portrait of her cousin and nemesis, Mary Queen of Scots, locked away in a cabinet, and Shakespeare has collectors paying large numbers of ducats for miniature portraits of Hamlet's father (*Hamlet*, II,2). In addition to the air of mystique that surrounded early miniatures, the detailed work that went into the craftsmanship lent them a precious air. The jewel-like nature of this miniature harks back to Hilliard's first training as a goldsmith. The raised pigment creates the impression of a stone-studded, gold-threaded doublet and the quality of the lace effect of his ruff is remarkable, the muted tones of the underside giving way almost as if to thin air.

Whilst Hilliard painted most of his portrait miniatures in the round, he also introduced the oval as a new standard. In *Young Man among Roses* the shape of the miniature further accentuates an impression of suspended animation, as if echoing a long-drawn-out sigh and the next intake of breath. This extenuated existence is subtly enhanced by the climbing rose. It shadows the youth the length of his elegant legs before following the incline of his head and the curve of the oval. On Accession Day, the day of tournaments orchestrated by Sir Henry Lee, the Queen's colours were black and white. One of the many symbols she adopted was the rose, and the colour white signalled her status as Virgin Queen. If there is a connection between this miniature and the Queen, it is unknown. As in his other whole-length miniatures, for example that of Robert Devereux, 2nd Earl of Essex (1593–5), Hilliard has portrayed the Elizabethan courtier at his youthful best, steeping it in mystery and hidden meaning.

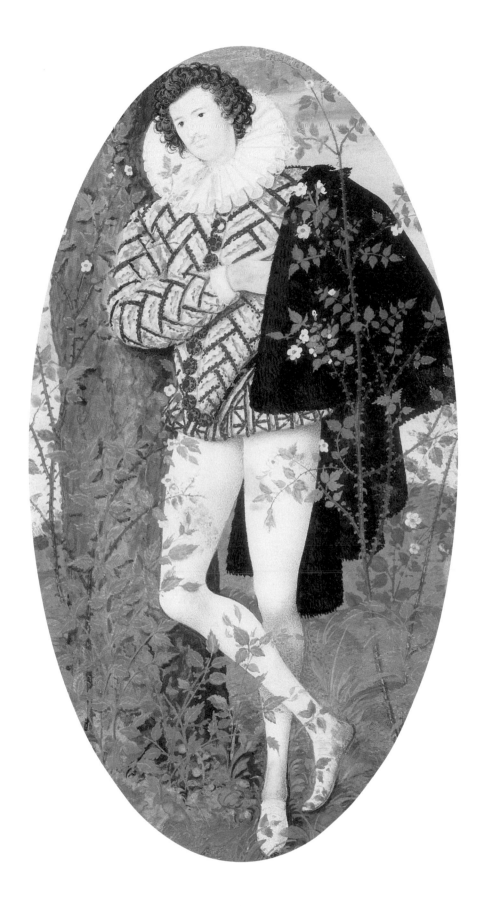

ISAAC OLIVER *c. 1565–1617*

EDWARD HERBERT, 1ST BARON OF CHERBURY 1613–14

Courtesy of the Earl of Powis / Bridgeman Art Library

HILLIARD'S pupil, successor and closest rival was an artist called Isaac Oliver. Born in England of French Huguenot parents, he won the patronage of Queen Anne of Denmark, wife of James I. Hilliard continued to occupy the position of chief portraitist to the King but his style fell from fashion. Oliver's miniature of Edward Herbert, 1st Baron of Cherbury, is a glorious example of the miniature portrait, but allows for more depth and expression than previously seen in Hilliard's work. Its dimensions (18.1 **x** 22.7 cm) are large by miniature-portrait standards, perhaps indicative of a change in the genre's purpose. It could no longer be considered a personal jewel and is too big to slip into a pocket. Whereas in Hilliard's masterpieces shimmer and tactile quality were dominant features, here prominence has been given to depth and scale. If the miniature was becoming an object of connoisseurship and display, virtuosity in painting a receding landscape or a distant seascape was of equal if not greater value than giving the illusion of a gold gem.

In another of his exquisite miniatures, *Unknown Man* (1590–95), Oliver shows his skill in painting the effects of light and shade. In the foreground the delightful young man shelters in the shade of a tree, propped up against its thick trunk, and gazes wistfully into the distance. In the background, the sun shines on a formal enclosed garden which is seen from above: the young man seems to be sitting on a hilltop or raised bank. Below, a couple are seen walking in the garden, and the sunlight plays on the arcaded colonnade that runs the length of the garden; a turreted palace is seen in the distance.

In the miniature opposite, the subject reclines in a glade, propped up on one elbow, in a melancholic pose. He appears to be choosing between a life of contemplation and one of military action. Lord Herbert's armour is seen hanging on a branch in the background and the ties of his doublet to hold it in place hang loose around his neck.

This choice between philosophy, military prowess and statecraft may have been a common theme in Elizabethan and Jacobean miniatures – Hilliard's portrait miniature of the 2nd Earl of Essex contains elements of a similar dilemma, but is shrouded in enigma. Certainly at the end of the sixteenth century reclining in a landscape, resting on one's elbow, was a fashionable and suitably melancholic pose for young noblemen. A full-size portrait of Peregrine, 12th Baron Willoughby de Eresby, in the Grimsthorpe and Drummond Castle Trust collection has the sitter in the same pose but leaning on his left side, his armour also in the background, one image the mirror of the other.

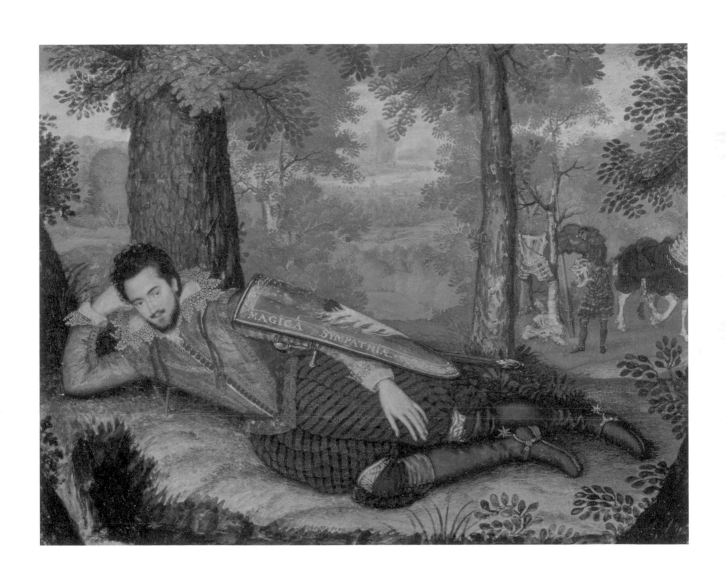

Queen Elizabeth in Procession (Eliza Triumphans) c. 1601

Private collection / Courtesy of the Bridgeman Art Library

WHEREAS portraiture had been the domain of kings, queens and, increasingly, the nobility, group portraiture was growing more and more popular by the late 1590s. Full-length portraiture was also back in favour, leading to the commissioning of series of 'costume pieces', such as those by William Larkin in the Ranger's House, Blackheath, London. Larkin was less concerned with representing his subjects in a recognisable space; his paintings are consummate exercises in the linear qualities and surface texture of pattern, fabric and jewellery, recalling Hilliard's miniatures.

Queen Elizabeth in Procession (Eliza Triumphans) is one of the most famous images of the Queen and combines the fashion for costume pieces with group portraiture. It was painted, interestingly, on canvas rather than wood, the former being more flexible and easy to prepare. She is transported on a canopied litter, surrounded by her Knights of the Garter; their individual features are observed from life. The central figure in the painting, apart from the Queen, is probably the commissioner of the picture, Edward Somerset, 4th Earl of Worcester, who was appointed Master of the Horse in 1601, the year this painting was completed and two years before the Queen's death. In style it is far removed from her earlier portraits, a celebration less of her physical being, more of her as idealised monarch, to be adored and fêted in the tradition of chivalric love. Portraits of the 1570s, such as 'the Cobham portrait' in the National Portrait Gallery or the 'Pelican Jewel' portrait in the Walker Art Gallery, Liverpool, show more concern with facial likeness and convincing human form than do portraits painted towards the end of her reign, although the symbols which would shore up her Virgin Queen persona are already much in evidence. These earlier works may also have been commissioned as part of a number of marriage negotiations, whereas 'the Ditchley portrait', to which this image of the Queen bears a striking resemblance, and those painted after the defeat of the Spanish Armada in 1588, are celebrations of victorious and triumphant majesty.

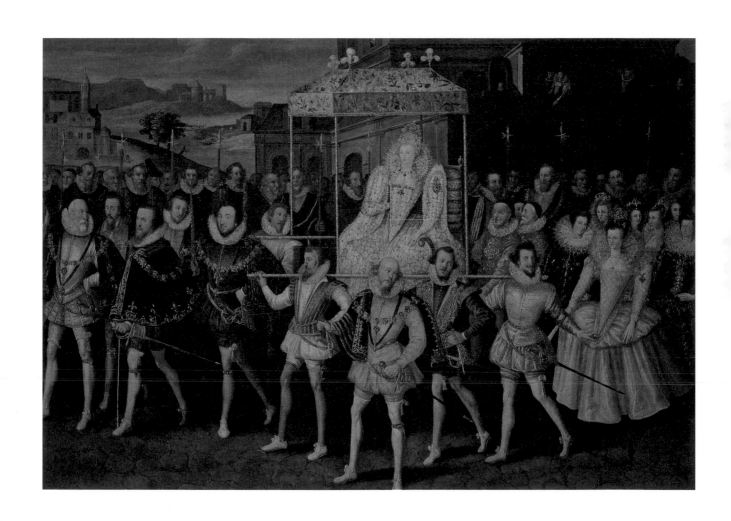

THE CHOLMONDELEY LADIES c. 1600–10

Courtesy of the Tate Gallery, London

IT is not known who painted *The Cholmondeley Ladies* or exactly why it was commissioned. The son of Mary Queen of Scots, the Stuart King James VI of Scotland (d. 1625) succeeded the heirless Queen Elizabeth as James I of England in 1603, uniting the two crowns, but there was little immediate difference in prevalent artistic style. A number of pictures have survived from these times, but the names of the artists have not. Nevertheless, similarities in style, subject matter and materials have encouraged scholars to group them together, into the British School tradition. The inscription to this portrait was added at a later date, probably a hundred years later. It reads 'Two ladies of the Cholmondeley Family/Who were born on the same day/Married on the same day/And brought to bed on the same day'. The painting once belonged to a descendant of the Cholmondeley (pronounced 'Chumley') family.

The women portrayed came from Cheshire, and it is likely that they were the Cholmondeley sisters. They are physically very similar, although not identical: one has blue eyes, the other brown. They are both dressed ornately, but with slight variations, each sitting upright in bed and clutching a child dressed in red christening robes. Each woman wears a slightly differently brocaded dress and this feature is repeated in the dresses of the infants; and the eyes of each child, in a direct dynastic statement, are the same colour as its mother's. The painter has tried to give a sense of corporeality and of foreshortening in the folds of the children's robes and the bedcover, but the overall effect is one of two-dimensional stiffness and symmetry, not unlike tomb sculpture.

Whether or not the inscription is accurate, there is an air of commemoration to this image. If so, it is to commemorate new birth, probably of sons. Only males could inherit title and land and ensure the continuity of the family name. Position in society was determined by family and by marital alliances that brought increases in wealth and social standing.

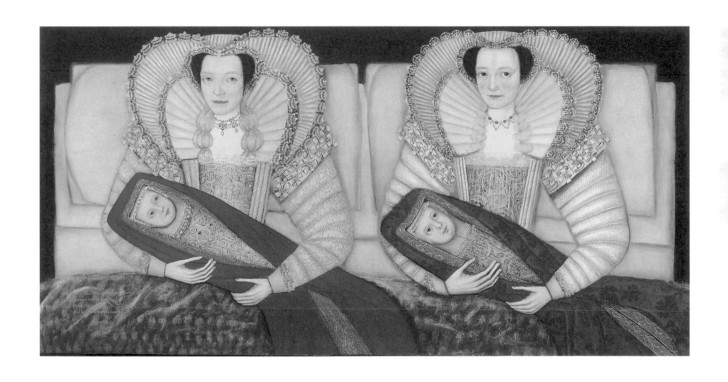

DAVID DES GRANGES *1611/13–75*

THE SALTONSTALL FAMILY C. 1636–7

Courtesy of the Tate Gallery, London

ANOTHER group picture, *The Saltonstall Family*, by the miniature painter David Des Granges seems to tell a story of legitimacy and dynasty. Des Granges's family was from Guernsey, although he himself was born in London. He was of Huguenot (French Protestant) extraction but converted to Catholicism. Although this painting is his most famous work, he was miniature painter to Charles II from 1651 and his early training was as an engraver.

This group portrait shares certain characteristics with *The Cholmondeley Ladies* (see page 42) and *Sir Thomas Aston at the Deathbed of His First Wife* (see page 46). In subject matter it is concerned with record: the death in 1630 of Elizabeth, the mother of Sir Richard Saltonstall's first children, and the birth of one of his two children by his second wife Mary, whom he married in 1633. There is a sense of emotion and of loss in this family portrait that is not found in tomb decoration, in which this type of picture has its origins. Sir Richard is the lynchpin in the frame – the structure of the image displays his sadness and the threat to the future of his family name. A diagonal line starts from the lower left, passing along the joined hands of the two children, daughter Ann and son Richard – boys wore dresses until the age of about nine – and up into their father's hand. He is prominent in black and gold embroidery, slit sleeves and conical black hat, fashionable at the time. The eye is led up to the apex of this triangle, pausing to take in Sir Richard's impressive appearance, before falling down the length of his arm to a point of suspense – the outstretched hand of the ghostly bedridden first Lady Saltonstall. Sir Richard's gaze falls on the newborn son, Philip, in the lap of the second Lady Saltonstall, and it is from this father figure that the visual links are made between one dynastic grouping and another.

Any doubts as to the seated lady's identity – perhaps a nursemaid rather than a second wife – are dispelled by the elaborate nature of her dress, made of fine silk and elaborate lace. She would produce two sons, one in 1634 and the second in 1636.

The dimensions of this painting – 214 x 276.2 cm – are greater than those of other surviving paintings of this type and suggest that it was intended for prominent public display in the family house. As a document of an early-seventeenth-century interior it is fascinating, and shows the use of woven tapestries for wall decoration. Elements of its outdoor scene are visible beyond the heavy curtains of the four-poster bed.

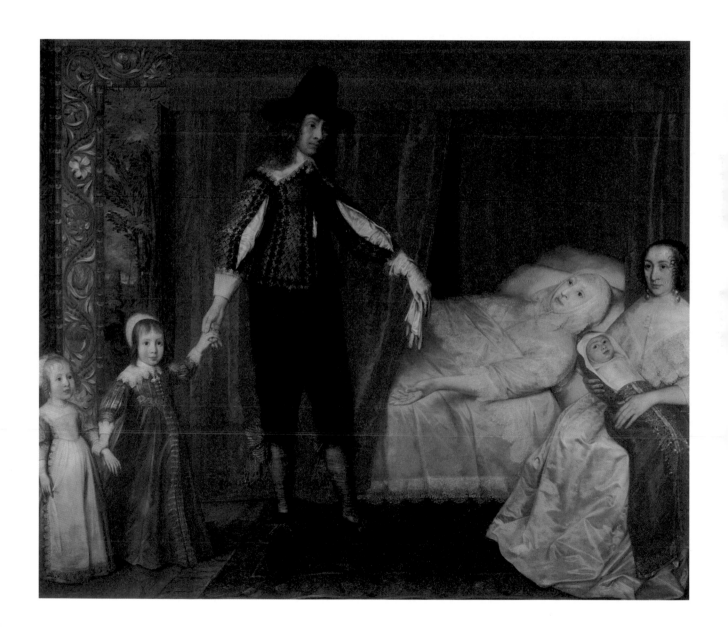

JOHN SOUCH *1594–1644*

SIR THOMAS ASTON AT THE DEATHBED OF HIS FIRST WIFE **1635**

Courtesy of Manchester City Art Galleries, City Art Gallery

EARLIER family portraits, such as that of William Brooke, 10th Lord Cobham, his wife, sister-in-law and six children (1567), give few insights into the sitters' characters or the dynamics between the family members. None of the children look at each other and although the family is placed before a dining table laden with fruit, the interior is anything but domestic. The painting has a sense of unreality about it, similar to John Souch's *Sir Thomas Aston at the Deathbed of his First Wife*. As in *The Cholmondeley Ladies*, the Cobham family portrait records genealogical information, with the young sons grouped by their father, the daughters by their mother. Souch's work recalls the sort of family imagery found on tombs and church monuments, where it was common to depict scenes of birth and death, the deceased and the living in the same image.

Little is known about Souch's life and work. He worked and lived in Chester and he is recorded in 1616/17 as an apprentice to the Chester herald painter Randle Holme. A signed portrait by Souch of George Puleston, also a Cheshireman, is in the Tate collection and perhaps it was this first training that is responsible for the unreal appearance to this painting too. The contrast with *The Saltonstall Family* (see page 44) is striking: Souch has not arranged his figures in any way that could be considered realistic. There is no link between them, neither physical gesture nor gaze. Instead Sir Thomas rests one hand on a cross and the other on a skull. His young child is simply a smaller version of himself, dressed in almost identical clothes.

This is not so much an account of personal loss as a comment on life. It shows that life must be led in the knowledge not only that death comes to all and the soul's final resting place depends on one's deeds in life, but also that death and life forever coexist. Although more emblematic and old-fashioned in style, Souch's painting is not unlike the themes of indecision seen in Isaac Oliver's miniatures or in the full-length portrait of William Style of Langley in the Tate, painted in the same year as this work, by an unknown artist. The same dilemmas are presented – choices to be made between earthly splendour and spiritual pursuits – and although Souch's picture is made of sterner stuff, presenting less a choice than a reality, the same questions run through them all to differing degrees.

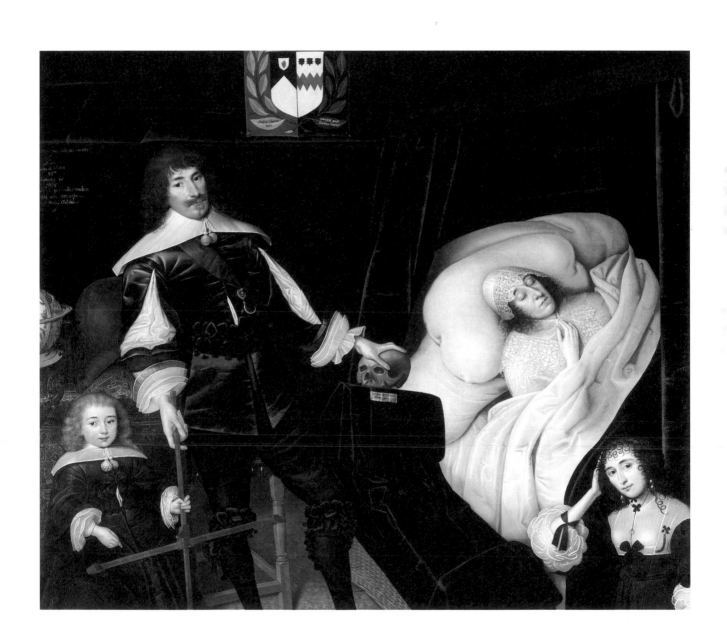

CORNELIUS JOHNSON *1593–1661*

THE CAPEL FAMILY C. 1639

By courtesy of the National Portrait Gallery, London

THE greatest British-born portrait painter of this period was Cornelius Johnson, whose roots were in Antwerp and Cologne. Not much is known of his early training, and he left England in 1643, as civil war loomed, to settle in Holland. Renowned for the sensitivity and characterisation that he brought to his portraits, he specialised particularly in the oval format, reminiscent of the miniature, and in depicting single heads as opposed to full- or half-length portraits. Mytens and van Dyck, who had come to England in 1618 and 1620 respectively, influenced his later work.

This portrait of the Capels, a wealthy Hertfordshire family, is remarkable for the domestic and peaceful tone it achieves, just before the outbreak of civil war. Arthur Capel was made Baron in 1641, fought as a Royalist during the Civil War and followed his king to the scaffold in 1649. Des Granges had evoked a note of pathos in his family portrait of the Saltonstall family but Johnson pulls this family group together with the look of tenderness that passes from wife to husband, while at the same time maintaining the status quo of more dynastic family portraiture, grouping the daughters around their mother, the sons around their father. In *The Saltonstall Family* Des Granges showed us a domestic interior; here Johnson, in response to a growing interest in topographical landscape, includes a formal enclosed garden in the background. The garden is peppered with fountains and classical statues amid geometrically designed raised beds; the only trees to be seen are those beyond the garden's walls. The origins of this style of garden are Italian – the fashion spread first to France and then to the rest of Europe – and by the seventeenth century the Italianate garden was universal. The earliest record of a garden in British portraiture appears in a painting of Henry VIII and his family (1545). Gardens in portraiture appeared mostly as insets but with little or no sense of scale or proportion in relation to the sitter.

The placing of figures in family portraits such as these vaguely recalls that of earlier religious pictures of the Virgin and Child and company of saints. The mother and daughters here are positioned near the garden. In religious art one of the symbols of the Virgin's virginity, derived from the Books of Solomon and Ezekiel, was the enclosed garden or *hortus conclusus*.

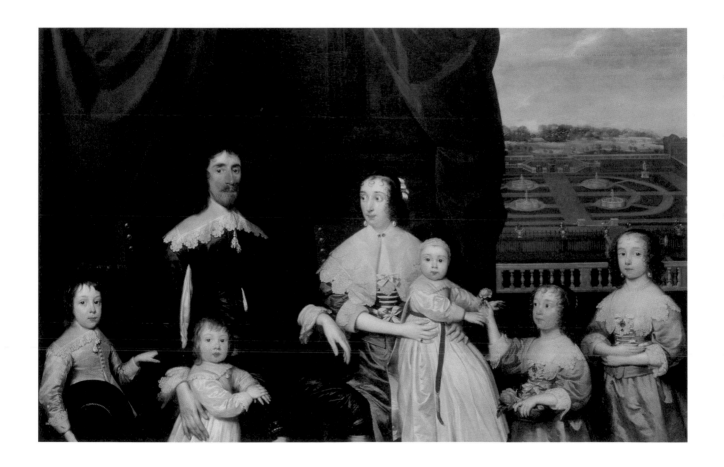

NATHANIEL BACON *1585–1627*

THE COOKMAID WITH STILL LIFE OF VEGETABLES AND FRUIT C. 1620–25

Courtesy of the Tate Gallery, London

NATHANIEL Bacon was a Norfolk landowner and amateur painter who painted mainly for himself and his family. One of his four self-portraits (in the collection of the Earl of Verulam, Gorhambury, Hampshire) shows him to be of equal talent to Mytens and Johnson and reveals a persistent interest in still life, also evident in *The Cookmaid with Still Life of Vegetables and Fruit*. Usually, fruit and vegetables were chosen to indicate a certain month of the year, but here the produce is from all the seasons – spring onion, summer melon, autumn pear and winter cabbage. Once the cookmaid's abundant cleavage has been negotiated, the view is of the fields beyond; mounds of fertile earth and two labourers can be seen in the distance. Fertility in

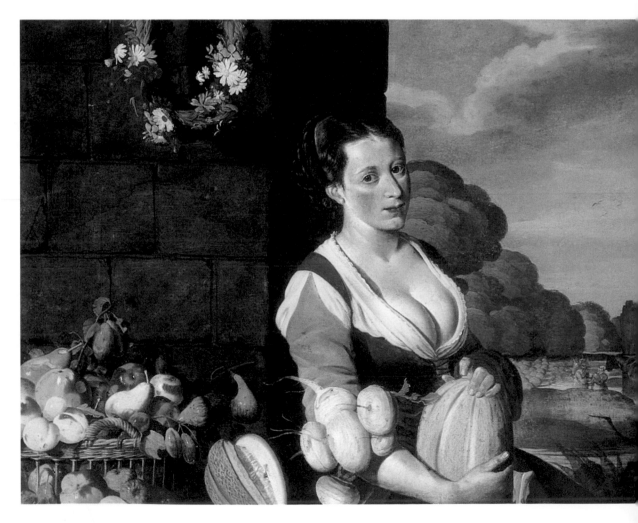

nature seems to be the general theme; the analogy of the melon and the cookmaid's breasts is too flagrant to be missed! The juxtaposition seems amusing today, and not particularly subtle, but the painter's vision is clear.

Still life and landscape were forms of painting little practised in England but widely prevalent on the Continent, especially Holland and Flanders, from the early seventeenth century. Bacon painted the first known British landscape, a miniature in copper that is in the Ashmolean Museum, Oxford. As in Johnson's *The Capel Family* (see page 48) and *William Style of Langley*, both later than Bacon's *Cookmaid*, there seems to be a general edging towards the outdoors, a hovering on the threshold. In both of these latter pictures figures stand in the interior, but by gesture and suggestion of movement appear also to pass between the two. William Style of Langley gestures towards the garden in his portrait, as if to beckon the viewer to join him there, and the two Capel daughters are painted against the garden backdrop. The gift of a rose (another Marian symbol) to their youngest sibling is silhouetted against the point where the interior drapery meets the exterior balustrade.

ANTHONY VAN DYCK *1599–1641*

QUEEN HENRIETTA MARIA 1634

Private collection / Courtesy of the Bridgeman Art Library

THE demand for portraiture amongst the court and aristocracy continued. The greatest figure in seventeenth-century English portraiture was another foreigner, Anthony van Dyck. Born in Antwerp into a wealthy family, he was to die in London, having settled there in 1632 at the behest of Charles I, who had succeeded James I, his father, seven years previously.

Charles I was renowned across Europe for the collection of paintings he amassed, and like van Dyck was a great admirer of the works of Titian. Knighted by Charles in 1632, van Dyck was provided with a house and extensive finances, and granted domicile status in 1638. The King even orchestrated a marriage with a titled English lady to make his stay permanent in 1639–40, as by this time the great painter was making moves to return to Antwerp or settle in Paris. He was buried in St Paul's Cathedral with full honours, according to Catholic rite, and the King commissioned a memorial plaque for his tomb. Van Dyck's patrons were almost exclusively the royal family and the inner court circle – some of his patrons died during the Civil War, others swapped sides. When anyone pictures the era of Charles I in their minds, chances are they will conjure up a van Dyckian image, inflected with Rubens's robustness and the Venetian Titian's vitality: outclassing his contemporaries, including Daniel Mytens, van Dyck revolutionised British portraiture. Neither Charles I nor his wife Henrietta Maria, who was the daughter of Henry IV, King of France and whose portrait is shown here, was particularly tall or graceful, according to contemporaneous accounts. Van Dyck's portraits of the King and Queen, however, emit regality. The painter has been accused of distracting a nascent 'true' British tradition of portraiture, but a concern for verisimilitude was not uppermost in the minds of commissioners. His portraits of Charles in particular are full of energy and power, and he was the first to paint an equestrian portrait of an English king, *Charles I on Horseback*. As a portrait it speaks of virility, exoticism, leadership – it is more in the European tradition than in any other.

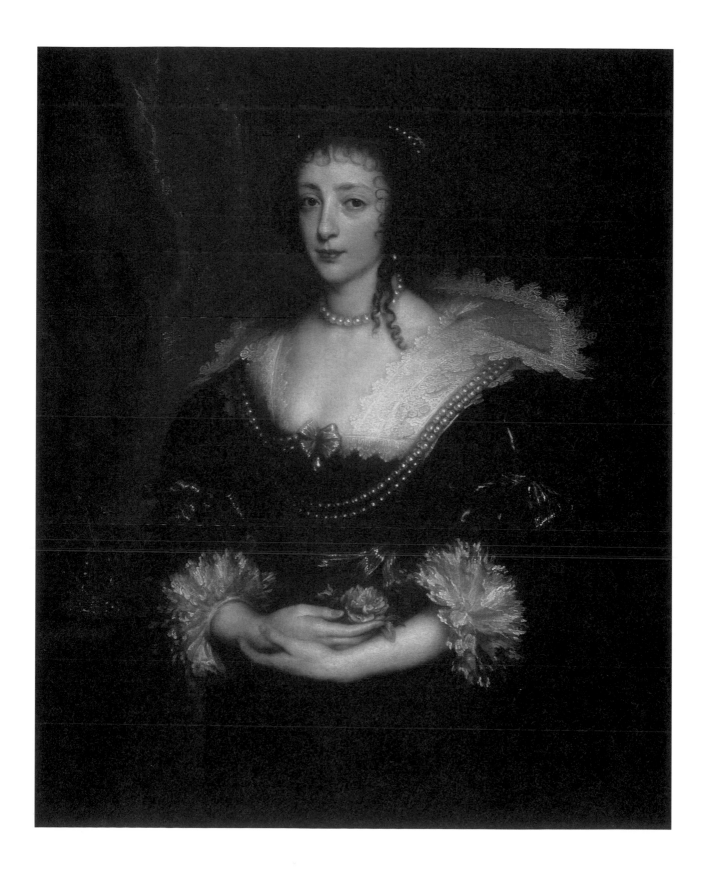

SIR PETER LELY *1618–80*

QUEEN MARY OF MODENA C. **1673–80**

Courtesy of English Heritage Photo Library

FEW painters could equal the precedent set by van Dyck. Out of those who tried, Lely was to be the most successful.

Lely was born and trained in Holland. His family name was van der Faes – 'Lely' is supposed to have come from the name of his father's house in The Hague. He moved to London in 1641–3 to step into a vacuum created by the death of van Dyck in 1641 and Cornelius Johnson's departure to Holland at the threat of civil war. William Dobson (b.1610/11), the English portrait painter associated with the exiled royal court of Charles I in Oxford, died in 1646, leaving the field even more open to Lely. Lely soon switched from landscape and history painting to make his fortune in portraiture. He painted Charles I and his children whilst they were in the custody of the Parliamentarians. Following his defeat by the Roundheads, Charles was held at Hampton Court. His children, in the care of the Earl of Northumberland, were held further up the Thames, at Syon House. Lely also painted portraits of the opposing side, of Cromwell and other Commonwealth leaders, but he is mostly associated with the Restoration and Charles II, who appointed him Principal Painter in 1661. His self-portrait reveals a proud-looking man, sure in his abilities and position.

By the 1670s, Lely was running a busy studio – surviving bills and records list the names of his assistants responsible for backgrounds, draperies and ornaments, as well as the prices he charged. In his portraits he used a variety of poses, one of which the sitter would select, and then the outline would be drawn in. The face was painted from life, but models were used from which to paint the rest of the portrait. Much of his work is repetitive, but this is a remarkable picture of Mary of Modena, daughter of Alfonso d'Este IV, Duke of Modena, and wife of James II. She is seen picking orange blossom, which had connotations of lasting pleasure and love. Lely's use of colour and his rendering of texture were spectacular, as was his depiction of voluptuous, silk-clad, sleepy beauties in a variety of poses, best represented by his work of the 1660s. Lely was knighted in 1679/80 and buried in St Paul's, Covent Garden.

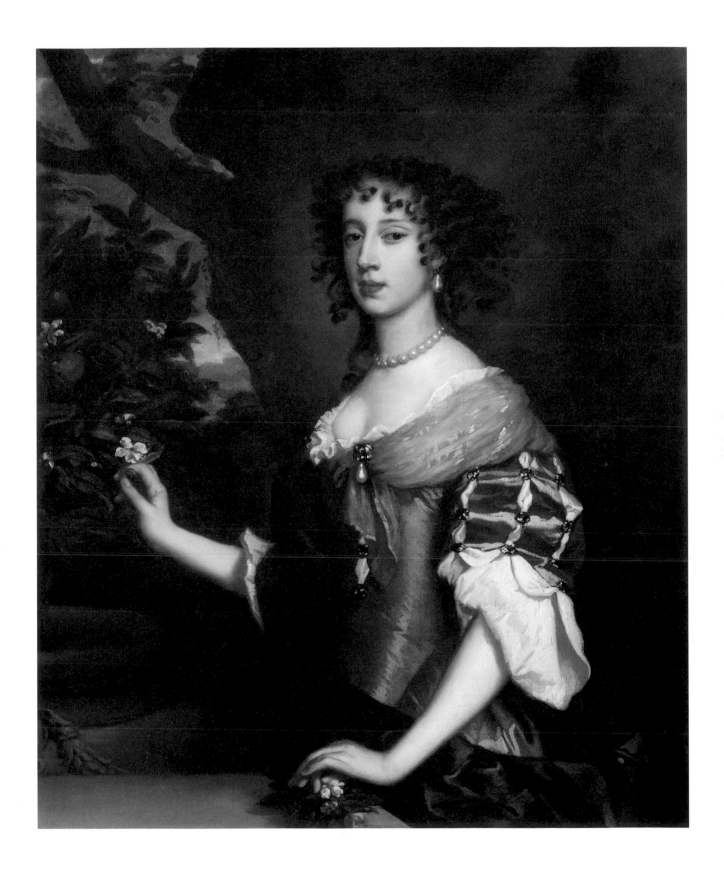

MARY BEALE *1633–99*

CHARLES BEALE C. 1675

Private collection / Courtesy of the Bridgeman Art Library

MARY Beale was born Mary Craddock, the daughter of a Suffolk clergyman. Largely self-taught, she supported herself and her family, became extremely prolific in society and clerical portraiture in Restoration London, and as a copyist of Lely was much in demand. Lely's pupils included John Greenhill and Willem Wissing, both of whom died young before they could fully emerge from Lely's studio control. Unsurprisingly, the only painters Lely is known to have recommended to Charles II were the decorative painter Verrio and others equally unlikely to pose a threat to his position as leading portraitist. Whilst it is extremely unlikely that Mary Beale was ever a pupil of Lely's, she was an avid follower of his. The commissioning of pictures in the style of another artist was quite a normal occurrence – it was not until the nineteenth century that the supremacy of the original obtained.

Mary's husband, Charles Beale, of whom this is a portrait, kept a diary of her artistic output for six years in the 1670s. He recorded 140 commissions for portraits and for copies after Lely during this period; for many of her sitters she painted heads framed in feigned stone ovals replete with fruit. Another professional painter, a Mrs Carlisle, is known to have worked in Covent Garden from 1654 and a few works by a Miss Killigrew also survive from this period.

Charles Beale is portrayed as a poet – since Elizabethan times, the preserve of poetic or melancholic genius was to dress with unkempt abandon. More than a century after this portrait was painted, Wright of Derby would portray a pensive Sir Brooke Boothby (see page 78) in a similar dishevelled state. Beale's circle of friends certainly included artists, scientists and clergymen of the day. Another portrait by Mary of her husband shows him holding a laurel wreath, the symbol of literary achievement, more likely as not earned by association alone.

The family had moved to Hampshire from London in 1665 as her husband lost his post as Deputy Clerk of Patents, but were back in Pall Mall in 1670. Her (now Grade II listed) Hampshire home and studio, Allbrook Farmhouse, near Eastleigh, was rediscovered in the 1950s – the new occupants found canvas-drying racks still in the dining room. The house was subsequently threatened with conversion into a pub and at present belongs to a property development company.

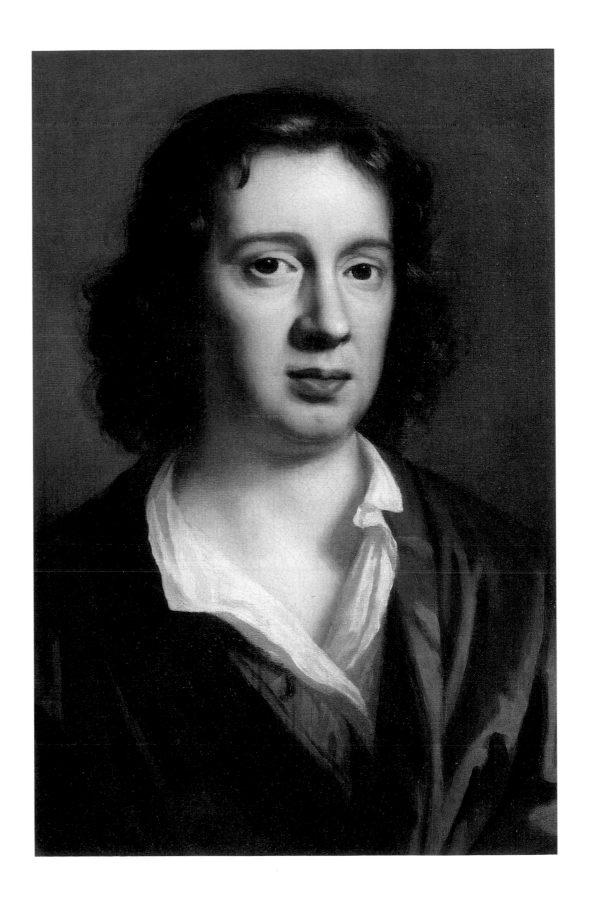

SIR GODFREY KNELLER *1646/9–1723*

SIR CHRISTOPHER WREN 1711

Courtesy of the National Portrait Gallery, London

THE German-born painter Godfrey Kneller came to London from Holland in 1676, encouraged by the merchant John Banckes. He had studied mathematics before joining the painting studio of Ferdinand Bol, a former pupil of Rembrandt's. Fortunately perhaps for Kneller, Sir Peter Lely died in 1680, and Kneller was quick to fill his shoes. He produced portraits of Charles II and James II, and in 1688 was appointed joint Principal Painter, together with John Riley, upon the accession of William III and Mary II. Riley died in 1691 and Kneller held the post alone for 32 years. He was knighted in 1692 and created a baronet in 1715. He was the principal artistic figure in England throughout the reigns of William and Mary, of Queen Anne and of George I.

Like Lely, he managed a formidable studio machine, which would become more formalised during his dominance of society portraiture – he and his assistants could produce up to fourteen portraits a day. Kneller's most famous series (in the vein of Lely's *Windsor Beauties* of the 1660s) is that of the members of the Kit-Kat Club, a drinking and political club which congregated in Christopher ('Kit') Cat's pie house. The 'Kit-Kat' portrait became a new standard formula, half-length and with one hand showing. This portrait of Sir Christopher Wren (1632–1723) shows him as an old man – he lived to be over ninety years of age – a pair of compasses in his hand and his plans for St Paul's Cathedral unfolded on the table. By 1711 Wren was regarded as old-fashioned by the younger generation of architects, such as Nicholas Hawksmoor and Sir John Vanbrugh, whose portrait Kneller also painted. Although Wren's name is synonymous with St Paul's Cathedral, which he rebuilt after the Great Fire along with other London churches, he also designed the Library at Trinity College, Cambridge, and the Sheldonian Theatre, Oxford. The Great Hall at Greenwich and the Royal Observatory, sections of Chelsea Hospital and Hampton Court Palace were also designed by Wren. Sir James Thornhill, England's first Baroque fresco painter, decorated some of the architect's greatest buildings. In his youth Wren had been an eminent scientist and astronomer, and it is tempting to imagine a certain empathy between the portraitist and his sitter. The great architect was buried in the crypt of St Paul's and his son later set a tablet on the wall there. The final epitaph reads 'Lector si monumentum requiris circumspice' – 'Reader, if you seek a monument, look around you.'

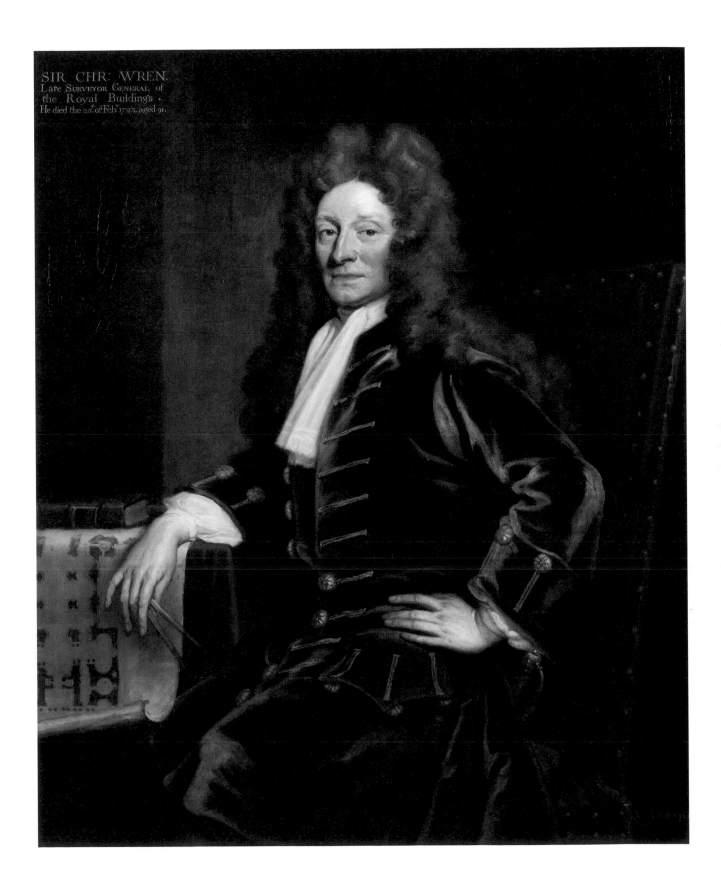

SIR CHR: WREN.
Late Surveyor General, of
the Royal Buildings .
He died the 26. of Feb.y 1723, aged 91.

JAN SIBERECHTS *1627–1703*

AN ELEVATED VIEW OF LONGLEAT HOUSE, SEEN FROM THE SOUTH 1676

Courtesy of the Tate Gallery, London

LANDSCAPE painting, together with decorative painting, still life and sporting pictures, grew in popularity towards the end of the seventeenth century, not least because of the steady influx of Flemish and Dutch painters – as a native genre, landscape was still marginal. Two main sorts of work were fashionable: the topographical, and the ideal landscape. The first included the depiction of country estates, a sort of architectural face-painting along the lines of 'I am what I own', and generated a parallel interest in the recording of antiquities. The 'ideal landscape' was more often than not a direct pastiche of the work of the Old Masters, with no hint of native scenery. Works by Claude (1600–82) and Dughet (1615–75), Poussin (1594–1665) and Rubens (1577–1640) were to be found in private collections at the turn of the century.

Jan Siberechts was born in Antwerp and came to England in 1672–4, where he remained until his death. One group of pictures shows Siberechts practising the art of 'country house portraiture' – commissions from wealthy owners to paint their houses and the surrounding landscape. Between 1675 and 1678 he painted various views of Longleat House for its then owner, Thomas Thynne, which still hang in the house. Much is substantially unchanged from the house depicted in *An Elevated view of Longleat House, Seen from the South*.

Siberechts also painted topographical views, and whilst most of them are more reminiscent of Flemish landscapes, some could be considered to be the beginnings of the British landscape tradition. Many of the buildings seen in *View of Nottingham from the East* (c. 1700) are still standing and *View of Nottingham and Trent* contains clear elements of a recognisable English panorama.

Landscape with Rainbow, Henley-on-Thames in the Tate collection shows the village nestling in the valley, while clouds pass overhead and a rainbow fixes the moment after the passing of a storm. This painting contains themes and approaches to landscape that would dominate the nascent British tradition. Constable and particularly Turner would explore their interest in storms, clouds and luminosity; Constable would delight in the domestic agricultural scene. The complexities of light effects and their ability to animate a landscape to dramatic effect would also become an integral part of British landscape painting and the debate on the nature of landscape.

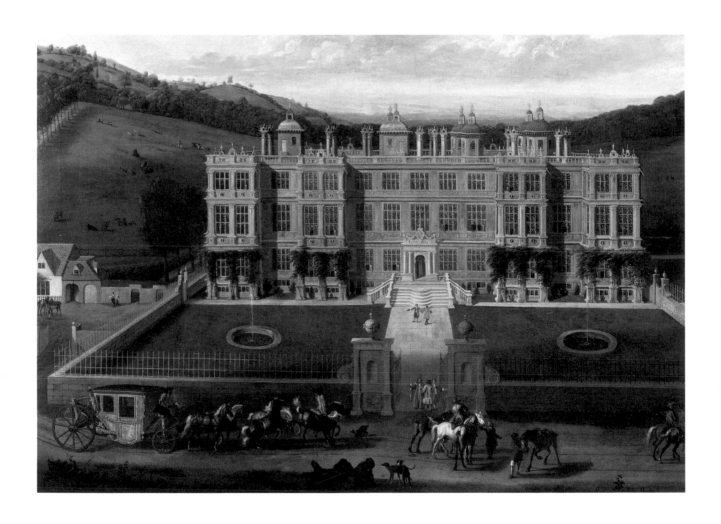

GEORGE LAMBERT *1700–65*

A VIEW OF BOX HILL, SURREY 1733

Courtesy of the Tate Gallery, London

IN the early eighteenth century George Lambert was a leading landscape artist in the idealised manner. His *Classical Landscape* (1745) reflects the taste for landscapes in the style of the Old Masters. Two schools of landscape painting prevailed – the Italianate school and the less popular topographists.

Lambert, who was also chief scenery painter at the Covent Garden Theatre in the 1730s, painted mostly idealised landscapes with overtones of classical antiquity. *A View of Box Hill, Surrey* reveals these influences in the balance and structure of the picture. Various points in the panorama are carefully marked and the eye effortlessly passes from one to another. From the figures in the foreground, the next pause in the sweeping view is the middle ground, where a figure on horseback can be spotted, in a direct line from the central group in the foreground. The landscape is wide and

welcoming in the foreground, only to corral the view into the apex of a receding triangle, just at the point where the mounted rider passes. The woodland on the right of the picture and the crop on the left almost converge at the same spot, so forcing the viewer to pause before widening out again in the background. A mental continuation of the diagonal running from right to left, along the line of the woodland, takes the eye on and up the hill, whilst the left-to-right sweep downwards from the hayfield takes the viewer on and out to the valley beyond – here the foreground triangle is reversed.

At the same time there are elements to this picture that are recognisably an English landscape on a summer's evening. The play of light in particular, the long shadows of the setting sun, the farm labourers and the clouds glinting in the last of the sun's rays are in stark contrast to the formal composition. Lambert includes three gentlemen, in the foreground. The setting is harmonious – they seem to have just finished a picnic; there is a discarded wine bottle to the right of the picture and one of them is sketching. Lambert's figures are Hogarthesque in style; he was a friend and colleague of William Hogarth and it is possible that Hogarth painted Lambert's figures while Samuel Scott, another friend and a marine painter, supplied him with ships and boats.

SAMUEL SCOTT *1702–72*

THE TOWER OF LONDON AND THE THAMES 1750

Courtesy of the Tate Gallery, London

SCOTT began his artistic life as a marine painter in the tradition of the Dutch master van de Velde the Younger. Like his father, Scott was adept at painting ships but combined this with his own interest in capturing the tranquil tone of the sea – it was not until Turner that the waters would be troubled pictorially. Scott was injecting a dramatic note into his records of naval action in 1745, but after Canaletto's arrival in London in 1746 he turned his attention to painting river views and views of London. Canaletto had made a great success out of the Grand Tour and the subsequent demand for views of Venice. He would do the same in England, with paintings such as *View of London from Richmond House* (1746).

Canaletto left England in 1755, having created a fashion that Scott pursued. Scott

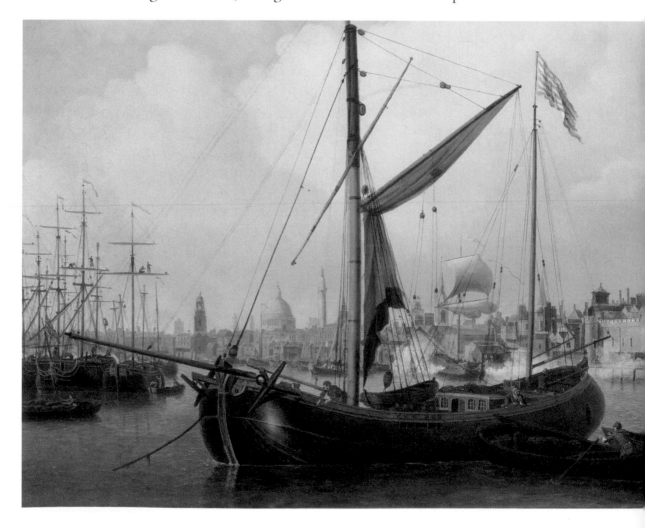

successfully combined views of London's waterfront with influences from the Dutch marine painters, but imbued it all with a sense of gaiety through the introduction of small figures and a watery light that was more English than Canaletto's Venetian shimmer. In *The Tower of London and the Thames* Scott accurately records the skyline and London riverscape looking northwest. The Tower itself is brilliantly lit by the sunlight as it hits the waterfront, and the sky behind is darker in contrast. The sides of the buildings are in deep shadow, contributing to the painting's air of vitality and movement. The foreground is dominated by the hull of the boat, its mast silhouetted against the cloud behind, and the dome of St Paul's can be seen in the distance. *An Arch of Westminster Bridge* (*c.*1750), painted while the bridge was under construction, is a fine example of Scott's eye for detail. It was intended to be hung high and viewed from below, as if the viewer was in the boat on the left, looking up at the workers high above his head. Again, shade and light are employed to naturalistic effect, darkest under the bridge's arches, and dappled over the stonework of the balustrade.

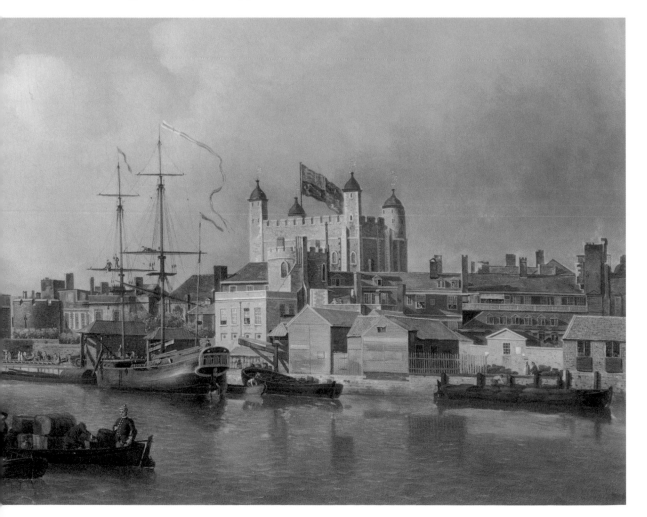

WILLIAM HOGARTH *1697–1764*

MARRIAGE À LA MODE: I, THE MARRIAGE SETTLEMENT C. 1743

National Gallery, London/Courtesy of the Bridgeman Art Library

WILLIAM Hogarth trained initially as a silver engraver. In portraiture and history painting he aspired in vain to gain the honours accrued by the acclaimed decorative painter, Sir James Thornhill, not least by eloping with his daughter. Hogarth remains best known today for his satirical scenes, to which he also owed his success during his lifetime. In an effort to encourage patronage of contemporary British artists and the foundation of a British tradition of history painting, he beat the nationalist drum, but his work was heavily influenced by that of the Old Masters he loudly denigrated.

Hogarth made his name in small-scale portraiture and conversation pieces, an art form introduced to England from France, largely by Philip Mercier; the swiftness and lightness of touch of his figures reveal the influence of the French Rococo. These art forms also encouraged a wider scale of patronage; smaller canvases cost less, conversation pieces allowed for groups of people to be portrayed at one go, and informal settings were more attuned to middle-class taste. In the 1730s he composed two series of cautionary tales, *A Harlot's Progress* and *A Rake's Progress*, and invented his own modern morality genre. Around this time he tried to establish himself as a portrait painter, still the only way to become famous and successful as a British painter, having failed to kindle substantial interest in history painting amongst his patrons. In the eighteenth century various academies of painting existed in London, including one run by Hogarth but with nowhere to exhibit. He approached the Foundling Hospital, of which he was a governor, and throughout the 1740s artists hung works of portraiture, history and landscape painting there, available to the visitor. A body of artists gradually took shape, and in 1760 became first the Society of Artists, in turn the Royal Academy in 1768. Hogarth's portrait *Captain Coram* (1740), of the man who obtained the charter for the Foundling Hospital in 1739, is a fine example of the directness and informality that were then the fashion – here we no longer find a mere type, nor an aristocrat, but an individual and a philanthropist.

Marriage à la Mode was Hogarth's third series and, in contrast to his technique with its predecessors, he painted the six scenes with great care. This is the first in the series *The Marriage Settlement*. New, moneyed blood is being brought into a crumbling aristocratic family by way of marriage. The gout-ridden father trades the family tree for gold, while the architect surveys the building of a new family pile previously unfinished through lack of funds. The young man, oblivious to his bride, dreams on; he is got up in the latest fashion – ruffles and brocade, red heels and dainty fingers; his eyes glint with the promise of more gambling and feckless pleasure while his bride receives instruction from the ingratiating lawyer, Silvertongue.

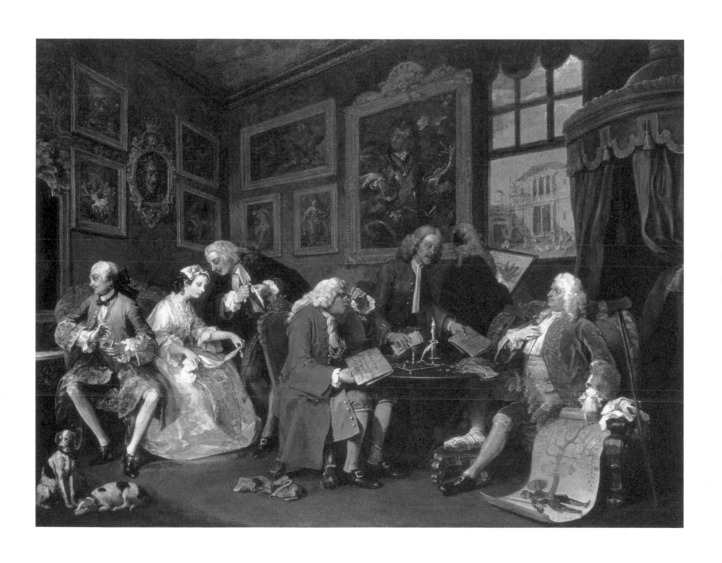

FRANCIS HAYMAN *c. 1708–76*

THE SEE-SAW C. 1742

Courtesy of the Tate Gallery, London

FRANCIS Hayman was born in Devon and was first employed as a scenery painter at the Drury Lane Theatre in London. Here he met the famous actor-manager David Garrick, whose portrait he would paint on many occasions. In the 1740s and 1750s, Hayman concentrated on the outdoor conversation piece, his patrons mostly drawn from the middle classes. His pictures are distinguishable by the absence of an air of ownership. During his lifetime, his reputation rested on his history paintings, both pieces for ceilings and the history paintings he submitted to the London Foundling Hospital. Like Hogarth, Hayman was also active in the politics of his day. He led the

newly established Society of Artists in their quest for the founding of a state-run academy and for the introduction of public exhibitions of contemporary art, and was a founder member of the Royal Academy.

Hayman showed tremendous variety in his work – engraving, history painting, stage scenery and conversation pieces, as well as charming canvases for the Vauxhall Pleasure Gardens. Only some of the fifty-odd large paintings commissioned by Jonathan Tyers to decorate the supper boxes at the Gardens survive. Influenced by the decorative spirit of the French rococo, the idea was Hogarth's – he was rewarded by Tyers with a lifelong free entrance ticket. Typical were scenes from popular pastimes, such as *Cricket in Marylebone Fields* or *The Milkmaids*. *The See-Saw* is in the French rococo vein – a frivolous, elegant variation on a pastoral theme – but less otherworldly in style. Mildly erotic in subject matter, it has an impromptu air about it, suitably light-hearted for its setting.

THOMAS GAINSBOROUGH *1727–88*

POMERANIAN BITCH AND PUPPY C.1777

Courtesy of the Tate Gallery, London

MAN'S relationship with dogs and other animals is a constant theme in Gainsborough's paintings. He was apparently a great animal lover, and his earliest dated surviving painting is of *'Bumper': a Bull Terrier* (1745). An inscription on the back reads 'A most Remarkable Sagacious/Cur' and the artist has conveyed the terrier's alertness and intelligence by a heavily characterised posture. *Wooded Landscape with Hounds Coursing a Fox* (1784–5) is a picture that Gainsborough never sold. Three hounds chase down a fox as it reaches a brook. They stream out of the woods into a wide receding landscape and the fluency of the brushwork is such that it is more like a watercolour sketch than a finished oil. In later portraiture, dogs of various breeds accompany their owners. Pomeranian dogs originate from a region in North Europe on the Baltic Sea, once part of Prussia, with Romantic credentials.

Dogs reappear in a delightful painting, *Sportsman with Two Dogs* (late 1750s). The informality of the composition is related to the positioning of the dogs. The sportsman pauses and stares out of the canvas, acknowledging the viewer and indicating his hunting terrain to his right as he cleans his gun. Of his two dogs, one sits, looking up at its master as if to give encouragement, whilst the other stands, as if pointing down to the pheasant at the figure's feet. With its ears cocked and its front paw forward, the dog is the only hint of dynamism other than the cleaning of the gun; the rod protrudes from the gun barrel on a parallel diagonal to the dog.

In the artist's earliest surviving full-length, *William Wollaston* (1759), the sitter is seen casually leaning against a gate, neatly framed by trees. As Gainsborough's confidence increased, so did the role of the dog in the full-length portrait. *Thomas John Medlicott* (1763) is also framed by trees, but instead of leaning against the gate Medlicott sits on a stile. His pose forms a spiral shape, and this is continued in his dog, which turns to look up at its owner. In another example of empathy between dog and sitter, an unknown young lady poses with a greyhound: the dog is emblematic of the character and mood of the portrait. This culminates in a rare male portrait of tenderness: in *Henry, 3rd Duke of Buccleuch* (1770) the sitter is depicted holding an appealing pet dog under his arm. In *The Morning Walk* (1785) the young couple, noble personifications of young love, walk gently forward through the romantic wooded landscape. The accompanying dog here is a wonderful Spitz dog. Its thick coat and curled tail counterbalance the rustle and sheen of the young woman's dress, whilst its upward gaze is the starting point in compositional terms of an energetic diagonal line that culminates in the couple's joined hands.

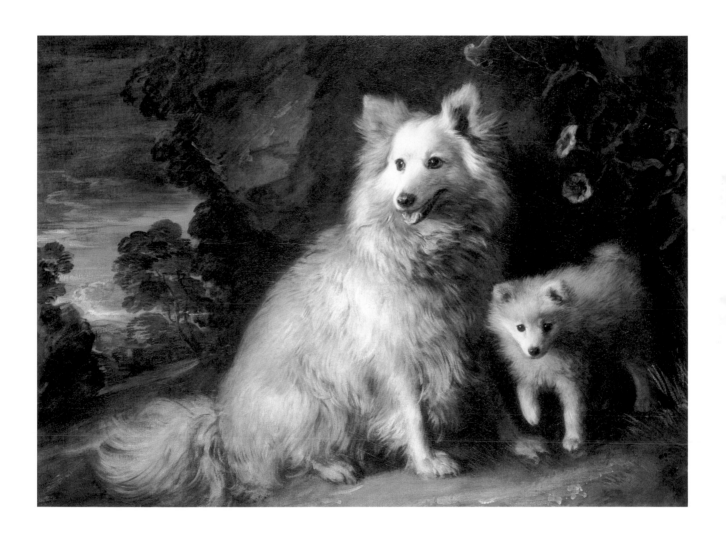

Thomas Gainsborough *1727–88*

Mary, Countess Howe c. 1763–4

Courtesy of English Heritage Photo Library

THE young Thomas Gainsborough moved to London from his family home in Sudbury, Suffolk, to study with the French engraver Hubert-François Gravelot, through whom he met Hayman and Hogarth. Gainsborough also came into contact with Dutch landscape masters such as Jacob van Ruisdael (1628/9–82) through restorers' studios, prints in circulation and auction houses. Following Hogarth's efforts to establish a public exhibition space at the Foundling Hospital, Gainsborough exhibited a view of the Charterhouse (1748). This formed part of a series of contributions by artists of views of London hospitals. Whilst the other works were topographical in style, Gainsborough's was a more naturalist landscape, with a play of light and shade and passing clouds.

The countryside, especially his native Suffolk, would always be a source of inspiration and Gainsborough never ceased producing landscapes, influenced by the Dutch masters and, later, by the expansiveness of Rubens. But the way to earn one's fortune in England was still in portraiture. One of his most renowned works was painted at this stage of his career, *Mr and Mrs Andrews* (1749). The influence of Hayman and Hogarth can be seen in the couple's manner, informal and at ease. Gainsborough gave equal weight to the landscape as he did to the sitters, but as a model it was not to prove popular. His interest lay in landscape other than the classical landscape that was being emulated in the gardens at Stourhead. He moved to Bath in 1759, where he established himself as a successful, fashionable portrait painter. The opportunities he had to examine the collections of Old Masters in nearby country estates such as Wilton House had a profound effect on his painting style. *Mary, Countess Howe* was painted during this period. Aloof and commanding, while come-hither in her gaze, she conveys a sense of elegant assurance reminiscent of van Dyck. The delicacy of colour and the airy lightness of her lace sleeves and the shimmery folds of her dress are remarkable, and far removed from Gainsborough's earlier conversation pieces.

Gainsborough was invited to become a founder member of the Royal Academy at its inception in 1768. He would later quarrel with the Academy about the height at which his pictures were hung at the exhibitions. He withdrew his submissions more than once and abstained from contributing altogether, instead showing in his own London studio. His portraiture of this period is almost removed from reality – his vision of loveliness was ideal and fanciful, best seen in *The Morning Walk* (1785). Although Gainsborough was a favourite of the royal family, his rival Joshua Reynolds was appointed King's Principal Painter.

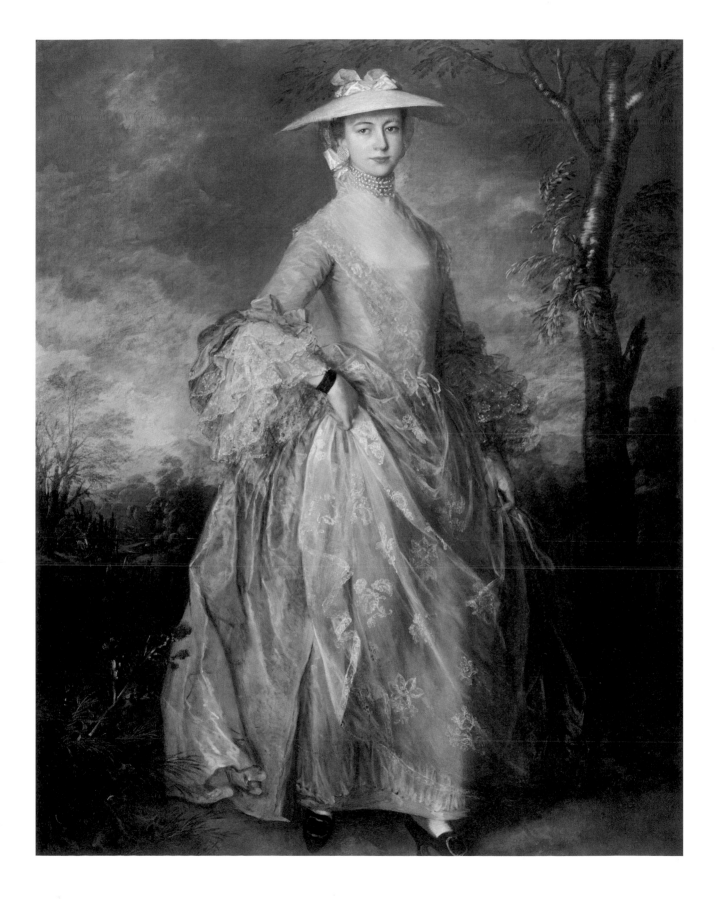

GEORGE ROMNEY *1734–1802*

LADY HAMILTON AT PRAYER C. 1782–6

Private collection / Courtesy of the Bridgeman Art Library

ARRIVING in London from his native Lancashire in 1762, George Romney achieved fame as a portrait painter, with Gainsborough and Reynolds as his contemporaries in the 1770s and 1780s. As with Gainsborough, his interests lay elsewhere – in history, the Bible and classical texts – but these came to little. Where Reynolds and Gainsborough occupied extreme grounds in their portraiture, Romney amply covered the middle ground. Reynolds dominated with his conflation of history paintings and portraiture, while Gainsborough indulged in his particular vision of beauty.

Romney's visit to Rome and Venice in 1773–5 matured his style, evened out his draperies so that they fell naturally, and brought poise to his earlier attempts at the antique in contemporary costume. He was most at ease with subjects who were in the prime of youth, confident in their wealth and beauty. *Sir Christopher and Lady Sykes* makes for an interesting comparison with Gainsborough's *Morning Walk*. The latter is a paradisical image of young love, whereas Romney's young pair (the picture is also known as *Evening Walk*) have their feet gracefully but firmly rooted in the fashionable portraiture of the 1780s. Romney retired to Kendal in the Lake District in 1798 and died insane. His output was prodigious and even. He never strayed beyond the status quo, but some of his portraits attain an individualism and refinement that explain his successful career.

Romney's favourite model was Emma Hart, whom he painted repeatedly – over thirty oils and countless sketches in various poses, or 'attitudes'. *Lady Hamilton at Prayer* shows her demure and modest in fervent devotion. Emma Hart was no lady, and modesty probably did not become her. She had come to London as a nursemaid but swiftly manoeuvred herself into higher circles, first becoming the mistress of Charles Greville. A portrait Greville commissioned from Romney of her sitting at the spinning wheel (1782–6) displays her youthful beauty and alludes to her uncorrupted charms. In 1786 she left Greville for his uncle, Sir William Hamilton, with whom she went to Naples and married in 1791. In Naples she famously became Lord Nelson's mistress but years later died alone and impoverished in Calais.

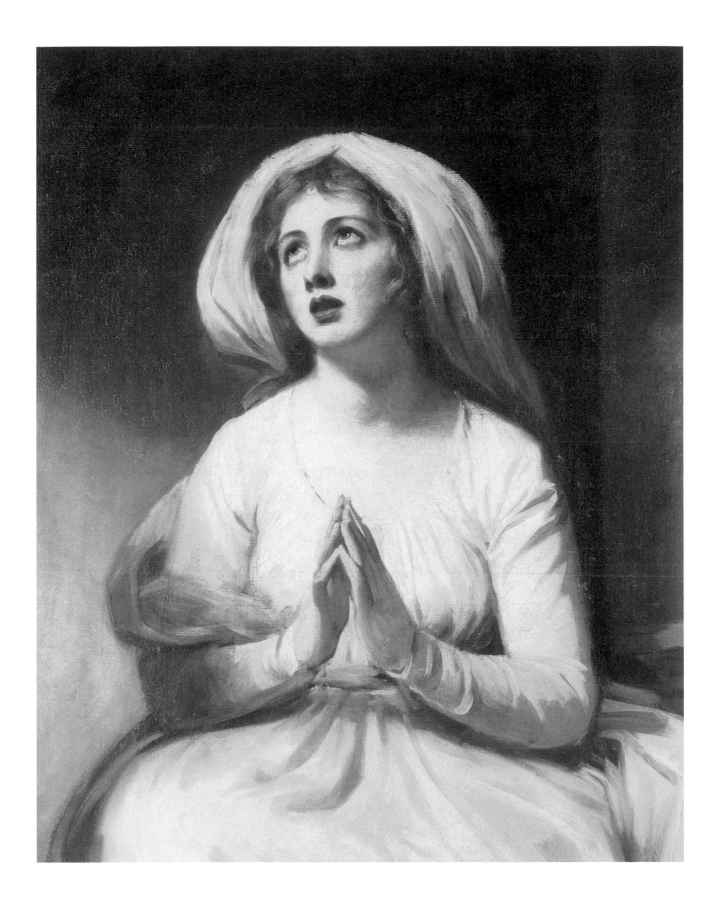

JOSEPH WRIGHT OF DERBY *1734–97*

DRESSING THE KITTEN C. 1768–70

Courtesy of English Heritage Photo Library

JOSEPH Wright came to London to study with the portrait painter Thomas Hudson in the late 1760s and early 1770s. He worked mostly in Liverpool, painting with great character the rich industrial class, the shipowners, slave-traders and their wives.

Wright had close personal contacts with the Lunar Society and the first founders of industry in the Midlands, such as Josiah Wedgwood and Richard Arkwright, pioneers in the pottery and cotton industries respectively. The Lunar Society was a group of philosophers and scientists based in the Midlands, a nucleus of innovation and scientific experiment. The Derby area, rich in natural resources and in new techniques of production, was connected by road and canal to Liverpool, Birmingham and Sheffield, as well as industrial and literary centres, Coalbrookdale and Lichfield. Wright developed his own pictorial style, centred on the study of light, initially artificial, which he worked into the depiction of groups engaged in scientific and industrial activities, such as *An Experiment on a Bird in the Air Pump*. Wright combined in these works a passionate interest in science with a design that expressed the full range of natural human emotion. In *An Experiment on a Bird* he depicts a variety of reactions in the observers of the experiment. The young wife to the left of the picture observes her husband's enrapture. To the right a father comforts his elder daughter whilst admonishing her to watch the fate of the bird – perhaps the scientist is about to let the air back – and the younger daughter is torn between fear and curiosity. The older man sits deep in thought, contemplating the section of human skull in the jar, a reminder of death and counterbalance to the bird, soon to be revived.

Dressing the Kitten is another sort of experiment, but equally a depiction of discovery. The kitten looks as inanimate as the doll lying on the table but the girls' expressions are charming. Wright's study of the fall of light is wide-ranging here, from the children's skin to the silver candlestick, the polished wooden table, the fur of the kitten and the porcelain doll, the fabric of the girls' dresses and the string of pearls. The back of the girl who turns outwards from the scene is entirely in shadow; her arm blocks out the direct light from the candle and so is in full silhouette.

By the 1770s, Wright had mostly exhausted his subject matter by candlelight, painting pictures of industrialisation such as *The Forge* and *A Blacksmith's Shop*. His trip to Italy in 1773–5 led to an understanding of how to apply his study of light to landscape. He painted moonlight scenes, and many versions of the explosion of Mt Vesuvius and the annual Girandola firework displays at Castel Sant'Angelo in Rome – a firework painting and its pendant went to Catherine the Great, Empress of Russia.

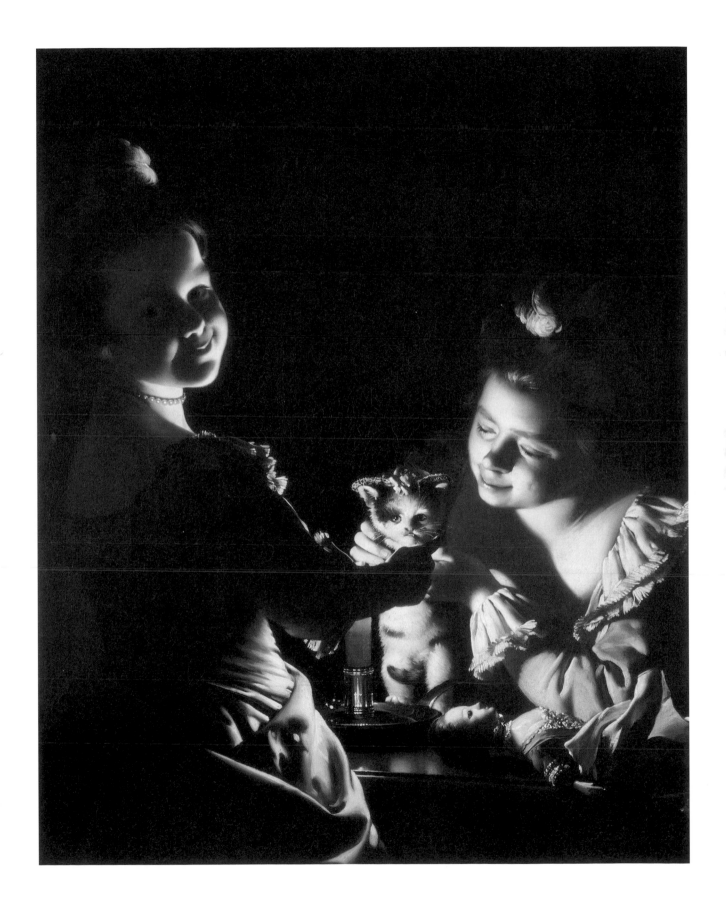

JOSEPH WRIGHT OF DERBY *1734–97*

SIR BROOKE BOOTHBY 1781

Courtesy of the Tate Gallery, London

ON his return from Italy in the mid-1770s Wright moved to Bath, hoping to fill Gainsborough's shoes as leading society portraitist (Gainsborough had recently decamped to London). He had little success, perhaps unsurprisingly given the contrast between his own innovatory spirit and the attitudes of some of Bath's gentry. He returned to Derby in 1777, where he had a ready source of clients.

The new god of reason was to abolish tyranny and exclusion and beckon in a new age of enlightened order, permeating every aspect of scientific, artistic and social practice. Throughout his career Wright used a variety of genres to explore different aspects of the Enlightenment. Alchemy, prison reform, the abolition of slavery, industry, the knowledge of geography and astronomy provided him with the subject matter with which to combine a commentary on society and human nature.

A fine example of his portraiture is the painting of his friend, Sir Brooke Boothby. In an abandoned and carelessly dishevelled state, he lies in a clearing by a stream meditating on the works of Jean-Jacques Rousseau. Boothby was a Derbyshire landowner and part of the Lichfield literary set. He took an active interest in the new scientific and philosophical ideas of the time and was a friend of Rousseau, whose manuscript, *Rousseau Juge de Jean-Jacques*, he had had published in England in 1780 after the philosopher's death in 1778.

Boothby's pose brings to mind Isaac Oliver's miniature, *Edward Herbert, 1st Baron of Cherbury*. Since Elizabethan times, the traditional melancholic stance was either to loll against a tree or, more dramatically, to lie full-length on the ground, a position more readily disposed to the contemplation of nature. Rousseau's writings, with their examination of the civilising effects of nature, had greatly impressed the Lichfield set. Boothby is modestly dressed in clothes fit for wandering about in the countryside and his wide-brimmed hat is consciously old-fashioned. *Émile*, a text that warranted Rousseau's temporary departure from France, emphasised experience over theory, study in the open air and learning through discovery rather than by rote. Emotion became the guide to reason: through man's natural responses a golden age of innocence could be regained. If man's natural impulses led to something other than goodness, this resulted in a dualism between ideal beauty and the sublime, where the jagged irregularities of nature gave rise to man's more turbulent emotions.

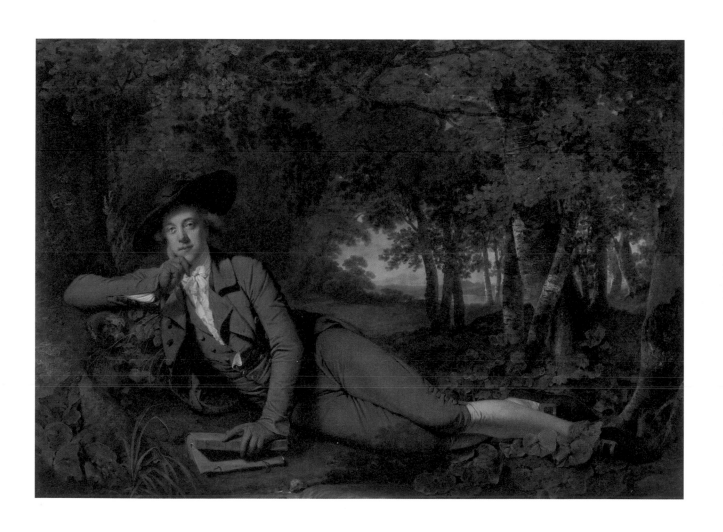

GEORGE STUBBS *1724–1806*

A LION DEVOURING A HORSE 1769

Courtesy of the Tate Gallery, London

THE son of a currier, Stubbs was born in Liverpool and was mostly self-taught as a painter and engraver. More a natural scientist, like Wright of Derby, Stubbs was driven by his interest in anatomy rather than a desire to pursue the tradition of sporting pictures, a little-regarded genre in the Royal Academy's hierarchy of painting. His approach to painting was through scientific study, rather than through the Academy and the antique. Apart from a trip to Italy in 1754, he spent most of the 1740s and 1750s in the North of England, studying human and equine anatomy through dissection; in 1751 Dr John Burton's *Midwifery* was published, with illustrations engraved by Stubbs. Ensuing publications would win him further critical acclaim for scientific accuracy and the quality of his animal pictures. Of particular interest were the results of Stubbs's eighteen months of study of equine anatomy, which were published in 1766 as *The Anatomy of a Horse*.

Success as an animal painter quickly followed; although initially excluded from the Royal Academy, he would exhibit with the Royal Society of Artists, and subsequently with the Royal Academy, for nearly fifteen years. The upper classes were Stubbs's main source of patronage, the racing noblemen anxious to have the most fashionable sporting painter of the day immortalise not only their nobility within nature but also their racehorses, jockeys, hounds and grooms. At times his compositions are forced, demonstrative more of his analytical ability than of his artistic talent, where strings of horses and dogs are carefully placed in a strictly observed landscape but with little sense of purpose to pull them together into a whole.

In line with the Grand Style, he expanded on the theme of the lion preying on the wild horse, a favourite subject matter in antique sculpture, which he may well have encountered on his visit to Italy. *A Lion Devouring a Horse* is one of seventeen works by Stubbs on this subject. He painted every wild animal he came across – zebra, moose, rhinoceros – with the exactitude of the natural scientist and experimented with techniques, using different types of paint – such as enamel – and surfaces such as copper and earthenware panels made for him specially by Josiah Wedgwood, the industrial innovator who actively sought collaboration with scientifically minded artists such as Stubbs and Wright.

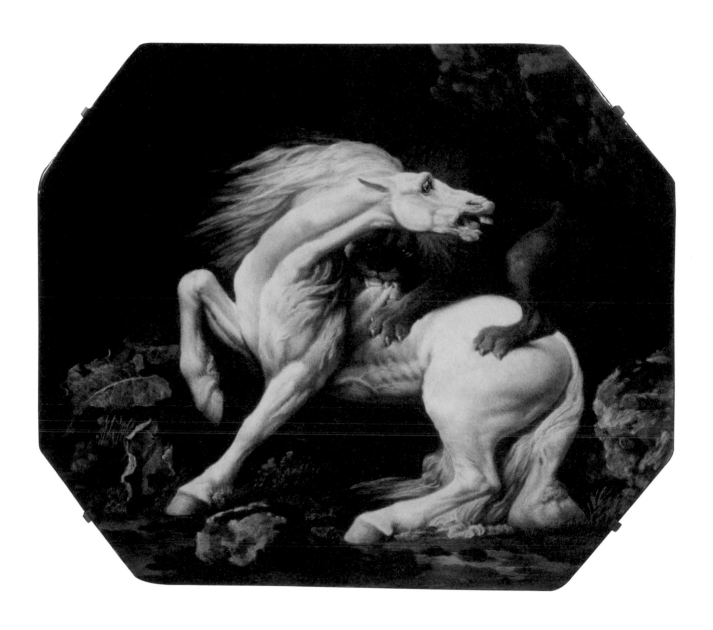

SIR NATHANIEL DANCE-HOLLAND *1735–1811*

LANCELOT 'CAPABILITY' BROWN C. 1770

Courtesy of the National Portrait Gallery, London

NATHANIEL Dance was one of the youngest founding members of the Royal Academy, although he resigned in 1790 to become a Member of Parliament and in 1800 was created a baronet, Sir Nathaniel Dance-Holland. Dance studied under Hayman from 1753 to 1754 and spent the following twelve formative years in Rome, in the company of his architect brother George.

This portrait is of the famous landscape designer Capability Brown (1715–83), so called because he is supposed to have said of prospective properties that they had the 'capability' of improvement. From Northumberland, where he began as a gardener's boy, he worked at Stowe under the landscape architect William Kent. Kent had started out as a painter, but returned to England after ten years of study in Italy to practise, first, decorative paintings and then landscape design. Part of the gardens of Stowe and Chiswick Park were created or modernised by him. The fashion for asymmetry and artful informality in gardens had already started in England, but Kent's designs resulted from a highly individual sense of the pictorial, where gardening and landscape painting merged.

Capability Brown went on to design some of the great estates of the day. Underlying orderly principles of vista and perspective were followed but achieved using 'natural' means, such as the undulations of the land, trees planted strategically in clumps or singly to arrest or carry the eye, and lakes to provide reflection. His vision often necessitated the destruction of many of the pre-existing formal gardens – according to Brown, the line and the rule served only to separate instead of to link the garden into a harmonious whole. His 'successor' was Humphry Repton, who prepared 'Red Books' for his clients – watercolours of the grounds and an overlay of his proposed modifications on movable flaps, creating a 'before and after' effect.

Brown's work was later denigrated by Richard Payne Knight (1750–1824), most famously in *The Landscape, a Didactic Poem in Three Books* published in 1794. Knight was a renowned amateur antiquarian and connoisseur who had his estate, Downton Castle in Herefordshire, redesigned along principles of picturesque wildness. Complete with withered trees and unkempt bushes, 'accidents' of nature, the new design was intended to impress the spirit and appeal to the emotions. Brown's serpentine lines, endless stretches of uninterrupted 'shaven' grass and graceful trees were considered dull in the extreme and alien to the new fashion for irregularity, roughness and ruin.

SIR JOSHUA REYNOLDS *1723–92*

LADY ANSTRUTHER 1761

Courtesy of the Tate Gallery, London

ON his death in 1792, Reynolds was buried with great ceremony at St Paul's Cathedral, an honour conferred on no other painter in Britain since van Dyck. Reynolds had done more than most to elevate the status of the artist in eighteenth-century Britain, with the foundation of the Royal Academy in 1768, of which he was the first president and for which he received a knighthood in 1769. Reynolds's fifteen annual speeches to the students, his *Discourses*, embody the art theories and practices that he believed paramount in the elevation of the status of art in Britain. This rested on an observation of nature through the filter of idealised, ageless beauty, inherited from classical antiquity and the Renaissance. Art was not to be imitative: it was to take its cue not from nature but from the intellect. The greatest of all the painterly arts was history painting, the depiction of scenes from the Bible and classical texts. Reynolds counted Edmund Burke and David Garrick amongst his friends and had Oliver Goldsmith and Dr Johnson appointed RA Professors of Literature and Ancient History. The RA had 40 founder members, a constitution, and a council. Its main aim was to establish formal 'Schools', a hierarchy inherited from the French Academy, with free tuition, regular public exhibitions of the best work in each category, the disbursement of profits to poor artists and the beginnings of a national collection of art – royal patronage was a key source of funding.

Despite his insistence on history painting, Reynolds was most successful as a portrait painter in London – his attempts at history painting met with less enthusiasm, and presumably less remuneration. He was born in Plympton in Devon, where his father was a schoolmaster in holy orders. After studying under Thomas Hudson (1701–79), the fashionable portraitist of the day, he went to Italy in 1749. Like all aspiring painters, he spent two years immersed in the antiquities of Rome before travelling back via Venice. His portrait of his friend Commodore Keppel (1753/4, National Maritime Museum, Greenwich) met with a consensus of excited approval – the pose reminiscent of the Apollo Belvedere, the Roman copy of a Greek statue held up as the ideal of male beauty, and the marriage of the figure with the background achieved through a use of light and shade learnt from the Old Masters. By 1759 he had 150 sitters and a considerable studio operation, and was hiking up his prices to dampen demand. He married his theoretical principles concerning history painting with portraiture to create the historical portrait, although much of his work was on a more domestic scale. He idealised figures and used poses and drapery reminiscent of the Old Masters and the antique, creating group portraits that implied allegorical themes such as *Three Ladies Adorning a Term of Hymen*. In 1773 he

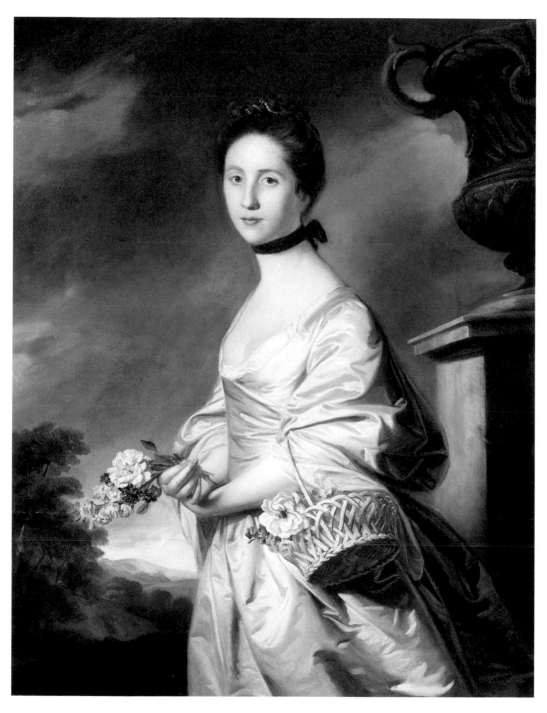

painted Sir Joseph Banks, the great botanist whose collection of plants from his travels across the world created the kernel of Kew Gardens. In his later work Reynolds developed a more informal style, perhaps because of the presence of his rival, Thomas Gainsborough, in London: this portrait of Lady Anstruther offers an interesting exercise of comparison with Gainsborough's *Mary, Countess Howe* (see page 73), which it predates by only a couple of years.

MARY MOSER *1744–1819*

STILL LIFE OF FLOWERS

Private collection / Courtesy of the Bridgeman Art Library

MARY Moser's father was the Swiss goldsmith and engraver, Michael Moser. She trained with him and her painting career took off in 1759 when she was awarded a medal in Polite Arts for a watercolour and gouache of flowers by the Royal Society for the Arts – a precursor of the RA. The painting hangs in the RSA today. Only Moser's flower paintings survive and it is on these that her reputation rests, but she also painted allegorical portraits and historical subjects. The Victoria and Albert Museum has seven of her botanical studies of tulips along with oil paintings of flowers, which have symbolic significance. The Fitzwilliam Museum has a number of her flower-pieces in which the vases are decorated with signs of the zodiac, and the flowers correspond to the associated season. In style, her dark backgrounds and tones are more akin to the Dutch masters of the seventeenth century than to her contemporaries. Both she and her father became founder members of the Royal Academy (she was the only female founder member, other than Angelica Kauffmann), and her father was also Keeper of the RA. Mary Moser was one of only two floral painters admitted to the Academy – as a genre, it was far more popular on the Continent than in England. In the 1790s she received the patronage of Queen Charlotte. An avid botanist, collector of botanical drawings and books, the Queen had Moser decorate an entire room at Frogmore House, Berkshire. The room simulated a garden or conservatory, with an illusory ceiling 'open to the sky'.

Flower painting as a genre had its origins in medical books and religious painting. The medicinal use of flowers demanded the close study of plants and although the herbals of classical times have not survived, Dioscurides' *De Materia Medica*, five volumes of botanical drawings and their medicinal properties, would remain an authority until the seventeenth century. Illuminated manuscripts and altarpieces were filled with painted flowers, symbolising aspects of the Virgin's and Christ's lives. In fifteenth-century private prayer-books, especially Dutch and Flemish, the borders of the pages were covered with studies of flowers and butterflies that superseded the miniature proper in both brilliance and skill. The systematic study of plants began in the sixteenth century with the work of Charles de Lécluse, and over the centuries botanists would work closely with the best flower painters of their day, such as Bauer, L'Héritier and Redouté. With the development of botanical science came the development of horticulture and the religious symbolism of flowers faded, to be replaced by that of the transience of life. Although little considered by the Academies, by the end of the seventeenth century the popularity of the genre wrought changes to the flower-piece: vases were placed off centre and flower paintings became valued for their decorative properties, whilst remaining faithful to the role of botanical record.

JOHN ROBERT COZENS *1752–99*

LAKE NEMI, CAMPAGNA, ITALY 1788

Fitzwilliam Museum, University of Cambridge/Courtesy of the Bridgeman Art Library

THE work of Newton and Locke at the end of the seventeenth century encouraged an analytical approach to most aspects of life, including aesthetics. Theoretical speculation into the human response to visual phenomena abounded in the eighteenth century, and the Revd William Gilpin (1724–1804) developed a systematic analysis of landscape to try and identify those qualities that made nature as pleasing to the eye as a painting. The picturesque landscape was born, and with it the 'correct' portrayal of nature in painting.

Alexander Cozens (1717–86), John Robert's father, took this further, publishing in 1771 *The Shape, Skeleton and Foliage of Thirty-two Species of Trees*. He would extend this classifying approach to types of landscape. Typical categories were wild, cultivated, garden, America, morning and sunset. He reduced the components of land and sky to various graded permutations, ranging from all sky to all foreground, which were each equated to different sets of emotions. Landscape painting was composition, light and shade; colour

was merely local – it was the tones of composition that were the foundations of theory. In line with Reynolds's pronouncements on 'high' art, landscape had to be universal. It had to refer to the historical as opposed to the contemporary, and to the grand rather than the ordinary. This was the exercise of the imagination – painting what was seen was considered mere copying.

The picturesque would change – local variety and rough texture became key components of landscape design, and the earlier watercolour technique of broad, sweeping washes was slowly discarded for short brushstrokes and broken sweeps in the washes. The romantic landscape had the same source as the topographical – gentlemen on the Grand Tour taking an artist with them to record the scenery. Cozens travelled to Italy in 1776–9 with the connoisseur Richard Payne Knight, and again to Italy and Switzerland in 1782–3 with William Beckford and other major patrons.

His watercolours were completed in the studio from drawings made while on tour. These were revolutionary in their technique, with substantial use of hatching and washes in a muted range of greens, blues and greys, rich in tone. Cozens's life-long history of depression has no doubt coloured our interpretation of his work.

WILLIAM BLAKE *1757–1827*

THE ANCIENT OF DAYS 1794

British Museum, London / Courtesy of the Bridgeman Art Library

RENOWNED as a poet, Blake was prolific in engraving and print-making. He trained as an engraver, entering the drawing school of Henry Pars in the Strand, London, at the age of ten. He was later apprenticed to the master engraver James Basire (1730–1802) from 1772 to 1779, for whom he drew the monuments in Westminster Cathedral and other churches in London. He joined the Royal Academy Schools in 1779, although he was to clash there with Reynolds, and later exhibited watercolours whilst also working as a commercial reproductive engraver. By 1787 Blake was creating his own designs and techniques, introducing watercolour and washes into his own works. Drawing remained a crucial stage in the artistic process for Blake; he considered the line as the nearest mark to his inspiration, and engraving as drawing, merely on a different surface. From early on, Blake rejected drawing from life, which precluded spiritual expression, preferring to draw the results of his imagination. *Songs of Innocence* was finished in 1789, a collection of Blake's own poems, with his own illustrations; this was conceived as one decorative unit through the use of his own innovative process, relief etching on the same plate, to which colour was then added by hand.

In the aftermath of the French Revolution and the execution of Louis XVI in 1793, it was unwise to proffer a personal set of radical beliefs. Thomas Paine, author of the *Rights of Man,* had left the country in haste. Blake and his wife, Catherine Butcher, removed themselves to Lambeth. From 1793 to 1796, Blake worked on illustrated books of his personal mythology, expounding on the union, not separation, of the mind and the body, or of the spiritual and the material. In his mystical vision, the artist was a divine prophet duty-bound to show mankind the error of its ways. *The Ancient of Days* was the frontispiece to *Europe, A Prophecy*, produced in 1794. The motif is creation, symbolised by the compasses. In Blake's mythology Urizen ('your reason') is the creator who represents the destructive dominance of law: *Europe, A Prophecy* foretells the triumphant overthrow of reason. Blake invented a cast of characters with primitive-sounding names to play out his religious and political beliefs, conflated from a wide range of biblical and classical sources. England was Albion, once the Garden of Eden that through war and the tyranny of reason had fallen from this state of grace. Albion's counterpart was Jerusalem, or liberty. Passion and energy, the creative powers, were represented by Orc, Urizen's antithesis by whom he was repressed. Imagination and creation, the mind and spirit, were Blake's chief weapons against the limitations of the physical, but his illustrations are remarkable for their physicality, their repeated images of human strength and sinewy flesh doubtless influenced by the widespread analytical eighteenth-century interest in human anatomy.

WILLIAM BLAKE *1757–1827*

ELOHIM CREATING ADAM 1795–1805

Courtesy of the Tate Gallery, London

ELOHIM *Creating Adam* pinpoints the moment Paradise is lost in Blake's personal vision – not the expulsion from the Garden of Eden, but the creation of man. Elohim, a Hebrew word for God of the Old Testament, means 'judges'. To Blake, God's creation dragged man into existence and irrevocably enslaved spiritual man in a material world. Blake would spend much of his life illustrating the consequences of this loss and the path back to Paradise Regained through his writings and paintings. To look at reality was to see God's creation on earth: the dominance of reason and law thwarted this continuum. From a Neoplatonic viewpoint, the physical was to be seen as part of a greater entity and Blake's writings are filled with specifics of his daily reality.

The medieval world was his artistic ideal. Gothic art and architecture, where soaring lines expressed the beauty of God, and which he had studied at length during his apprenticeship to Basire, epitomised the wedding of the spiritual to the aesthetic. Blake was a religious man, and primitive and medieval texts such as the Bible, Chaucer's *Canterbury Tales*, Dante's *Divine Comedy* and Milton's *Paradise Lost* would be subject to his revisionary vision. Blake's unconventional subject matter and chosen medium both contributed to his lack of recognition during his lifetime.

After producing his illustrated books, he created a series of individual prints on the subject of the myth of creation, of which *Elohim Creating Adam* is one. He also developed a method of colour printing – pigments were thickly painted on to a type of board, then a sheet of paper laid on top and pressed. He made a number of impressions, each one varying in depth of colour as the paint slowly dried. He then worked on the prints with ink and watercolour. In *Newton* Blake gives further expression to his anti-rationalism. At the end of the eighteenth century Newton was considered by the majority as the founding father of modern science and central to the British Enlightenment. Blake instead places him at the bottom of the ocean, where no light of the spiritual and intuitive world can penetrate, and there he sits measuring the world with compasses. To Blake, the scientific approach to the world revealed only a mirror image of the self – it was the irrational, creative approach that could unmask the world beyond the self.

In the last years of his life, Blake was almost entirely financially dependent on the patronage of two men, Thomas Butts and John Linnell. The former commissioned a large number of biblical subjects and illustrations of Milton's *Paradise Lost*; for the latter he embarked on the illustration of Dante's *Divine Comedy*. Blake died, however, impoverished and dismissed.

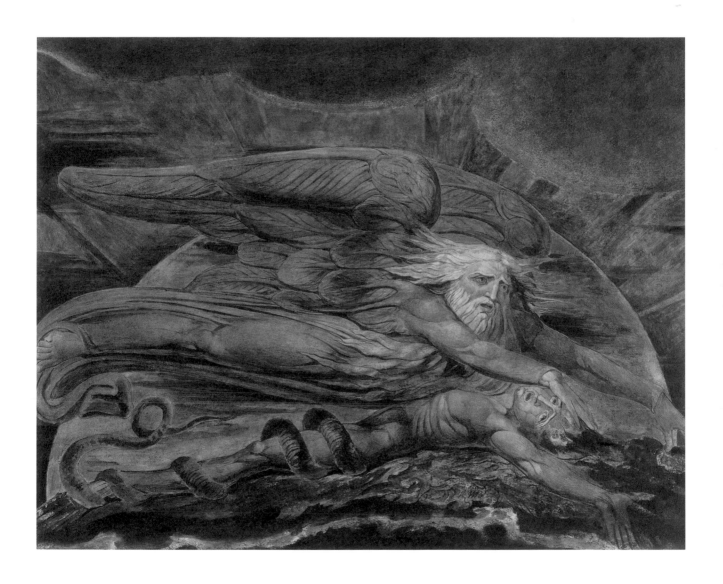

GEORGE MORLAND *1763–1804*

ROADSIDE INN 1790

Courtesy of the Tate Gallery, London

WHILE Blake was distilling his inner soul, George Morland was churning out sentimental genre subjects, which he exhibited at the Royal Academy from the late 1770s. He was apprenticed to his father, Henry Robert Morland, a landscape and conversation-piece painter. Morland senior was also a restorer and copyist of Dutch landscape Old Masters and similarly taught his son to copy, restore and forge.

George Morland is known particularly for his scenes of low- and middle-class rural life, although his style owes more to Dutch and international landscape influence than to archetypal English scenery. He first came to public notice with pseudo-rustic scenes, which were heavily popularised by high-quality engravings – Morland had married the sister of the engraver William Ward in 1786. The body of his mature work consisted of peasants and animals on the farm, rustic figures in a generic landscape and figures of common life – sailors, soldiers and deserters – poignantly portrayed. The origins of these paintings lie in a saccharine conflation of Mercier's conversation pieces and Hayman's depictions of everyday life. Morland himself was much copied and forged, and the popularity of his paintings and engravings ensured that the English village scene would become part of the repertory and taste of the Victorian era.

Morland's contemporaries included Francis Wheatley (1747–1801) and Philippe Jacques de Loutherbourg (1740–1812), who was first employed by David Garrick as a scenery painter at Drury Lane Theatre in the 1770s. He revolutionised theatre design with his knowledge of the effects of contrast and introduced painted flats on transparent gauzes lit from behind. As a landscape painter he visited the Lake District in 1783, at a time when the region was becoming the epitome of all that was rough and wild. Rusticity was valued over pastoral glamour, cosy close-ups such as Morland's scenes over sweeping views, and roughly textured painterly surfaces grew in popularity. It was in this climate that Morland painted *Easy Money* in 1788. A 1751 parliamentary Act had limited the sale of distilled spirits to licensed public houses, and the 1780s was a period of reinforcement of the Act. The painting's appeal is almost voyeuristic: Morland's interior seems to be a private house turned into an illegal gin shop – a notorious drunk himself, the characters he portrays were probably recognisable types. The figures are distorted, leering and devious, with pickpockets and prostitutes amongst the motley crew. If anything, this was 'dirty picturesque', a genre with visible links with the work of Hogarth and Rowlandson. Part modern moralising (Hogarth, in *Gin Lane,* had treated the subject with his habitual caustic eye) and part humoristic, the rhythmic positioning of the degenerates as they queue at the makeshift bar brings Rowlandson's caricatures to mind.

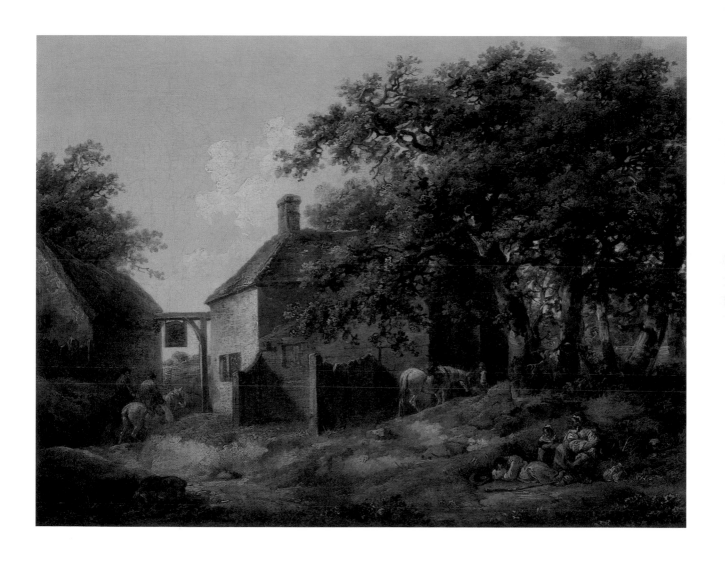

ANGELICA KAUFFMANN *1740–1807*

RINALDO AND ARMIDA 1776

Courtesy of English Heritage Photo Library/Jonathan Bailey

KAUFFMANN was to be one of the most famous female painters in England in the eighteenth century. She had spent her youth travelling with her father, a Swiss ecclesiastical painter, and most of the 1760s copying and versing herself in Renaissance works and classical composition in the collections of Florence, Parma and Bologna. Her arrival in England coincided with a taste for the Grand Manner as preached by Reynolds and practised by Richard Wilson and others. Whilst in Italy she frequented a group of painters that included the American Benjamin West, Nathaniel Dance and Gavin Hamilton. West would succeed Reynolds as president of the RA and Dance and Hamilton were equally well connected. The stumbling block for Kauffmann in her ambitions as a history painter was that as a woman she was unable to attend public academies or life drawing classes, prerequisites for any aspiring history painter. The theatrical conversation painter Johann Zoffany's (1733–1810) picture *The Academicians of the Royal Academy* (1771–2) omits Mary Moser and Angelica Kauffmann from the group of male artists gathered around the male model. Instead these two women, both founder members of the RA, are represented by portraits hanging on the wall. There would be no other women members until Annie Louise Swynnerton became an associate member in 1922 and Laura Knight in 1936.

Kauffmann initially established herself as a portrait painter – Reynolds sat for her – and her success allowed her the independence to put her years of study in Italy to stunning effect. In 1768 a visiting royal provided Kauffmann with the occasion to exhibit three history paintings. These would win her that year her founder membership of the RA, and were again exhibited at the RA in 1769. Until her return to Italy in 1781 she had a dazzlingly successful career as a neoclassical decorative painter, both on canvas and for architectural schemes, her history scenes steeped in the decorative and romantic strain of classicism.

Her most famous commission was the four ovals for the entrance hall of the Royal Academy (originally located in Somerset House), allegories of colour, design, composition and genius that were completed for the Lecture Room in the RA. With her husband, the decorative painter Antonio Zucchi, she was associated with the famous architect of the day, Robert Adam, who designed Kenwood House in Hampstead. Zucchi's ceiling paintings are still in place in the hall and library, and part of the John Bowles collection of Kauffmann's works, those illustrating Tasso's *Gerusalemme Liberata* (*Jerusalem Delivered*, the tale of the First Crusade to Jerusalem, published in 1581), can also be seen there.

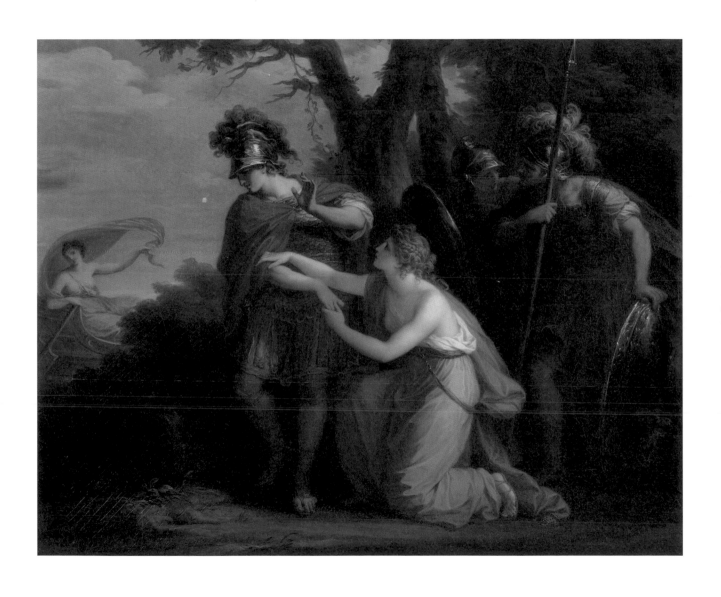

PAUL SANDBY *1730–1809*

A MOONLIGHT EFFECT C. 1790

Castle Museum and Art Gallery, Nottingham / Courtesy of the Bridgeman Art Library

SANDBY was one of the first professional British artists to establish watercolour as a respectable medium for a body of work. Like his brother Thomas (1721–98) he trained as an ordnance draughtsman at the Military Drawing Office in London. He worked on the survey of Scotland, commissioned following the Jacobite uprising of 1745–6, and spent the 1750s in Windsor – his brother was Deputy Ranger to the Duke of Cumberland at Windsor Park – where he painted many views of the area. From 1760 Sandby lived in London and became a founder member of the Royal Academy; Thomas was the first Professor of Architecture there. Paul gained praise from Gainsborough as one of the first artists to paint what he called real views of nature as opposed to compositions, and the naturalist Sir Joseph Banks was a great collector of his work.

The gulf between topography and the ideal landscape was as wide as ever. The topographer recorded, the ideal landscape painter manipulated for aesthetic ends – Paul Sandby's work bridged this gap. Whilst remaining faithful to his topographical remit, Sandby was able to bring expression and sensitivity to his work. The careful selection of the viewpoint was vital if he was to create the most interesting composition. When coupled with the genre's expressive capabilities – the full range of naturalistic effect and climatic change – even the soft light of the Ideal landscape oil was no longer the latter's exclusive domain. In particular Sandby introduced realistic human figures into his work, most significantly in the records he completed for the *Military Survey*. Well positioned figures contributed to a sense of place in the landscape, and he was one of the first to use the human figure in topography with conviction. Throughout his career Sandby used only watercolour and refined his works with washes and tonal subtleties, effects that elevated them from topographical record. Later in his career he experimented with other techniques and was the first professional artist to publish work in aquatint (a form of etching) – *Twelve Views in Aquatint from Drawings Taken on the Spot in South Wales* (1775).

Just as for the *Military Survey*, the medium of watercolour – more portable than oils, more suitable for on-the-spot sketches and records of local costume – was more suited to the Grand Tour and to expeditions. Watercolourists William Hodges and John Webber accompanied Captain James Cook on his second and third voyages to the South Seas. When travel on the Continent was restricted, the Grand Tour found a new direction: the antiquities and regions of Britain became the focus of amateur historians, and watercolourists such as Turner and Girtin explored the combination of imagination and record.

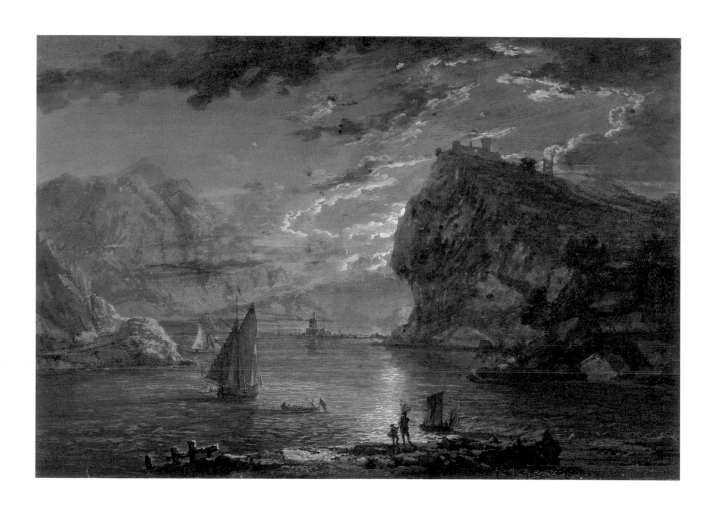

THOMAS BEWICK *1753–1828*

ANIMAL ENGRAVINGS

Courtesy of Image Select

BEWICK single-handedly revived the tradition of wood engraving as an expressive art form as opposed to a primarily reproductive technique. The son of a farmer, he spent most of his life in and around Newcastle upon Tyne. Between 1767 and 1774 he was apprenticed to the engraver Ralph Beilby. In the late 1770s they became business partners, until 1797. The bulk of the business was in silver and copperplate engraving, but Bewick learnt much of his wood engraving technique in the partnership. He would become famous for his book illustrations and the inclusion of vignettes, a practice he learnt during the time he spent engraving enamelled glass for the Beilby partnership.

Bewick's fame and reputation as a minute observer of nature rest on two key publications, *A General History of Quadrupeds* (1790) – from which these three engravings come – and *History of British Birds* (two volumes, 1797 and 1804). Eight editions of *Quadrupeds*, including an American edition, had been published by 1824, and by 1826 eight editions of *Land Birds* and six of *Water Birds*. *A History of British Fish* was planned but never completed and much of his later work on *Aesop's Fables* consisted of joint ventures, with Bewick overseeing the work of his apprentices. Popular interest in natural history was increasing. It was after having received commissions for the illustration of a children's book that he initiated *Quadrupeds*, as the standard of such publications was poor and mostly derivative in nature.

Bewick's animal engravings combine memory with observation of private and travelling menageries as well as recent four-footed arrivals brought back as specimens from natural history expeditions. In addition to writing and collating the texts, he produced engraved illustrations of the markings and other features of birds and animals, which were acclaimed as works of scientific documentation. The illustrations to his *History of British Birds* were even more of a success than those of *Quadrupeds*, not least because Bewick was less reliant here on secondary sources, able to observe his subjects at length, and to a certain extent in their natural habitats. The most satisfying pictures in *Quadrupeds* are those of domestic or semi-domestic animals. Each small engraving places the bird or animal in a detailed landscape background, and each entry finishes with a 'Tale-piece', a vignette at the foot of the page that reveals elements of rural life. His volumes are valued as much for these as for his observation of birds and animals from nature because they inject humour and narrative into the usually strait-laced natural history publication. Some vignettes are simply there for amusement and casual observation, such as that of the dog peeing against the stone or a boy crossing stepping-stones in a river while carrying a heavy

box. Others are more personal to Bewick's beliefs – to comment on the cruelty of the circus man he counterposes an itinerant showman accompanied by his bear and monkey with the silhouette of a gibbet in the background. Others combine wry humour with common sayings: in *The Overlong Grace before Meat* Bewick gibes at false piety: neither a grace nor a preface should be too long, he comments.

SIR WILLIAM BEECHEY *1753–1839*

PORTRAIT OF SIR FRANCIS FORD'S CHILDREN GIVING A COIN TO A BEGGAR BOY 1793

Courtesy of the Tate Gallery, London

BEECHEY was a successful portrait painter in Reynolds's wake, until he was eclipsed by Thomas Lawrence's affable elegance. His contemporary rival, who would also be eclipsed by Lawrence, was the portraitist John Hoppner (1758–1810). The differences between the works of these two artists, the one staid and conventional, the other flashy and daring, represent portraiture as it was on the threshold of the Romantic era. Beechey's first success at exhibition was at the Royal Academy in 1789 but throughout his career his private commissions substantially outweighed the number of pieces he exhibited, and by 1790 Lawrence's star was already rising. In 1794, Beechey was an associate of the RA and Principal Painter to Queen Charlotte, and he would receive a peerage in 1798. Lawrence was on his way to full membership of the RA and also in the Queen's patronage. Hoppner, an associate Academician, appealed to the more extravagant Prince of Wales, and was appointed his Portrait Painter.

Before entering the RA Schools, Beechey had trained as a lawyer. He is thought to have studied with Zoffany, the acclaimed painter of the conversation piece and practitioner of the theatrical genre. Although there is little sense of theatre or excitement in his portraits Beechey's early work was mostly conversation pieces. His mature portraiture, apart from the occasional flash of brilliance, was admired precisely for its chaste competence in the manner of Reynolds, his sure handling of colour and his lack of exuberance.

This picture was painted not long after the storming of the Bastille. A young brother and sister are out walking in parkland. He is dressed in a red outfit, with lace collar and jaunty black hat with plume; his sister is in an ivory silk dress, cape and bonnet, all prettily tied with pink sashes and bow. They appear to be miniature adults playing out their future roles. Light falls on her as she stretches out to hand a coin to the pale, bareheaded, barefoot beggar boy, whose rags are improbably reminiscent of her brother's outfit. A spaniel emphasises the act of giving by following the movement with its head, and the hands are framed as they meet against the brother's sleeve. This is a sanitised scene, a portrayal of landed gentry and of false reassurance – of the maintenance of the status quo, in other words.

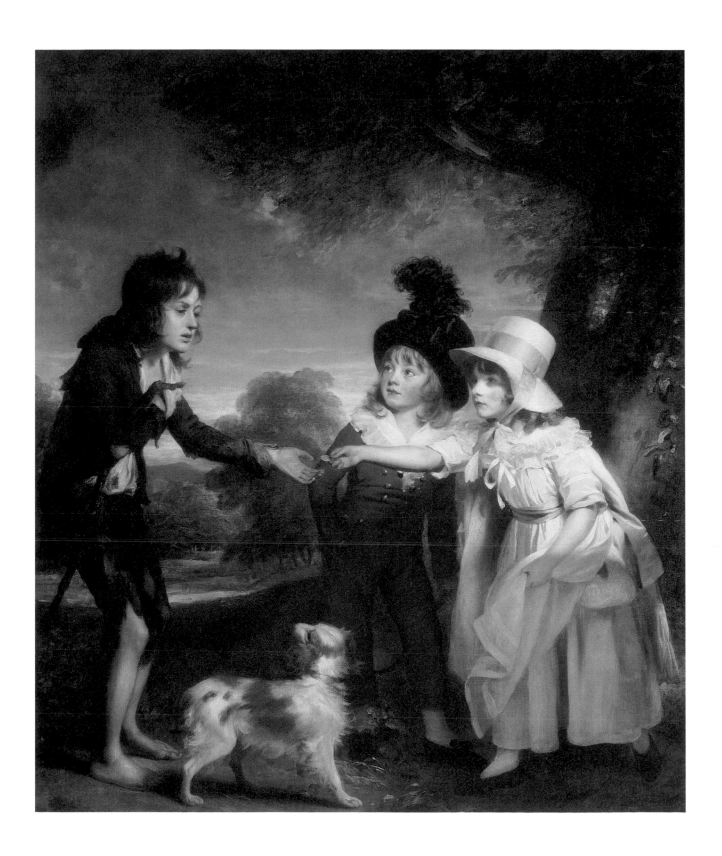

THOMAS ROWLANDSON *1756–1827*

THE EXHIBITION STARE CASE, SOMERSET HOUSE C. 1800

British Museum, London/Courtesy of the Bridgeman Art Library

JAMES Gillray (1757–1815) was the great political satirist of his day; Rowlandson was his equal in social satire. He originally trained and practised as a portrait painter, but his tendency to gamble required a supplementary source of income. In his caricature work Rowlandson favoured watercolour over print-making, and became so successful that he was said to live off gentle mockery alone. He was a superb draughtsman, and the line-and-watercolour wash remained his domain for much of his life. Rowlandson created a gallery of recognisable types – the lecherous old man, the buxom wench and so on – which he strung together with a rhythm and line that recall Hogarth and the French Rococo style, and that are delightfully demonstrated by the continuity of movement in this cartoon.

Rowlandson gently pokes fun at the exhibition-going public, more concerned with putting themselves on display than with the works on show, hence the work's punning title. Human action is foremost in his caricatures – but he is ultimately humane in his humour – and the physical surroundings are often of minor significance. In his watercolour *London: Skaters on the Serpentine* (1784) Hyde Park is certainly recognisable, and the watercolour wash with which he creates the atmospheric wintry afternoon light contributes to the theatrical effect. The setting is as much a stage on which the throng play and tumble as it is a real physical place.

Except in his later years, Rowlandson's work remained of consistently high quality despite a huge output, and his collective work has been described as a visual *comédie humaine*.

THOMAS GIRTIN *1775–1802*

MORPETH BRIDGE 1802

Christie's, London / Courtesy of the Bridgeman Art Library

GIRTIN was an innovator in the field of watercolour. He conveyed drama and tension solely through his depiction of light, while choosing otherwise undramatic viewpoints, a famous example being *The White House at Chelsea* (1800). The whiteness of the house is heightened by leaving the paper bare to contrast with neighbouring washes, and its intensity mesmerises the viewer, otherwise lulled by the stretch of low horizon and immense sky broken only by a few clumps of trees and a mill, the river like glass in the aftermath of sunset. Girtin demonstrates the pure expressive powers of the watercolour, which J. R. Cozens (see page 88) had begun to evoke in his vast melancholic expanses.

With Turner, his exact contemporary and fellow Londoner, Girtin built on the work of Cozens and Sandby to irrevocably transform the watercolour from simple topographical description. First apprenticed to Edward Dayes, a talented topographical draughtsman, Girtin left early, presumably to follow his own direction. He first exhibited landscape watercolours at the Royal Academy in 1794 and by 1795 he was working with Turner on copying Dr Thomas Monro's collection of J. R. Cozens's drawings. Dr Monro had cared for Cozens until his death and owned a substantial

international art collection that Girtin must have studied intensely. The year 1794 also saw Girtin's first visit to the Midlands; the significant body of his work dates from the late 1790s. Much of this period was spent in the North of England on sketching tours of antiquarian and architectural subjects. In 1796 his visits to Northumberland and Yorkshire introduced him to a landscape far removed from such subjects, and the stretches of moorland and heavy skies would inspire his greatest watercolours. In *Morpeth Bridge* the artist seeks a balance between objectivity and classical control on the one hand and expression on the other. The setting is superficially picturesque – the horses are watered, and in another version a dog plays by the water's edge. It is the stillness and grandeur of the sky and the light rather than the bridge and surrounding buildings that are the real subject. Great clouds pass overhead, and the water and buildings are dramatically darkened as they move over. Through breaks in the cloud blue sky can be seen, reflected in the water's surface, glacial in its stillness, and the sun's rays highlight the arc of the bridge and the church behind.

By 1801, Girtin's health was failing but he was working on a panorama of London called the *Eidometropolis*, painted in oil on canvas 108 feet long and 18 feet wide. Urban panoramas, housed in purpose-built circular structures, were in vogue, and in many respects were the ultimate expression of urban topography. Only Girtin's preparatory drawings survive, but they reveal amongst the exactitude of detail his prevailing interest in atmospheric effect.

Joseph Mallord William Turner 1775–1851

A Coast Scene with Fishermen Hauling a Boat Ashore c. 1803

Courtesy of English Heritage Photo Library

THE son of a London barber, Turner began his professional career in the world of engraving – he was a colourist of engravings and drawings, and apprenticed to an architectural draughtsman before entering the Royal Academy Schools in 1789. From the 1790s he painted large-scale oils, sea-pieces, history paintings and historical landscapes, and on the strength of these became an Academician in 1802 and was Professor of Perspective from 1807 until 1837. Turner's first visit to the Swiss Alps followed in the steps of J. R. Cozens – Turner spent three years in the late 1790s copying Dr Thomas Munro's collection of Cozens's watercolours, and he coupled his technique and compositional invention with the full drama of the chasms and ruggedness of the Alpine mountainscape. His later trips to Italy and the Alps produced his greatest experiments in light and weather effects.

The Society of Painters in Water-Colours (later the Old Water-Colour Society) was founded in 1802, and Turner was a prime force behind its establishment although he never became a member. The aim was to show watercolour as a medium equal to oil in the historical genre, to combine figures and grandiose landscape in heroic style. Girtin and Turner, traditionally considered the fathers of British watercolour, were firmly rooted in the importance of observation. Turner's *Study of Fish: Two Tench, a Trout and a Perch* (1822) and *Head of a Heron* (1815) are watercolour studies of natural phenomena – the pattern and reflection of the types of fish, the plumage on the bird's head. Observation of such realistic detail would be seen again in paintings of High Victorian realism and in the minutiae of Pre-Raphaelitism. During the 1820s and 1830s, Turner illustrated a number of topographical books. The most ambitious, *Picturesque Views in England and Wales*, was not a financial success: travel on the Continent was again possible, and whilst the eighteenth-century traveller had visited the classical sites, the nineteenth-century middle-class tourist was more interested in novelty and exoticism.

In oil, as in watercolour, Turner explored mythological, biblical, historical and marine painting, while developing a theory of colour association and an examination of light that would fascinate the Impressionists. The origins of his most famous early history piece, *Snow Storm: Hannibal and His Army Crossing the Alps* (1812), and his shipwrecks lay in Burke's theory of the sublime, which gave precedence over ideal beauty to pictorial effects that produced the strongest emotion. At the same time, Turner was painting British landscape in Ideal form, for example *Richmond Hill on the Prince Regent's Birthday* (1819). This search for subliminal naturalism lies behind much of his work, whether in the swirling waves of his 'shock' oil paintings of shipwrecks and sea storms or in the study of light and pure colour in his watercolours.

Henry Bernard Chalon *1770–1849*

A Representation of the Persians, in the Costume of Their Country, Attending at Carlton Palace 1819

Courtesy of the Tate Gallery, London

BORN in London, Chalon was the son of a Dutch engraver, Jan Chalon. His mother, Jackey Bernard, had been disinherited upon her marriage by her father Sir John Bernard, but her children received a small legacy. Chalon studied at the Royal Academy Schools and specialised in sporting and animal painting. He married the sister of James Ward the painter, and their brother William Ward engraved many of Chalon's works, thereby allowing him to reach a wide audience. This paid off, as he was appointed Animal Painter to Frederica, Duchess of York, in 1795, and subsequently held the same position for the Prince Regent and later George IV and his successor William IV. The Dukes of Beaufort and Devonshire and Earl Grosvenor were amongst his prestigious patrons during the Regency period, but despite exhibiting over two hundred works at the Royal Academy and publishing twelve plates in *The Sporting Magazine* he was never elected an Academician. Chalon had had an illegitimate son and some blame is apportioned here to James Ward, who is said to have blocked his candidature.

Chalon was influenced by Stubbs in his style and approach to animal painting; he would never strive for the heights of Stubbs's art, but published a number of studies of horses, including *Book of Animals and Birds of Every Description. Studies from Nature* was published in 1804 and included diagrams of a horse's skeleton and musculature. Chalon painted horses as strong and loose-limbed with big shoulders and fine pace. The particular detail he paid to the head and nostril area occasionally obstructed the sense of movement he brought to his sporting pictures.

The style of sporting pictures would change with the invention of the camera: hunt meets became grandly composed subject matter on wide canvases, riders and hounds spread out in a variety of positions that allowed the artist to record the animals from all angles. It was not until the 1880s that the horse's gallop would be correctly observed. Eadweard Muybridge discovered how a horse moved in a gallop by setting up a series of cameras, the shutters of which the horse would release by breaking the cotton thread that Muybridge had stretched across the track. The effect on sporting art was dramatic, as galloping horses had always been portrayed as if flying through the air, their front and hind legs outstretched in opposite directions.

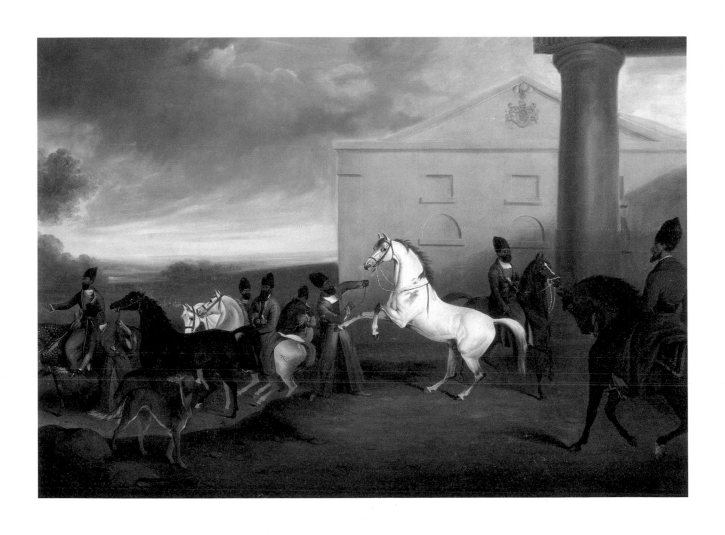

John Constable *1776–1837*

Dedham Vale with the House Called 'Dedham Valley'

Courtesy of the Tate Gallery, London

THE second son of a wealthy miller, Constable was born in East Bergholt, Suffolk. By 1799 he had moved to London and joined the Royal Academy Schools. Elected an associate member of the Royal Academy only in 1819, he painted for exhibition his famous 'six-footers', large oil landscapes of his native Stour valley, worked up from full-size oil sketches. Highly valued in themselves for their spontaneity, there was no precedent for these preparatory oil sketches, but the size of the finished canvas suggests the great efforts required to organise disparate elements of natural observation into a structured whole.

Constable never left Britain, and apart from images of Hampstead and Brighton, where he moved the family for his wife's health, the majority of his landscapes were of his native Suffolk. Ironically, in his lifetime Constable was valued more in Europe than in his own country – appreciation here grew largely through the efforts of C. R. Leslie, who wrote his biography in 1843, and of Philip Wilson Steer and the New English Art Club.

Constable was revolutionary because he painted his landscapes from direct studies of nature, thus reducing the controlling influence of the classical and Dutch styles.

Working on his oil sketches he strove to emulate the laws of nature, the fleeting changes of light and the drama of the sky and cloud formations. In the early 1820s and again in the 1830s he studied the different types of cloud formation above Hampstead Heath, painting first in oil and later in watercolour either the sky alone or the sky and the tops of trees, often marking the studies with time of day and direction of the wind. Constable would use the results of his observation to expressive effect, succeeding in combining direct notation with sentiment – imitation of landscape was not his purpose. Significantly, his first studies in atmosphere were in oil; he used watercolour at a later date. Like Turner and other practitioners of watercolour as the essential medium for the study of light, Constable interchanged the two media. His application of oil paint in individual dabs and scoops prompted his critics to claim his works unfinished. His broken brushwork gave the surface of his paintings a texture, and his method of adding flecks of white, seen in clumps of trees in *Flatford Mill* (1818), brought energy and the impression of wind and movement to the canvas. His technique sacrificed those aspects of landscape painting traditionally considered pleasing to the eye and disregarded the conventions of tonality and finish. Constable's naturalism was high-handed in some respects, his motivation one of superior moral purpose – the study of God's creation – but he was not alone at this time in painting direct observations of landscape (John Linnell's *Kensington Gravel Pits* (1811–12) is strikingly stark).

SIR THOMAS LAWRENCE *1769–1830*

MISS MURRAY 1825–7

Courtesy of English Heritage Photo Library

LAWRENCE enjoyed enormous success as a portrait painter. Mostly self-taught, the son of an innkeeper in the West Country, he became an Academician very early on in his career, received a knighthood in 1815, and was made President of the Royal Academy in 1820, after Benjamin West. He was generous in his support of young artists and was actively involved in the founding of the National Gallery in 1824.

Not only was he the most fashionable portrait painter in Britain, he also had considerable success in Europe; on a visit to Paris in 1825 he received the Légion d'Honneur. His portraits epitomise the notion of the dandy in the England of George IV. He brilliantly conjured a stylish vitality that delighted his patrons, including George III, whom he painted in 1792, having succeeded Reynolds as the King's Painter. Using an extra-long full-length format, he painted the victorious generals of the Napoleonic Wars in 1818, as commissioned by the future George IV.

Lawrence favoured observation rather than narrative: one of his objectives was to paint in a lively manner that would be sustainable, that would conjure sensation and present modern subject matter but with the gravitas and timelessness of the Old Masters. Louisa Georgina Murray was the only daughter of General the Rt Hon. Sir George Murray MP and goddaughter of the Duke of Wellington. Lawrence was keen to capture the child's beauty while she was still young, and late in his career he held this painting up as a yardstick against which to measure his other portraiture. The vitality and glitter of his technique and his awareness of his sitters' temperaments were unrivalled in his lifetime – *Margaret, Lady Blessington* (1822) is another magnificent example of the verve and glamour he brought to his portraits. Other patrons included Sir Robert Peel – Lawrence's portrait of his wife Lady Peel is in the Frick Collection, New York – and Richard Payne Knight the connoisseur, but this did not prevent him living in debt during his lifetime, nor his portrait style falling from fashion.

JOHN SELL COTMAN *1782–1842*

GRETA BRIDGE, YORKSHIRE C. 1810

Courtesy of Norfolk Museum Service (Norwich Castle Museum)

FROM Norwich, Cotman came to London in 1798 where first he earned a living making drawings and watercolours for print-sellers, and entered Dr Thomas Monro's unofficial academy in Adelphi Terrace, just as Turner and Girtin had done. Because of the French Revolution and the Napoleonic Wars (1793–1815) the Continent was largely closed to travel, so the touring gentlemen turned their attention to the Lake District and Wales. Demand flourished for picturesque topography and antiquarian views. With Sandy Munn, Cotman made several visits to Wales, and whilst in Yorkshire he spent five weeks on the Rokeby Hall estate as a guest of the Morritts, where he painted some of his most famous watercolours on the banks of the River Greta. The bridge had been built by the neoclassical architect John Carr of York (1723–1807), and spans the Greta at the south gates of Rokeby Park. *Greta Bridge, Yorkshire* is a magnificent example of Cotman's pictorial composition, combining expression with preconceived conceptions of landscape. The extremes of light and dark are echoed in the contrasting shapes of the inn and the arch of the bridge, itself reflected in the water. The apparently casual placing of the rocks in the foreground and the mountain peak in the background is carefully calculated to recall the gradations of classical landscapes – John Sawrey Morritt was a

classical scholar and collector, and the bridge was built on the grounds of an ancient Roman site.

Despite the accolades received by Cotman whilst in London he failed to become a member of the Society of Painters in Water Colours. He returned to Norwich in 1806 where he made vain attempts to establish himself as a portrait painter.

As in other urban centres of the country, the Industrial Revolution created a burgeoning bourgeoisie and increased leisure time. The Norwich Society of Artists, primarily an exhibiting society, had begun in 1803, grouped around the figure of John Crome (1768–1821; see page 118) – Cotman became President in 1811. Not only Norwich but at least twenty other towns across the country maintained local societies that held regular art exhibitions. However, this was not enough to sustain a professional artist through the sale of his works alone – Cotman took up etching in response to the interests of the local antiquarian societies, with ambitions to become Britain's Piranesi. He published collections of his work such as *Antiquities of Norfolk*, whilst also building up a circulating library of six hundred drawing models that could be hired for a quarterly fee. Most members of watercolour societies were teachers, and their amateur students were not simply confined to the daughters of local gentry. Exeter, Norwich, Bristol and Newcastle upon Tyne all had significant regional schools. Cotman accepted an invitation to move to Yarmouth, where he became the drawing master to the family of Dawson Turner, a fervent patron. He left in 1823, again to establish himself as a drawing master in Norwich. His last appointment was that of Professor of Drawing at King's College School, London, which he took up in 1834.

JOHN CROME *1768–1821* WITH
JOHN BERNEY CROME *1794–1842*

YARMOUTH WATER FROLIC – EVENING: BOATS ASSEMBLING PREVIOUS TO THE ROWING MATCH 1821

Courtesy of English Heritage Photo Library

A preparatory oil sketch for this painting by John Crome survives, but the difference in handling of landscape and boats on the right-hand side of the finished work has led to the suggestion that Crome senior started on this painting only to die before its completion and that his son finished the work. Not only are the raft and buoy additions, but, strikingly, a steamboat is moored on the right, the steam from its funnel visible against the shoreline trees. The state barge in the centre of the picture bears the arms of Yarmouth; every year in July, until the custom ceased in 1834, the mayors of Yarmouth and Norwich would 'beat the bounds', or meet in their state barges at their civic boundaries on the Rivers Yare, Bure and Waveney, eagerly watched by crowds of onlookers and regatta folk.

John Crome is regarded as the founder of the Norwich School: Cotman was Norwich's famous watercolourist, and Crome its oil painter. His pupils included his son, John Berney Crome, James Stark (1794–1859) and George Vincent (1796–1832); their impact in London and on the national scene would remain the basis on which the Norwich School's reputation was founded. Whilst the term 'school' is understood to mean a group of likeminded artists, in the nineteenth century it meant less a system and more a state of instruction. The influence of Dutch painting is clear in this oil; the region had a history of trade and commercial links with the Netherlands, and Crome, who had an artisanal background and worked as a restorer and dealer all his life, spent much time copying the collections of his local patrons, Thomas Harvey, Dawson Turner and the Gurner family. Both Crome and Cotman supplemented their incomes with etching and work as drawing masters to the local bourgeoisie, whose prosperity was tied up in the textile trade and banking or, in the case of the Colman family, in mustard.

Scenes of water frolics and sailing were common in Norwich painting, as were urban scenes of the town. Crome chose unlikely viewpoints from which to paint the city's backwaters, and the intimacy of these scenes, such as *St Martin's Gate, Norwich* (1812–13), contributes to their picturesque quality. Crome combined the picturesque with increasing naturalism and atmosphere, and his studies of nature for subsequent exhibition pieces, for example *Dock Leaves* (1818–20), must have been a response to a heightened interest in botany and in natural theology – the study of nature being the study of God's creation. The Linnaean collections of natural history were kept in the house of a local botanist, Sir James Edward Smith, and nearby a garden had been planted along Linnaean principles.

RICHARD PARKES BONINGTON *1802–28*

THE UNDERCLIFF 1828

Castle Museum and Art Gallery, Nottingham/Courtesy of the Bridgeman Art Library

BONINGTON was born in Nottingham, the son of a drawing master; when he was fifteen years old the family settled in Calais and established a lace-manufacturing business. From 1820 to 1822 he lived in Paris and was a pupil of Baron Antoine Gros, Napoleon's official battle painter, who would influence Eugène Delacroix. From 1825 Bonington shared his Parisian studio, and his links with English Romanticism, with Delacroix. He brought Delacroix to London to meet Constable – *The Hay-Wain* (1821) had been favourably greeted when exhibited at the Salon of 1824 – and admire his use of broken brushstrokes and multiple greens. Apart from two other trips to London, Bonington spent most of his short life in France and was as much part of the French Romantic movement of the 1820s as of its English counterpart.

He visited Venice in 1826 during a two-month tour of northern Italy, generating much of the output of his last two years, and exhibited his views of northern Italy in 1827 and 1828. His imagination was captured by Goethe (his lithograph illustrations

of *Faust* were published in 1828), Byron, Shakespeare and Scott, passions that were shared by his patron, Lord Hertford. (His substantial holding of Bonington's oils and watercolours is in the Wallace Collection, London.) Bonington was instrumental in encouraging the watercolour in France; his free handling of washes and his dramatic skies, his distant misty blue and purple landscapes, brought a sense of freshness and dynamism to his paintings, which are always filled with an unparalleled light and brilliance – for example, *Near Burnham, Norfolk* (1825). The influence of Bonington can be seen in the work of David Cox and David Roberts in the physical qualities of pure air and the intensity of light in their paintings. Turner's watercolours, after his trip to Italy in 1820, also recall Bonington in their luminosity and spontaneity.

Bonington died of consumption in London in 1828: *The Undercliff* was his last work, and unusually for Bonington there is a narrative element to the image. Sailors are seen waiting with pack-mules to receive contraband from smugglers who frequented the coastline near Dieppe. The cliff looms over the huddle below and reflects the stormy light, whilst all beneath is thrown dramatically into deep shadow. The sea is jet-black, and jade further out; waves foaming white at the shore, complemented by the passing clouds and changing light, energise the scene.

SIR DAVID WILKIE *1785–1841*

GRACE BEFORE MEAT 1839

Birmingham Museums and Art Gallery / Courtesy of the Bridgeman Art Gallery

WILKIE was born in Fife and studied in Edinburgh, where his early success propelled him to London. Influenced by David Allan, he specialised in genre painting, producing scenes of everyday life in the anecdotal mode. Most of his scenes were of Scottish peasant life, executed with a sense of narrative and humour reminiscent of Hogarth, but with none of Hogarth's satire.

His most successful paintings were works such as *The Blind Fiddler* (1806), which were gentler and more generous in spirit than any of Hogarth's work. Wilkie was in many respects the creator of the genre of the everyday, but his work stands apart from what is understood as typical Victorian painting, which was more saccharine than Wilkie's and less motivated by an interest in plain lives. The years 1830–40 were the heyday for this type of painting. Whilst history painting had never taken hold of the imagination, the depiction of everyday scenes, inspired by Dutch and Flemish painting of the seventeenth century, was highly regarded. Just as writers such as Charles Dickens and W. M. Thackeray narrated the everyday in fantastic detail, genre painters would visually narrate a moral tale. In 1858 Augustus Egg (1816–63) would paint his tripartite *Past and Present*, which recorded in detail the discovery of a woman's adultery, her ejection from the home and the separation of mother and daughters. Here too the prevailing influence is Hogarth, but where the latter presents a fatalistic sequence of events, Egg's narrative leaves the viewer wondering about alternatives. The technical perfection of Victorian painting was considered in itself a guarantee of quality, a mark of hard work – realism was the measure of perfection.

Wilkie remained outside the Pre-Raphaelite movement, and was an exceptional draughtsman. His careful observation of detail met with great approval both with the Prince Regent and at the Royal Academy, whose influence had increased markedly. Later in his career Wilkie developed an interest in historical painting, particularly after travelling in Europe from 1825 to 1828. He would die at sea on his way back from the Holy Land, where he had gone in search of subject matter for biblical paintings. Turner commemorated the event in *Burial at Sea of Sir David Wilkie* (1841–2, Tate Gallery). Wilkie left for the East in 1840, but little work survives of this

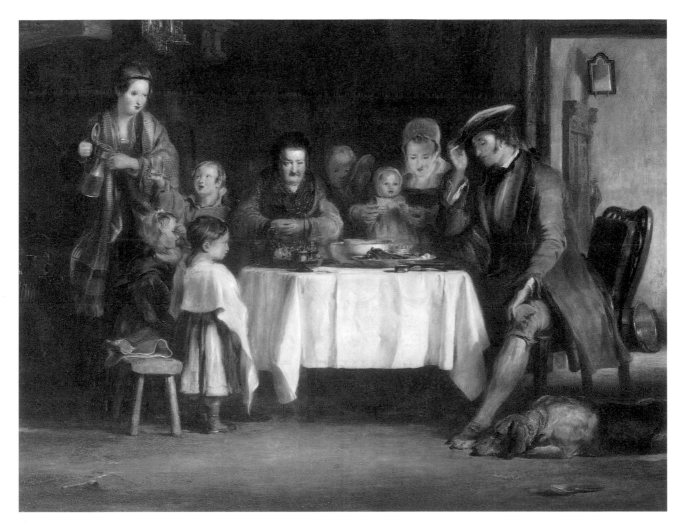

journey: sketches and watercolours, for example, *The Turkish Letter-Writer*, and two completed oil paintings, *Muhemed Ali* (1841) and *The Tartar Messenger Narrating the News of the Victory of St Jean*. Travel to the East permitted Wilkie the luxury of exposure to new influences and to new ways of representation. He would adapt his art according to the prevailing influence: here, his palette showed signs of the East but his eye was still seeking out the political and social subject. In *The Turkish Letter-Writer* he concerns himself with illiteracy and the subjugation of women in society, whilst in *The Tartar Messenger* the news of the British and Turkish victory over the rebellious Muhemed Ali is given to customers in a coffee shop, far from the scene of the battle.

HENRY THOMAS ALKEN *1785–1851*

THE BELVOIR HUNT: THE MEET C. 1830–40

Courtesy of the Tate Gallery, London

ALKEN came from a family of sporting painters, of Danish origin. His father, Samuel Alken, painted sporting landscapes in the manner of Stubbs, and his second son Henry would become one of the most famous sporting painters and illustrators of his time, excelling particularly in the hunting scene.

Henry Thomas Alken's coloured aquatints are still in demand among sporting-picture enthusiasts today, and he would have enormous influence over generations of sporting artists. His early artistic training came from his father, before his apprenticeship to the miniaturist John Thomas Barber Beaumont (1774–1841). In 1809 he was living in Ipswich, married to one Maria Gordon, and becoming known as a graphic journalist under the name Ben Tally Ho. He created one of the most famous sporting prints of all time during this period. Known as *The Midnight Steeplechase* or *The First Steeplechase on Record*, its correct title was *The Night Riders of Nacton*. The print illustrated a night race that was said to have started from the Cavalry Barracks in Ipswich and ended four and a half miles later at Nacton Church.

The first edition was published with a mistake – under the broken bar of a gate appeared its intact shadow. The error was rectified in the second edition but reinstated in the third, which sold in its thousands. In 1816 Alken wrote and published *The Beauties and Defects in the Figure of the Horse* and in 1821 he illustrated *The National Sports of Great Britain* and a number of textbooks on drawing.

The Belvoir Hunt: The Meet, one of a set of four, was painted at a time of heavy industrialisation and urbanisation as well as political and social unrest at home and abroad – the Reform Act was for many the slippery slope, widening the electoral franchise at a time of revolution on the Continent. Far from alluding to the climate of the time, this picture portrays the gentry pursuing an active life, the viewer's eye stretching for miles over the vale and the hounds milling about, giving a sense of the frenzied excitement of the meet before the hunt moves off. There is no obvious focal point – Alken's larger paintings tend to be composed in the manner of a frieze. Most of his work consists of hunting, racing, steeplechasing and coaching scenes, the latter often in snow, for example his *York to London Mail*. Although difficult to distinguish from the rest of his family's sporting paintings, his horses are usually more angular than those painted by his son Henry, whilst the latter's crowds are more acutely observed. Henry senior's horses were usually fashionable Arab types, and one of his trademarks was the end-of-day theme, with the horse's hind leg tucked beneath him, his body slung low, at rest.

DAVID ROBERTS *1796–1864*

FRONT ELEVATION OF THE GREAT TEMPLE OF ABU SIMBEL, NUBIA

Stapleton Collection, UK/Courtesy of the Bridgeman Art Library

ROBERTS began his career in his native Scotland as a scenery painter for the travelling circus and the Glasgow and Edinburgh theatres, then later went to London, where he worked in the Drury Lane Theatre with Clarkson Stanfield (1793–1867). Both artists became interested in topographical views, and from 1830 onwards Roberts toured Europe and the Mediterranean basin. In 1838 he toured the Middle East for eleven months, making sketches of biblical and classical sites. He sailed up the Nile, stopping off frequently to sketch ancient sites and contemporary exotic scenes before setting out from Cairo by camel to travel through Palestine, recording the wonders of Petra, the River Jordan and Jerusalem. Roberts exhibited his first group of Eastern oils at the Academy in 1840 and was elected an Academician the following year.

The oils and watercolours he painted went into his six-volume *Sketches in the Holy Land, Syria, Idumea, Arabia, Egypt and Nubia* (1842–9), from which he made a sizeable fortune. He had lithographs of his work made by Louis Haghe (1806–85), which he then sold as a 40-part subscription, published by Francis Graham Moon. Celebrity subscribers, to whom he was careful to dedicate the first volumes, included Charles Dickens, John Ruskin and the young Queen Victoria.

Roberts's success lay in his adaptation of the historical landscape idiom to the Victorian taste for exotic places – Fox Talbot invented his photographic processes in the 1830s. He approached his subjects with an acute observation which he blended with a feeling for romantic drama, thereby complying with his intended audience's desire to see far-away places rich in history – long-distance travel began around this time.

In this illustration from the *Nubia* volume a note of drama is injected into the scene, achieved by the dramatic diagonal across the image and the immensity of scale indicated by the tiny men at the top right, seated on the sand that perhaps hid these figures for so many years. As demonstrated by works like *Ancient Tartyris, Upper Egypt* (1848), the human figure is nearly always subordinate to the immensity of scale of the architecture in Roberts's work. His portrayal of contemporary costume added to the sense of adventure to which his patrons subscribed – Sandby had combined topography and the human figure in the eighteenth century – but Roberts's figures seem ill at ease in their landscape, positioned more for theatrical than for naturalistic effect.

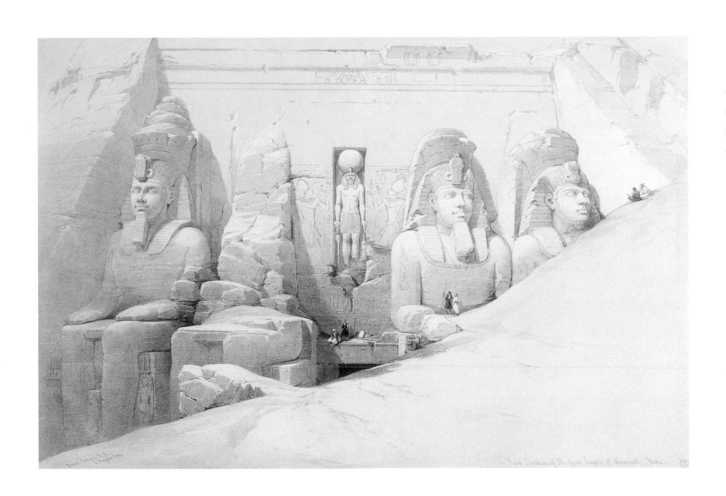

Samuel Palmer *1805–81*

In a Shoreham Garden 1826–30

Courtesy of the Victoria & Albert Museum, London

PALMER moved from London to Shoreham, a village in Kent, in 1826 and stayed there until the early 1830s. He had first exhibited at the RA at the age of fourteen. Five years later, his friend and wealthy patron John Linnell introduced him to William Blake. Blake had not produced much landscape art, but Palmer was particularly entranced by the wood-engravings Blake had made to illustrate some of Virgil's *Pastorals* and the Book of Job. Palmer developed a pastoral landscape that was infused with Christian vision, representing the dream of Paradise. For him and for fellow artists Edward Calvert and George Richmond, who had moved to Shoreham and named themselves collectively 'the Ancients' in reference to the German 'Nazarenes', awareness itself was an act of creation, and the study of nature thus a religious act, a spiritual revelation. From Blake, Palmer learnt to emphasise features and heighten textures, to depict 'dells and nooks' that revealed a pastoral ideal in the Kent landscape, steeped in Christian mysticism and the medieval, and abandoning the histrionics of the Renaissance.

Naturalism for naturalism's sake was not quite what Palmer intended when he created paintings such as *In a Shoreham Garden*. The painting is a glorious blaze of colour, dominated by the cherry blossom that towers over the pathway and melts into the foliage behind. The curving tree trunk is as sensuous as the swelling blossom, and a riot of gold. At the end of the path, a young woman can be seen against a backdrop of greenery. Distinct, she is also subsumed to the spiritual joy of the garden in full display.

Palmer's greatest work was produced between 1825 and 1835, when he worked on a series of sketchbooks, ink-and-wash landscapes and a small number of oil paintings. However, his experience at Shoreham in the 1820s and 1830s was anything but pastoral. At a time of rural unrest and the 'Captain Swing' riots, Palmer's marriage to Linnell's daughter offered the chance of a trip to Italy, where the couple spent two years travelling. Palmer's work after this period altered considerably. He broke with his visionary mode and reverted to conventional topography, and his pastoral watercolours illustrating Milton's *L'Allegro* and *Il Penseroso* are devoid of any personal mysticism.

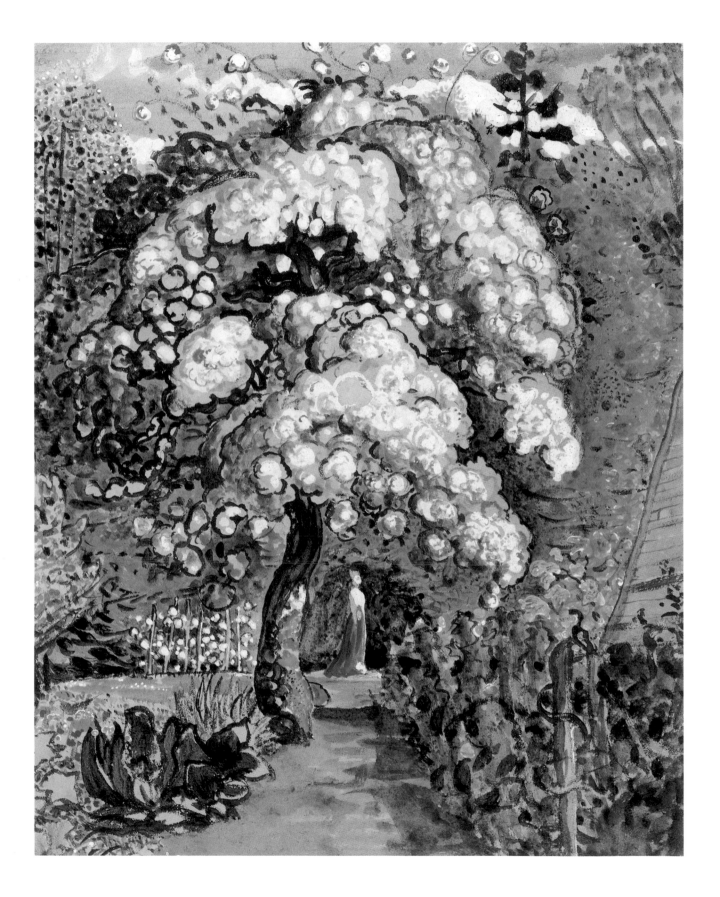

SIR EDWIN HENRY LANDSEER *1802–73*

DIGNITY AND IMPUDENCE 1839

Courtesy of the Tate Gallery, London

AS in so many of his most admired animal portraits, Landseer has imbued this with a sentimentality that was immensely popular in Victorian times. The characterisation, informed by the title of the painting, is acute. You can hear the impertinent yelp of the terrier while the bloodhound, grounded by its long ears, by its oh-so-elegant front paws, waits, looking down its long nose. The viewpoint is low, as if to empathise more closely with the dogs. In presenting them as anthropomorphic expressions of virtue, they represent an alternative portrait of Victorian society as it wished to be seen.

Landseer was a brilliant observer of animal anatomy. The son of an engraver and a child prodigy, he would become one of Queen Victoria's favourites and win admiration from the French Romantic painters. His friends included Dickens and Thackeray. As well as a painter, he was a sculptor, modelling the lions at the foot of Nelson's Column in Trafalgar Square which were unveiled in 1867. Landseer also depicted nature red in tooth and claw – he visited Scotland many times and frequently painted pictures of deer-hunting and hawking on large canvases, raising the animal picture to dramatic heights. He infused the animal world, both domestic and noble, with popular virtues, as exemplified in the dog of *The Old Shepherd's Chief Mourner* and in the majestic stag of *Monarch of the Glen*.

Landseer's later works were powerful and pessimistic. In *Man Proposes, God Disposes* (1864) he painted an arctic landscape and ferocious polar bears destroying the remains of an expedition. John Franklin had set out in 1845 with two ships and nearly two hundred men, but they never returned. Subsequent searches had found a telescope and human remains, with polar bear tracks nearby. Landseer's painting shows a scene of destruction and inhumanity; jagged icebergs close in, the light is unearthly. The title suggests the fruitlessness of human action in the face of Divine Providence, and the picture is one of force and irrationality.

Hawking in the Olden Time (1831) was one of several Highland scenes that Landseer painted after visiting Walter Scott in the Scottish Borders in 1824. Here Landseer presents a more natural order of things, the nobility of God's creatures in life and in death, the beauty of death in nature and the emotion such scenes provoke. Landseer also painted a small number of landscapes whilst working on specific history paintings. *Bolton Abbey* (1834) seems to have been sketched solely for the purpose of capturing the light and movement in the sky, quite at odds with the revelry of the finished picture, *Bolton Abbey in Ancient Times*.

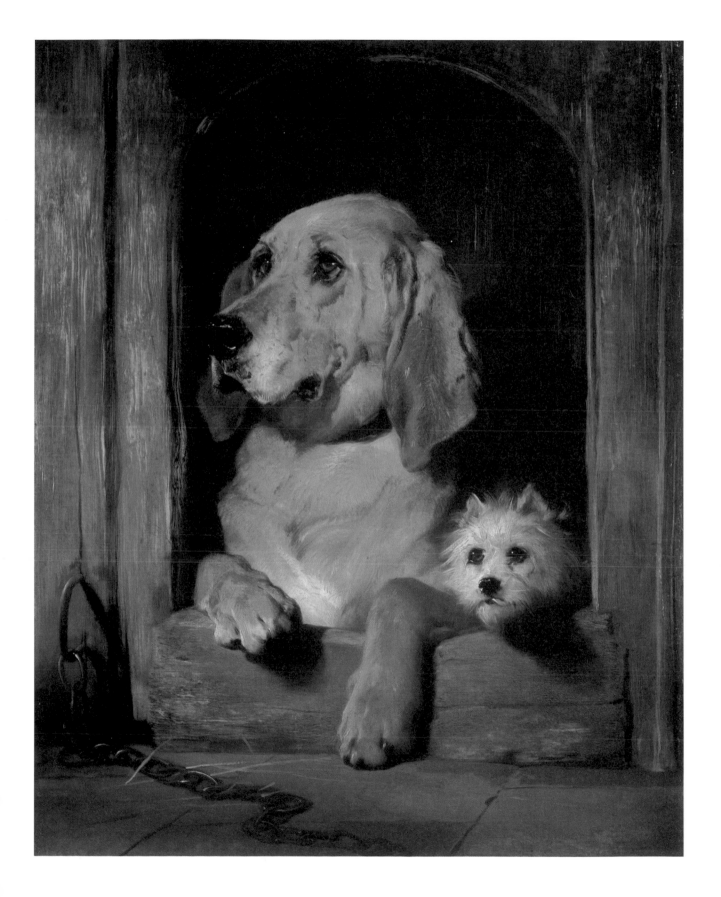

JOHN FREDERICK HERRING *1795–1865*

THE FRUGAL MEAL, EXHIB. 1847

Courtesy of the Tate Gallery, London

HERRING was born in Blackfriars, London; his father was of Dutch descent and a fringe-maker in Newgate Street. When Herring was eighteen he moved to Doncaster, arriving just in time to see the Duke of Hamilton's horse win the St Leger. By chance he became driver of the London-to-Doncaster coach, having assisted the coach painter in portraying the victorious beast on the coach's crest. He remained the driver of the Doncaster–London coach for seven years, and by this time was married with children. His move to the Doncaster–Halifax coach brought him into contact with his future patron, Charles Spencer-Stanhope, from whom he obtained his first serious commission. Herring resisted attempts to lure him into full-time painting, but a year as driver of the High Flyer, which left Doncaster at 6 p.m. and arrived in Fetter Lane, London, at 9 p.m., persuaded him to pursue his sporting art as a career, aided by the offer from Frank Hawkesworth, another patron, of a year of guaranteed commissions.

Like his brother and three sons, Herring made his name as a painter of all the major horse-racing events, producing animal portraits of 33 consecutive winners of the St Leger, and similarly of the Derby and the Oaks. His reputation was established by commissions from the *Doncaster Gazette* and other publications, and every year his sketch of the St Leger winner was engraved and published.

Herring first exhibited at the RA in 1818. In the 1830s he moved his family to London but, it seems, got into financial difficulties, whereupon he was helped by porcelain manufacturer W.T. Copeland who commissioned some hunting designs to be transferred on to Copeland Spode bone china. Herring was in great demand in the 1840s, travelling to Paris at the request of the duc d'Orléans and accepting appointments as painter to the Duchess of Kent; Queen Victoria also became a lifelong patron. Herring frequently used a grey horse as a model, the Arab Imaum which had originally been sent to England for the Queen. He left London and established himself in Kent in 1853. The move coincided with a change in subject matter: he began painting rural scenes, pictures of farmyards and animal portraits with moral undertones and suggestions of narrative. In *The Frugal Meal* the skies are dark, the birds ruffle up their feathers for warmth, and the horses, observed in different stages of grazing, have grown their winter coats.

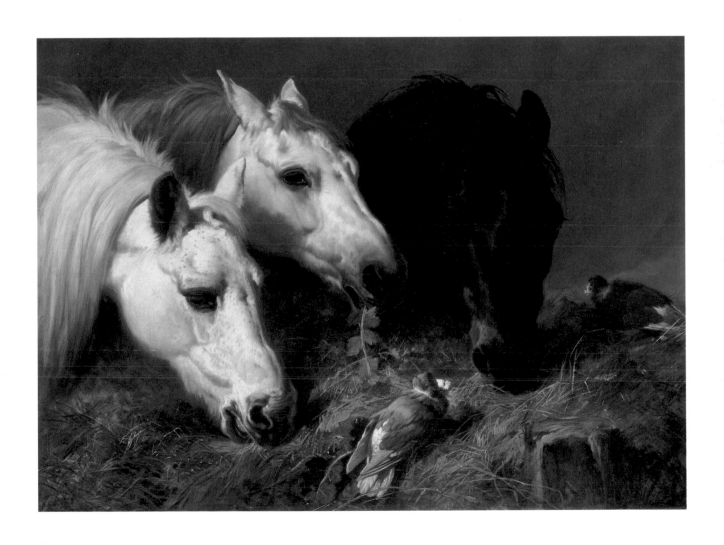

EDWARD LEAR *1812–88*

STUDY FOR MACROCERCUS ARACANGA, RED AND YELLOW MACAW 1830

Natural History Museum, London / Courtesy of the Bridgeman Art Library

LEAR is more familiar as the nonsense poet, but it was as a painter that he was known during his lifetime. From the age of sixteen he worked as an ornithological and natural history painter and illustrator, and in 1837 he indulged his interest in landscape painting. He developed a keen observation, depicting birds and animals in public and private collections. One of his first departures from tradition was to work from living creatures rather than stuffed ones, which also led him to include a pictorial notation of their habitat, real or imagined. In 1830 he was commissioned by the Zoological Society to draw the parrots in their collection, and their president Lord Stanley, later Earl of Derby, would be a substantial patron all Lear's life. Lear went on to record and categorise the Earl of Derby's private menagerie of birds and animals from around the world at Knowsley, near Liverpool. Over a hundred of Lear's watercolours, which reveal his awakening interest in landscape painting, survive.

The great natural history volumes of the day, Selby's *Illustrations of British Ornithology* and Audubon's *The Birds of North America*, covered many species – Lear's covered just one family. He started publication of *Illustrations of the Family of Psittacidae, or Parrots* independently, with Charles Hullmandel (1789–1850), the leading lithographer of the day. Expenses were to be met by the subscribers to each of the fourteen parts, but their delay in paying meant that the project was abandoned, incomplete. The process was lengthy – Lear would measure the birds, held by their keepers, and then make a smaller-than-life pencil drawing. Next, he would make a detailed lifesize master drawing, then trace it for a second outline, which he would paint with watercolour. An outline in greasy chalk would also be traced on to the lithographic stone, the final black and white product therefore the reverse of the original, which was then coloured in by hand, using Lear's watercolour version as a guide and after his approval of the outline. The hand-colourists would hang the plates and then circulate around the studio, painting in all the reds, then all the blues, yellows and so on until they had finished. The print run was 175 per plate, after which the lithographic stone was destroyed.

At the height of his critical acclaim as a natural history painter, Lear took up landscape painting, travelling extensively, but his rigorous eye would not permit him to indulge in the kind of Orientalist scenes that the Victorians wanted. He seemed incapable of compromise and unable to depict exotica that he did not see. Consequently, harems, ruins and markets do not feature in Lear's travel watercolours. He toyed with photography in the 1850s and always made copious notes of colour

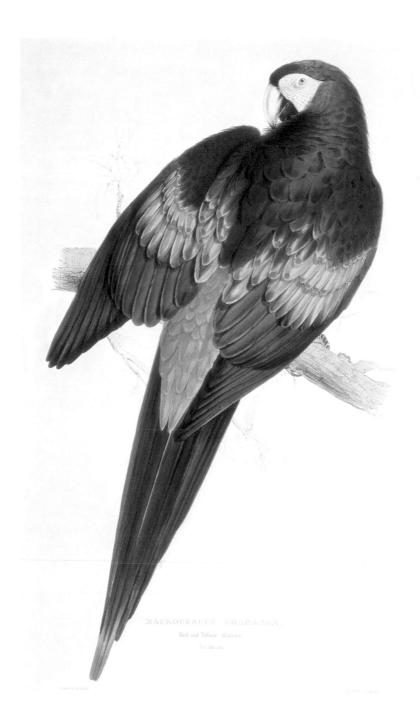

MACROCERCUS ARAPANGA.
Red and Yellow Macaw.

and proportion on his drawings, on the basis of which, on open days held at his studio, he took commissions for full watercolours and oils. His introduction to his *Journals of a Landscape Painter*, in the days before the *Rough Guide*, was used in the early editions of the publisher John Murray's *Handbook for Travellers in Greece*; it advised travellers to bring their own stirrups, cooking utensils and two changes of clothes, one for meeting dignitaries, the other for roughing it.

WILLIAM POWELL FRITH *1819–1909*

THE DERBY DAY 1865–8

Courtesy of the Tate Gallery, London

WILLIAM Powell Frith took fifteen months to paint this scene, using models and specially commissioned photographs. Epsom Downs on Derby Day was the climax of the racing season. It always drew huge crowds from London and a whole cast of recognisable 'types', which Frith set out consciously to record. The Victorians tended to believe that all aspects of a human's character and worth were revealed in his or her physical features.

A child acrobat in the centre right of the picture is distracted by a stranger's picnic, while a man in a top-hat is cheated out of his money at a makeshift betting stall; others naively line up to take the same fall, as a young wife tries to restrain her husband. Both scenes are framed by women. On the left, dressed in dark riding clothes, is a high-class prostitute, or 'pretty horse breaker', so called because her beat would have been the daily parades on horseback in Hyde Park. Her gaze directs the viewer to another woman, seated in a carriage. A fellow Academician, J. E. Hodgson (1831–95), mindful of Verdi's opera, referred to her as 'Traviata' – she is

the mistress of the offhand character who leans against the carriage with his back to her, his stance one of careless ownership. Crime, prostitution and poverty are just some of the Victorian vices that Frith set out to document in *The Derby Day*: the mix of toffs, prostitutes, thieves and country bumpkins is straight out of a contemporary popular novel.

Frith began his successful career as a painter in the 1840s, excelling in humorous scenes from the classics. In 1854 he painted his first portraits of modern life, such as *Life at the Seaside* and, later, *The Railway Station* (1862). In this picture people throng Paddington Station's platform, as if naturally self-organised into a social hierarchy, from third to first class, left to right; police arrest a ticket evader on the far right. As with *The Derby Day*, Frith packed his paintings full of incident as if to portray Victorian society as it wished to be viewed. The genre as epitomised in Wilkie's work (see page 122) was concerned with the country fair and the cottage interior, but by the 1850s there had been a shift in interest away from the rural to the urban middle class. Although he painted the latest developments such as railway stations and clothed his subjects in contemporary dress, Frith's crowd scenes were arranged along Academy-approved lines of composition and grouping. His work would inspire a rash of contemporary group scenes, for example George Elgar Hicks's *Dividend Day at the Bank of England* painted in 1859.

SIR JOHN EVERETT MILLAIS *1829–96*

OPHELIA 1851–2

Courtesy of the Tate Gallery, London

MILLAIS might have pursued an academic career, but as a result of his friendship with a fellow student he formed the Pre-Raphaelite Brotherhood with William Holman Hunt and Dante Gabriel Rossetti in 1848. The formation of the PRB was a reaction against the popular genre pictures of the time, which they regarded as trivial in their subject matter and sloppy in their execution. The Brotherhood's aims were to paint elevated subjects in a realistic style, basing everything on life, as opposed to idealised stereotypes – a return to the painterly values that had prevailed before the High Renaissance: pure forms and colour, clearly defined contours and few figures. The painstaking realism of their early paintings was almost a religious act, as if to find God in the minute and to rediscover awe in the familiar. Millais's *Christ in the House of his Parents* (1849–50; also known as 'The Carpenter's Shop') provoked reactions of outrage both for its perceived Catholic leaning and its realism, considered sacrilegious. Influential supporters weighed in, including Queen Victoria's husband and the critic Ruskin (1819–1900), although his support was tempered somewhat when Millais went off with his wife in1854. By this time, the members of the PRB were going their separate ways, Holman Hunt to explore vivid landscapes, Rossetti to pursue his mystical medievalism. The debate at the University Museum, Oxford, where the evolutionists defeated the theologians, drove the final nail in Ruskin's intellectual coffin. Ruskin had supported Turner's naturalist observation twinned with a sense of higher purpose, and in the work of Millais and later of William Morris he found examples of art that were religiously and ethically sound. In the face of mass production, the regeneration of art could come about only through a return to the highest standards of workmanship and the moral values to be found in medieval art.

The furore caused by the Pre-Raphaelites' religious subject matter made them turn to English literature, a means also of placing themselves within the cultural tradition. Ophelia, first spurned by Hamlet, is driven mad by her father's murder. She drowns, surrounded by garlands of flowers, painstakingly painted and paradoxically heavy in symbolism – the poppy symbolises death, the willow forsaken love, the nettle pain and the daisy innocence. The intensity of the colours was achieved by applying them to a white ground – 'wet white', so called as it was freshly laid for each day's work. The model for the painting was Elizabeth Siddal (in 1860 she would marry Dante Gabriel Rossetti), and Millais had her sit in a bath for days – her father threatened to sue him if he did not pay the ensuing doctor's bills.

Millais's final break from Pre-Raphaelitism came with *Autumn Leaves* (1855–6). More purely decorative and harmonious than any of his previous work, it is a melancholic comment on the passage of time and the inevitability of death.

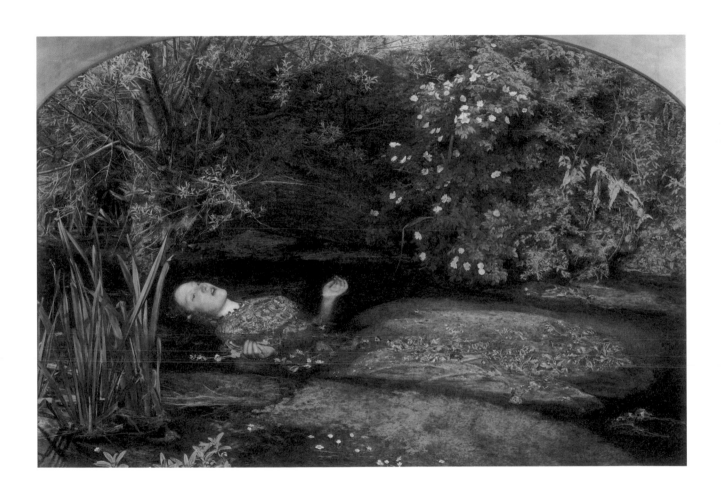

FORD MADOX BROWN *1821–93*

THE LAST OF ENGLAND 1864–6

Courtesy of the Tate Gallery, London

BROWN was born in Calais, the son of a ship's purser. After studies in Paris and Antwerp, he came to London in 1844, where he met Rossetti. Brown was already painting in the style of the Pre-Raphaelites, and reaffirmed his interest in medievalism during a visit to Rome in 1845, where he was influenced by the German Nazarene group. Rossetti briefly became his pupil and remained a great friend, despite Holman Hunt obstructing Brown's membership of the Pre-Raphaelite Brotherhood.

In the 1850s, Brown painted in an unrelenting realist style, and produced a series of landscapes painted outdoors and uncompromising in their notation of the effects of light – for example, *The Hayfield* (1855–6). This was painted in the fields of Hendon, north of London, and is more concerned with the effects of light than with an image of rural labour. The rain has just passed, hence the unusual colours: purple and green in the moonlit sky, green-grey streaks in the hay, and violet shadows. Two of his realist masterpieces were painted during this period, *The Last of England* and *Work* (1856–63), confronting respectively the issues of emigration and of industrialisation. Brown had himself contemplated emigrating to India with his family in 1852, when emigration was at its highest. He portrayed himself, his wife Emma and two children as the departing family. The dull, relentless daylight at sea picks out the family in unforgiving detail, as if to fill the scene with a harsh poignancy, and the oval shape of the painting further concentrates the scrutinising gaze.

Through his friendship with Rossetti, Brown joined William Morris's firm of designers, and with Edward Burne-Jones began to design stained glass and furniture until the partnership broke up in hostile circumstances and Morris took on sole responsibility. Morris believed in work as the self-fulfilling occupation of man; for him, creative work gave pleasure – it was not so much a means to an end, but the end itself. Life without pleasurable work was mere endurance.

Brown's *Work* is outwardly a celebration of the moral value of work. The whole gamut of society is represented, in occupations that their position in society awards them: urchins make mischief, labourers toil, intellectuals watch and discuss. At the heart of the picture are the labourers, with the rest of the characters spiralling outwards from them in an anticlockwise direction. The grouping is slightly manic and there is no coherence nor reason to the action depicted except a portrayal of human force seen in the light of day.

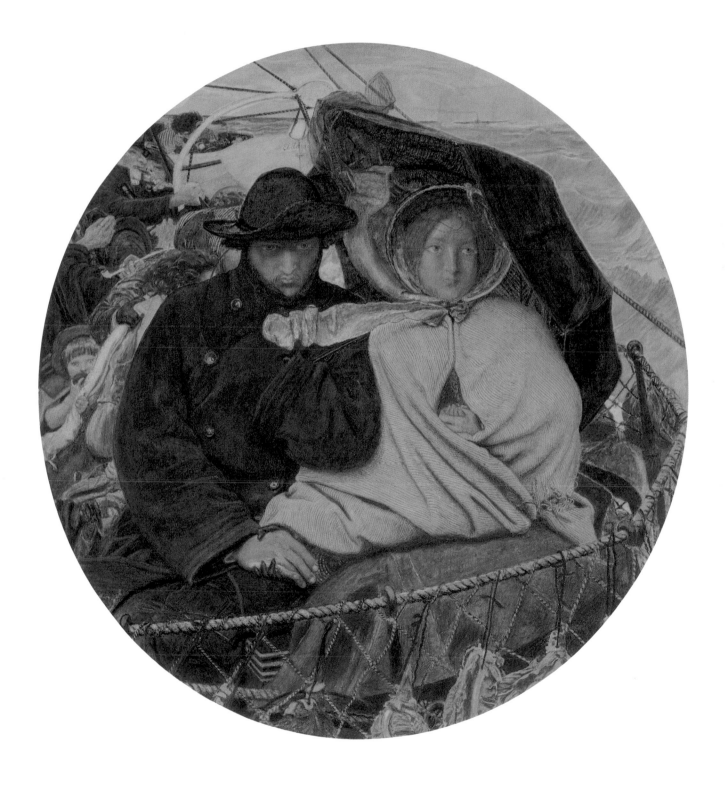

J. F. LEWIS *1805–76*

THE SIESTA 1876

Courtesy of the Tate Gallery, London

LEWIS was greatly admired as an artist for his precision and his vibrant colours, and for much of his career he regarded himself first and foremost as a watercolourist. An admirer of Wilkie, he left for the East in 1840 and whilst in Istanbul coincided with the Scottish painter. Arriving in Cairo in 1841, Lewis would spend the next nine years there, progressively shedding his Western habits and adopting local customs and dress. Part play-acting, part earnest, Lewis was both living a part and wishing to gain insight and understanding of another culture. When he returned to London, his output was almost exclusively watercolours of Orientalist subjects. His use of detail and his observation of architecture, fabric, light and colour brought him comparisons with the Pre-Raphaelites, who greatly admired his work, but his compositions were essentially imagined; the subject of the harem in particular was sure to win over his clientele. It was not only suitably Orientalist subject matter that determined Lewis's scenes – often the figures themselves were placed in familiar poses against exotic Orientalist backdrops. It has been said of a group of garden scenes such as *In the Bey's Garden: Asia Minor* (1865) that once the exotica were removed, the figures were reminiscent of an English vicar's wife.

Although there is a suggestion of narrative and character study in Lewis's watercolours, his prime concern is with surface pattern, the play and fall of light on various textures in his interior scenes. The women in his harems have a dreamlike quality about them, more visions than reality. Much of Lewis's work displays the influence of Antoine Watteau (1684–1721). He was the inventor of a genre, the *fête galante*, in which young people flirted and loved in the outdoors, part parkland part formal garden, mostly dressed as characters from the *commedia dell'arte*. The mix of play-acting, dressing up, and the ambiguities and ellipses in his paintings are to be found in Lewis's Orientalist scenes, although with none of the melancholy sometimes found in Watteau's art. Ruskin would admire one of his paintings, *A Frank Encampment on the Desert of Mount Sinai* (1842), for its Watteauesque qualities and for its vision of East and West meeting in an unchanging desert setting, Eastern style, with the grace and drama of a timeless encounter.

Here, a lady lies in a deep slumber during the afternoon heat, draped suggestively on a pile of cushions. A fan lies carelessly discarded next to a bowl of fruit. The effects of light are minutely observed – the lattice pattern as a shaft of light, distorted through the green curtain, falls on the carpet. Exotica abound – the opium flowers, the poppies, in the chinoiserie vases, the orange silk tablecloth and the woven Turkish carpet.

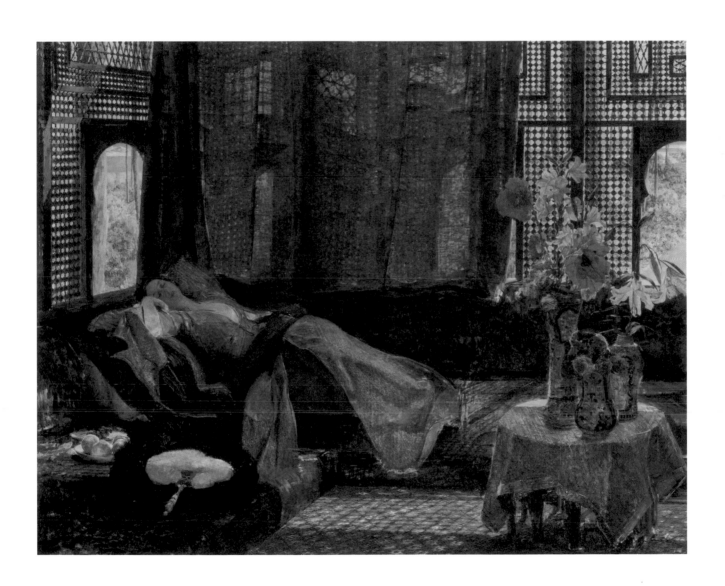

DANTE GABRIEL ROSSETTI *1828–82*

THE DAY DREAM 1880

Victoria & Albert Museum, London / Courtesy of the Bridgeman Art Library

ROSSETTI'S father was an exiled Italian revolutionary and scholar, his sister the poet Christina Rossetti, and Dante would find it hard to choose between painting and poetry. His interest in Keats brought him into contact with Holman Hunt at the Royal Academy, where they were both students. His work as a founder member of the Pre-Raphaelite Brotherhood caused a particular storm. *Ecce Ancilla Domini* (1849–50), an Annunciation piece, along with subsequent works, received howls of abuse and Rossetti vowed never to exhibit his work in public again. Whereas the Virgin is usually portrayed seated reading, here she is shrunk against the wall, semi-prostrate. Although the backdrop is blue, she is wearing white – again, not a traditional colour for the Virgin Annunciate to be wearing, any more than is her expression of reluctant dread. It was a highly emotive and personal rendition of a traditional scene.

Rossetti's later work centred on the illustration of medieval literature. Burne-Jones had made Rossetti's acquaintance in London whilst his friend William Morris was still up at Oxford. They had both renounced their intention to take holy orders: Morris now intended to become an architect and Burne-Jones a painter. Rossetti encouraged the two to join a team to decorate the walls of the Oxford Union Debating Hall with chivalric scenes from *La Morte d'Arthur,* a cycle of legends translated from the French by Malory in the fifteenth century. Neither Rossetti, Burne-Jones, Morris nor the others were versed in the technique of mural painting and their work was a failure. In 1861 Rossetti joined the firm of Morris, Marshall, Faulkner & Co. as a painter. Morris's increased control over the firm's activities led to an acrimonious split in the partnership in 1875, with Rossetti and Madox Brown amongst those who left, Burne-Jones amongst those who stayed. Rossetti's love for Morris's wife, the model for *The Day Dream*, also contributed to his departure.

His break from the Pre-Raphaelites in the 1850s allowed him to explore the works of Dante and the idea of chivalric love. Spring sits amongst sycamore and honeysuckle, a ripening prelude to Summer. Rossetti illustrated other medieval works, including those of Dante and particularly the poet's love for his muse, Beatrice. He had married Elizabeth Siddal, the model for Millais's *Ophelia*, and painted her constantly until her death in 1862; she was the first in a long line of idealised female figures, ruby-lipped and of pale complexion, wide-eyed and with a voluptuous head of hair. *Beata Beatrix* (1864–70) was painted in homage to his late wife and is a striking departure from his previous idealised portraits, which were essentially decorative and sensual in style, anticipating the Aesthetes' premise that art should serve no moral purpose. In *Beata Beatrix* the daydream has become a timeless vision, sensual and hypnotic.

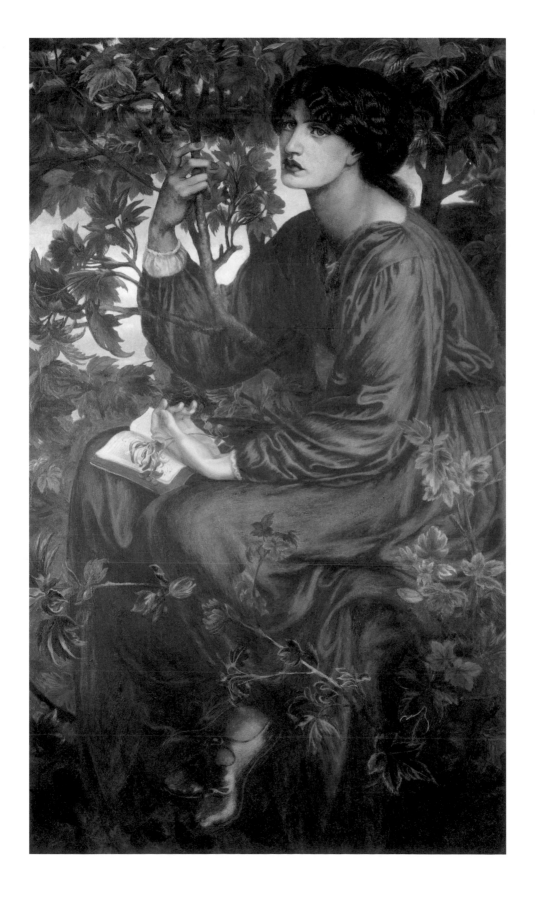

EMILY FARMER *1826–1905*

KITTY'S BREAKFAST C. 1883

Victoria & Albert Museum, London / Courtesy of the Bridgeman Art Library

THIS painting is a typical example of the genre pictures that were so sought after in Victorian times. Little is known about Emily Farmer, although she is remembered as a watercolour figure and domestic painter, with works such as *A Little Villager* recorded at the Royal Academy exhibition of 1850. Her pictures featured also in the exhibitions of 1847 and 1849. The majority of her watercolours were shown at the New Water-Colour Society and the Royal Institute. *Kitty's Breakfast* is sentimental, but there is a painterly fluidity in the way the artist shows the light falling on the girl's face and hand, with her skipping rope hanging up on the wall behind her, and the expectant cat waiting in its basket. The way in which the scene is lit from one side, the air of domesticity and quiet observation recall the Dutch and Flemish paintings from which the genre derived.

In the 1860s George Heming Mason (1818–72) had begun painting scenes of poetic reverie, children in smocks and bonnets, playing in the countryside or tending animals. Frederick Walker (1840–75) and John William North (1842–1924) were known as the Idyllists. Painting mostly in watercolour, they exercised the rigour of the Pre-Raphaelites in their noting of detail, which they would then proceed to partially erase. The work of Helen Allingham (1848–1926) was highly fashionable. She specialised in watercolours of picturesque cottages, slightly run-down and old-fashioned, and little girls in sunbonnets. Late Victorian landscape painting, too, was increasingly idealised. As a portrait of nostalgic charm, the fashion for idealising the rural came at a time when the rural was becoming increasingly suburban.

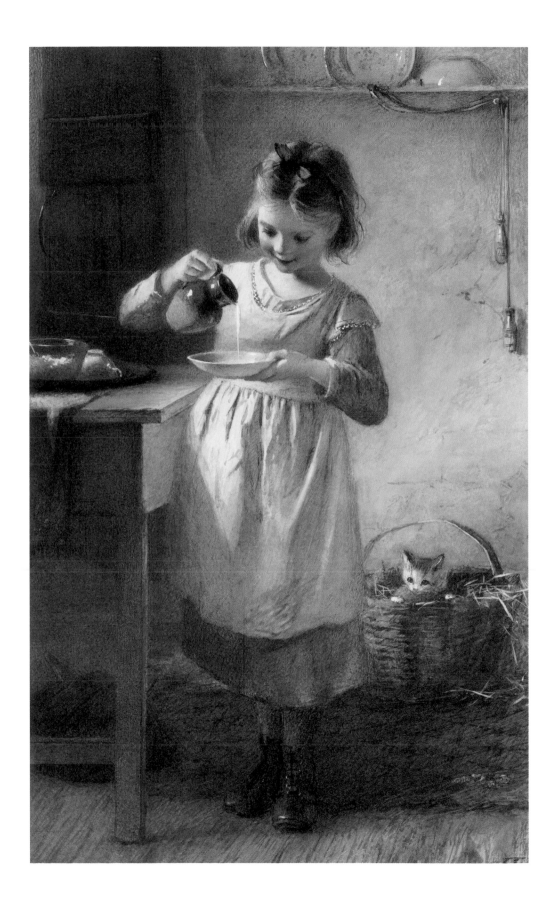

STANHOPE ALEXANDER FORBES 1857–1947

THE HEALTH OF THE BRIDE 1889

Courtesy of the Tate Gallery, London

FORBES was born in Dublin, where his father was a railway manager. The family subsequently moved to London, where Forbes joined first the Lambeth School of Art and then the Royal Academy Schools in 1876. In 1880 he worked in Paris, where he was influenced by the Barbizon School and Jules Bastien-Lepage (1848–84). Barbizon was a village outside Fontainebleau where a group of artists had settled to paint landscapes in the open air – joined in 1849 by Millet. Bastien-Lepage furthered realism's cause, concentrating on the rural worker and his environment and painting direct from life. In Brittany, 'the black group' of Cottet (1863–1925) and others, so-called because of the contrasts of the region, were depicting the daily lives of the coastal villages.

Realism was common in British art before the 1870s, but it now suggested an ugly or uncomfortable reality. Social realism concentrated on the difficulties of urban life and contemporary social problems, rural realism on the labourer's lot and the steady departure of the workers from the fields to industrial centres. The techniques employed in these scenes were much influenced by the earlier developments in France. Paintings by Millet (1814–75) and Courbet (1819–77) had provoked reactions of dislike; the latter's *Un enterrement à Ornans* (1849–50) shocked critics with its coarse and ugly models, who were themselves the villagers of Ornans in eastern France. On his return to England, Forbes moved first to Falmouth and then to the fishing village of Newlyn, soon to be joined by H. S. Tuke (1858–1929) and Frank Bramley (1857–1915), whose picture *A Hopeless Dawn* (1888) made his reputation. Along with his wife, the painter Elizabeth Armstrong whom he married in 1889, Forbes is regarded as the founder and leader of the Newlyn School, heavily influenced by the new French devotion to open-air painting, to depicting rural communities in their own setting, and to the necessity of the painter's immersion in the community he wished to accurately paint.

In *The Health of the Bride*, the wedding party has gathered to celebrate the marriage of a young sailor and his bride. The gathering is sombre, overshadowed by the ship's mast seen through the window, and minutely observed – from the stuffed animals in glass cases to the pink of a guest's dress and the hue of the oranges. Like Bramley, the artist has lit the scene from more than one angle, and the light source on the right of the picture, catching the backs of the guests' heads, is unseen. In *A Fish Sale on a Cornish Beach* (1885) Stanhope Forbes's use of the square brush – a technique learnt from Bastien-Lepage – can be clearly seen, especially in the effects of light and water on the sand. For all its naturalism the picture is strongly structured, with the boat and the crowd forming two arcs that meet at the centre of the canvas before continuing out to sea and the horizon beyond.

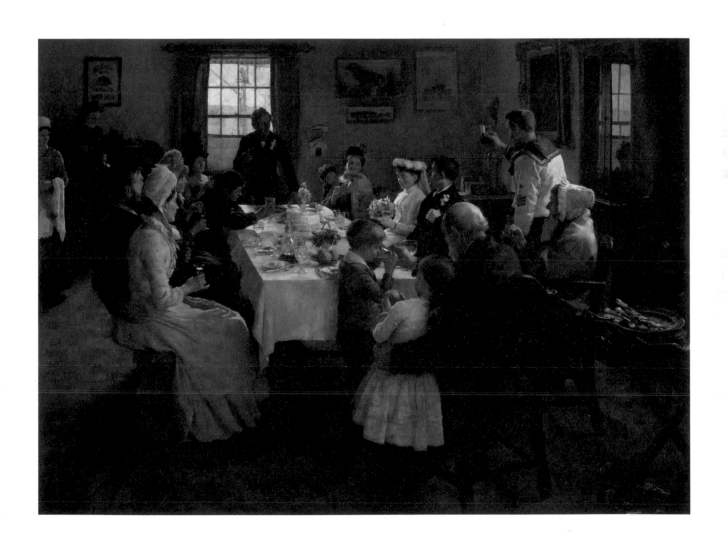

SIR GEORGE CLAUSEN *1852–1944*

THE STONE PICKERS 1882

Private collection / Courtesy of the Bridgeman Art Library

BORN in London, Clausen worked first for a decorating firm, studying art in the evenings, before taking up painting full-time. He was subsequently to travel to the Low Countries and to France, and his painting reflected the influences of both traditions. A founder member of the New English Art Club, along with John Singer Sargent (1856–1925) and Edward Stott (1859–1918), Clausen bridged the gap between the rigid canons of the Royal Academy, to which he was elected in 1908, and the London Impressionists.

Clausen was struck by the French naturalist painter Bastien-Lepage and his scenes of rural life (see page 148). He moved to the countryside of Hertfordshire to immerse himself in the agricultural community, which he wished to paint with the impartiality espoused by the French painter. He was also associated with the Newlyn School, whilst remaining independent. In the 1880s he made a series of paintings of agricultural workers preparing fields for ploughing. In *The Stone Pickers* stones are being manually removed from the fields. In another painting of the same name Clausen depicts two figures again, this time women in a similar configuration. In the foreground an upright figure pauses by a pile of flint whilst in the background the companion is bent double, into the upward slope, collecting stones. The field slopes gently in the background, occupying most of the canvas. Here, the stonepicker looks out, shading his eyes from the sun, whilst in others of the series the tones are muted, the light is dulled.

At pains to paint the countryside as it was, Clausen claimed to eschew social realism, preferring to depict what he saw in front of him regardless of social commentary. In *Sons of the Soil* (1901) he shows a group of five men hoeing a field. Of different ages, they seem to move forward in one unit, their hoes hitting the ground simultaneously, their movement suggested by a blurring at the edges as they blend into the landscape, and the struggle between tonal and impressionistic colour painting is evident. The intimate rusticity of Clausen's paintings was successfully transferred to the larger canvas, as seen in his monumental *The Boy and the Man* (1900). An official war artist in the First World War, Clausen went on to receive a knighthood for his mural *Wycliffe's English Bible* in the House of Commons, painted in 1926. After its completion, he concentrated on small canvases, mostly painting the mists in the Essex countryside near Duton Hill.

ALFRED SISLEY *1839–99*

VIEW OF THE CANAL ST MARTIN, PARIS 1870

Musée d'Orsay, Paris / Courtesy of the Bridgeman Art Library

SISLEY was of English parentage but lived mostly in France, firstly in Dunkirk, where his father had a business selling artificial flowers to South America. Sisley was expected to join the business, but after a stint in England he attended the École des Beaux-Arts. He met Renoir (1841–1919) and Bazille (1841–71) in the 1860s, and also struck up a long-lasting friendship with Monet (1840–1926). He devoted himself to landscape, and apart from a few visits to England, scenes of Paris and its environs were his main subject matter. Sisley was wonderfully effective at wintry scenes, and his observation of the sky and the changes in light in fog and snow are beautifully atmospheric, for example in *Fog* (1874) and *Snow at Louveciennes* (1878).

His main influences were the landscape painters Corot (1796–1875), Courbet (1819–77), and Charles Daubigny (1817–78) of the Barbizon group (see page 148); as 'Corot's pupil' he succeeded in exhibiting at the Paris Salons of 1866 and 1867 without submission to the selection committee. Until 1871, when the family business failed during the Franco-Prussian War, Sisley enjoyed a private income, but he would die in poverty, never claimed by the French, who refused his request for French nationality, or by the British, although his work is now in all their major collections. As one of the founders of the Impressionist Salon, he exhibited at the first Impressionist show in 1874, with Monet, Renoir, Pissarro, Cézanne, Degas and others, and at three subsequent group exhibitions. He also had one-man shows, but still failed to find substantial buyers. The Impressionists, in their different ways, were exploring representation in the light of nineteenth-century research into the physics of colour and the new technology of photography. Sisley was neither boldly revolutionary in his work nor academic, and he won an unjust reputation as a minor painter who demonstrated a sense of natural balance and sensitivity in his painting.

In his landscapes, like other Impressionists he broke with tradition. Landscapes were no longer classical: they did not recede, framed by trees, nor did strong diagonal lines lead the eye to the horizon. In *The Fields* (1874) lines of crops guide the eye in gentle irregular fashion and the human figures give scale to the composition, which is a view of the market gardens that supplied Paris. Forest landscapes also provided the artist with a subject matter that could break with the past and was free of connotations with classical landscape. Sisley was constantly on the move around the Île-de-France area, finally settling in Moret-sur-Loing in 1883. His views of the village, for example *Le Pont de Moret* (1893), depict familiar understated objects in monumental compositions: towards the end of his life he painted with broader brushstrokes and thicker paint in the style of Monet.

ATKINSON GRIMSHAW *1836–93*

LIVERPOOL QUAY BY MOONLIGHT 1887

Courtesy of the Tate Gallery, London

GRIMSHAW was born in Leeds and had little formal art training although his greatest early influence was a fellow Leeds artist, the Pre-Raphaelite landscape painter John William Inchbold. From the 1860s, Grimshaw took up painting as a full-time occupation and his first pictures of dead birds, fruit and blossom revealed the extent to which he had absorbed Ruskin's dictum of truth to nature. He began to exhibit in 1862 and his first patrons were the upstanding members of the Leeds Philosophical and Literary Society. Grimshaw came to prominence in the 1860s with his landscapes painted in the manner of the Pre-Raphaelites. He captured their use of crisp, hard-edged colour in his sharply observed daylight scenes, a number of which were of the Lake District; the influence of Holman Hunt can clearly be seen

in works such as *Autumn Glory: The Old Mill* (1869), where the detail of leaves and mossy stones is painstakingly recorded. However, Grimshaw is known mostly for his later paintings – moonlit scenes, wet urban streets glistening in the gaslight. His earliest moonlit scene is *Whitby Harbour by Moonlight* (1867). Urban scenes under the yellowish light were very popular amongst his middle-class patrons, as were his dock scenes of Liverpool, Hull and Glasgow. He experimented with photography, and his earlier work included genre and literary subjects, but it was these later works which were enormously successful, partly because of the sense of atmosphere that he conveyed.

He extended his work to include imagined scenes of ancient Greece and Rome, similar to the work of Alma-Tadema (see page 172), and also painted some literary subjects taken from Tennyson and Longfellow, as was the fashion. Nevertheless, Grimshaw's reputation rested on his townscapes, and perhaps his greatest in terms of its evocative powers is *Leeds Bridge* (1880).

Sir William Nicholson *1872–1949*

HM The Queen 1899

Courtesy of the Tate Gallery, London

NICHOLSON was born in Newark-on-Trent, the son of an industrialist and the largest employer in Newark. After studying the art of the woodcut in Paris, where he became familiar with the work of Toulouse-Lautrec, Nicholson returned and made his name as a graphic artist. This he did in partnership with his brother-in-law, James Pryde, as the Beggarstaff Brothers. They specialised in bold poster design. Their first commission was for a poster to advertise *Hamlet*, and their resulting bold black and white design showed a silhouette of the Dane talking to Yorick's skull. Another poster, for Sir Henry Irving's *Don Quixote* showing at the Lyceum Theatre in 1895, was ill received by the public but was reproduced in art magazines across Europe.

Despite moving the studio to London from Denham, the partnership failed. Nicholson returned to his woodcuts, but met similar resistance and financial difficulties. In 1897 *The New Review* published his diamond jubilee woodcut of Queen Victoria. It has been likened to a tea-cosy on wheels – the representation of the Queen as a rotund old lady caused a sensation. It was followed by six more portrait woodcuts that were published as lithographs by *The New Review*, including as subjects Sarah Bernhardt, James McNeill Whistler and Rudyard Kipling. In 1899 he added five more, creating the series *Twelve Portraits* which on the instigation of Whistler was published by Heinemann, and proceeded to win Nicholson the Gold Medal at the 1900 Exposition Universelle in Paris. About the turn of the century, he would produce a hundred woodcuts for titles such as *London Types*, *An Alphabet* and *The Square Book of Animals*. Each page bore a type, an animal or a letter such as *Barmaid-Any Bar* or *The Friendly Hen*. *A is for Artist* featured a self-portrait, whilst *B is for Beggar* contained a portrait of Nicholson's brother-in-law.

Although successful in this field, Nicholson had turned to painting by 1902. Initially he worked exclusively on landscapes and still lifes, but he lived more comfortably from painting portraits, which would also earn him immense fame and a knighthood in 1936. Winston Churchill and Max Beerbohm were just two of his more famous clients; in all he painted two hundred portraits. His later career would be devoted to Wiltshire landscapes and still lifes. Whereas Nicholson uses black extensively in his portraits, his still lifes and landscapes are often exercises in the whites of snow, silk, silverware and chrysanthemums.

FREDERIC LEIGHTON *1830–96*

FLAMING JUNE, EXHIB. 1895

Museo de Arte, Ponce, Puerto Rico, West Indies / Courtesy of the Bridgeman Art Library

IN 1859 Whistler and Leighton independently settled in London after long forays on the Continent. The two artists were leading members of the Aesthetic movement, with its emphasis on the formal over the narrative and on the greater importance of decorative abstraction over didactic painterly qualities or moral teaching. The writings of Walter Pater were influential in distancing art from the observation of nature and bringing it closer to music as the abstract expression of beauty. The female model was predominant in the art of Leighton, Whistler, Burne-Jones and Albert Moore during the 1860s as the embodiment of beauty for its own sake – paramount were the cultivation of beauty and the notion of the unified nature of colour and form, encompassing both the canvas and the frame as a single unit.

The revival of the classical ideal in the 1860s saw Leighton increasingly painting ancient Greek subjects, as would Alma-Tadema and Edward Poynter, no doubt influenced by the recent restoration and redisplay of the Elgin Marbles in London. The revival differed from the neoclassicism of the early nineteenth century: Greek art was upheld as the expression of harmony, and beauty in repose, free from the restrictive demands of historical narrative. Leighton's grand historical subjects brought him fame early on in his career but *Mother and Child* (also called 'Cherries', 1864–5) is an early example of his sensitivity to colour and mood. The figure of the mother derives from classical examples but the setting is more concerned with the aesthetics of line and shape set against a Japanese screen. Japanese art had been a recent discovery for Western artists, following the exhibition of a private collection of Japanese decorative art in London in 1862 that resulted in an additional emphasis on decorative surface pattern and simplified outline. Elected President of the Royal Academy in 1878, Leighton was granted a barony in 1896.

There is a total absence of narrative in *Flaming June*. Instead, the viewer glories in the rippling cascades of the drapery and colour and follows the horizontal planes up from the subject's feet to the view of the sea and the distant mountains. The sky is heavy with heat, but an awning stretched over the sleeping beauty lends a soft quality of light. A sense of monumentality is achieved by reducing the peripheral areas of composition – the only interruption to the horizontal, frieze-like planes is the red pole of the awning and the vase of oleander flowers. Oleander is poisonous: here Leighton introduces to sleep the notion of death.

PHILIP WILSON STEER *1860–1942*

BOULOGNE SANDS 1888–91

Courtesy of the Tate Gallery, London

STEER was born in Birkenhead, into an artistic family. His father, after whom he was named, was a local portraitist, and he encouraged his son in the art of drawing and painting. After attending Gloucester Art School, in 1882 Steer went to study in Paris. He would remain there for two years, until the introduction of a French language exam curtailed his stay at the École des Beaux-Arts, although his visits to France, including Brittany, continued until the early 1890s. Back in London, along with Walter Sickert, Henry Tonks and Fred Brown, Steer represented the 'Impressionist' clique of the New English Art Club, of which he was a founder member in 1886. The club was set up in an attempt to provide an alternative exhibiting platform to the conservative Royal Academy, and was predominantly naturalistic in outlook, its more conservative side represented by the Newlyn School. In 1889 the NEAC held an Impressionist exhibition at the Goupil Gallery, London, to the catalogue of which Sickert wrote an unsigned preface. Steer taught at the Slade School of Fine Art, the Francophile rival to the more conservative Royal Academy Schools, from 1899 to 1930 alongside Tonks. He was awarded the Order of Merit in 1931; a commemorative slab to the artist can be found in the crypt of St Paul's Cathedral.

Although called Impressionist, the British version did not show strong links with the French. Steer himself, despite his stay in Paris, seems not to have come into personal contact with Monet, Pissarro or Renoir – the influence was in generalities rather than specifics. In tune with developments in France, shadows were expressed in terms of colour rather than tone, and studies were made out of doors at the same time of day in order to replicate the same light conditions, however short-lasting. Similarly, there is little evidence that the work of Constable or Turner directly influenced Pissarro, Monet or Renoir. The work of British landscape artists was known in France, but the scientific curiosity that led Constable to study cloud formation or Ruskin to insist on rigorous naturalism had its own French counterparts. Articles in scientific and other journals reported on the latest discoveries in optical research, and Eugène Chevreul reported his findings on colour harmonies, the significance of the distance from which adjacent colours are viewed, and complementary colours (the primary colours and their strongest contrasting colours). When placed side by side the resonance of both the primary colour and its complement was found to be all the more intense.

The NEAC would subsequently become a byword for conservatism, and Steer's later work reverted to Edwardian elegance and smoothly painted surfaces, as in *The End of the Chapter* (1911). *Boulogne Sands* is one of a series of paintings completed in the late 1880s to early 1890s that were remarkably vivid and luminous.

KATE GREENAWAY *1846–1901*

TELL TALE TIT 1890

Courtesy of Image Select

THE Victorian period saw a sharp increase in the production of illustrated books, from cheap novels published in instalments to finely bound gift books. The population of England and Wales nearly tripled during Victoria's reign, and literacy rates improved through the establishment of working men's clubs and the power of sizeable town councils to levy a rate that was put towards libraries. This led to many periodicals being founded, such as Charles Knight's educational *Penny Magazine*, literary journals, and improving publications such as *Once a Week* and *Good Words*. Cheap paper and increasing mechanisation helped meet the demand for books and magazines from an increasingly middle-class population whose chief concern was self-improvement. Toy books first appeared in the mid-nineteenth century and consisted of six or eight square pages of coloured illustrations, sometimes with a few lines of text. The covers were made of paper and the price was low. As the process of colour printing became more efficient, the quality and availability of toy books increased. Edmund Evans, who had set up his own printing and publishing office in 1851, found that good toy books, if printed in sufficient quantities, could be commercially successful. He set about commissioning his own series of high-quality children's picture books.

Kate Greenaway was the most famous and most successful children's book illustrator of her day. The daughter of a Fleet Street engraver, she trained in London and produced her first commercial work, illustrations for Christmas and Valentine's Day cards, in 1868. When a book of her drawings was shown to Edmund Evans, he commissioned *Under the Window*, which sold a phenomenal 70,000 copies in English and was translated into French and German.

Her pictures of children clad in Regency-style costume, placed in idyllic rural locations, established a fashion in children's book illustration. In tune with the Idyllists' otherworldly landscapes and the Aesthetes' absence of narrative, she presented the realm of childhood as innocent and full of charm. There is rarely much narrative in Greenaway's illustrations, and she often left much of the page blank, giving a sense of space. She drew from models dressed in clothes she had made herself, copied from late-eighteenth-century bonnets and smocks, high-waisted dresses and jackets. *Tell Tale Tit* is an illustration for a book of nursery rhymes published in 1890. Greenaway sustained a long correspondence with the critic John Ruskin, who enjoyed her work. Her most successful publications, which include *The Birthday Book for Children* and *Mother Goose*, allowed her to have a house built in Hampstead in 1885.

Tell Tale Tit,
Your tongue shall be slit;
And all the dogs in the town
Shall have a little bit.

AUBREY BEARDSLEY *1872–98*

THE BLACK CAPE 1894

British Museum, London/Courtesy of the Bridgeman Art Library

BEARDSLEY had little formal training but, encouraged first by his artistic mother, who brought him up in Brighton, he developed his own distinctive style of black and white line drawing. In 1889 he became a clerk for the Guardian Life and Fire Insurance Company in London, but he had to leave after a year because of the onset of the tuberculosis that would ultimately kill him. In 1891 Beardsley called on Edward Burne-Jones, whom he referred to as the greatest living artist in Europe, and showed him his drawings, of which Burne-Jones was to be an early admirer.

Beardsley had discovered Whistler and Japanese prints, and these influences he conflated to create compositions that were austerely organised but vividly evocative. *Le Débris d'un Poète* (1892) is almost certainly a self-portrait. Extenuated in form, the figure's back speaks volumes. Beardsley's first successful project was a commission from the publisher J. M. Dent for a series of illustrations for Malory's edition of *Morte d'Arthur*. Published in monthly parts, it was completed in 1894. Burne-Jones was bitterly disappointed by the sloppiness of some of Beardsley's illustrations, and by the overt sexuality in others. Beardsley, in his turn, rejected all that the Aesthetes had held dear and abandoned medieval subject matter. His next commission was for seventeen illustrations for the English edition of Oscar Wilde's *Salomé*, of which *The Black Cape* is one. These drawings were reproduced by a cheap line-block technique, in direct and conscious contrast to the rarefied nature of William Morris's Kelmscott Press handmade books. But Beardsley's work reached a wider audience, and he became well known through the publication of his illustrations in magazines.

In 1894 Beardsley became the editor of a new quarterly literary and artistic magazine, *The Yellow Book*, which intended to provide a forum for all artists and writers outside the mainstream. With its connotations of cheap French novels and the ancient Chinese equivalent of the *Joy of Sex*, Beardsley's magazine quickly drew fire with its provocative sexual and social stance. His association with Oscar Wilde forced him to flee England temporarily in 1895 at the time of Wilde's trial for indecency. On his return he started another short-lived magazine, *The Savoy*, which published contributions from George Bernard Shaw, W. B. Yeats, Max Beerbohm and Havelock Ellis. Beardsley died young, but his output – some pornographic – was prolific, and his use of line strongly influenced the Art Nouveau current. His mature style had absorbed strains of French Rococo, which he evolved into a personal sense of the grotesque, and his drawings to illustrate Aristophanes' *Lysistrata* (1896) suggest the possible influence of ancient Greek vase painting.

BEATRIX POTTER *1866–1943*

THE TAILOR MOUSE C. 1902

By kind permission of Frederick Warne & Co.

HELEN Beatrix Potter was born into a comfortable existence. Her father was a photography enthusiast and friendly with Millais: Potter would later admit the influence of the Pre-Raphaelites in her handling of detail and her meticulous precision. Throughout what has been described as a lonely childhood, Beatrix Potter trained her eye in avid observation. Botany and the study of fungi were early enthusiasms, and she spent her twenties and thirties making systematic studies of mosses and lichens, as well as of Roman antiquities. Time spent in the Lake District produced microscopic studies of butterfly wings and beetles, and if her circumstances had been different it is possible that she would have become an eminent scientist.

As with Lewis Carroll, who wrote *Alice in Wonderland* as an expansion on the stories he told the Liddell children, Beatrix Potter's tales grew out of the picture-letters she sent to her ex-governess's children, based on her observations of her pet animals. *The Tale of Peter Rabbit* was first published privately in 1901, and the 42 pen-and-ink illustrations were in black and white. She had offered the manuscript to a number of publishers, and Frederick Warne accepted it, with some changes. The illustrations were to be in colour and reduced in number to 30, plus a frontispiece. Some of the text was removed and used for a later story, *The Tale of Benjamin Bunny* (1904).

As was to be expected from one so interested in detail and process, Beatrix Potter became closely involved in the printing of her book and was the first to suggest the use of a then innovative colour reproduction technique. The first commercial copy appeared in 1902, and 6,000 copies were printed by Edmund Evans. As much as Kate Greenaway's illustrations were of a Never Never Land, Potter's were the results of meticulous study of her domestic animals. The period costume of *The Tailor of Gloucester* derived from pieces of eighteenth-century clothing she studied in the Victoria and Albert Museum's collection. Her studies of her surroundings, from the furniture in her house to the plant life, all provided her with the natural accuracy of her illustrations. The text was of a mildly cautionary nature, at times sentimental, at others suggestive of violence. The success and financial independence that her subsequent books, published by Frederick Warne, brought led to the purchase of Hill Top Farm in Cumbria, and from the 1930s she devoted herself to sheep-farming.

Walter Richard Sickert *1860–1942*

La Hollandaise c. 1906

Courtesy of the Tate Gallery, London

ANOTHER leading light of the New English Art Club Impressionist clique, Sickert, like so many of British painting's successes, was born elsewhere – in Munich, to an Anglo-Irish mother and a Danish father. His family moved to London from Dieppe in 1868 and was friendly with William Morris, Edward Burne-Jones and Oscar Wilde.

After studies at King's College, London, and a failed attempt at an acting career, Sickert briefly attended the Slade School of Fine Art in 1881, ten years after its opening, before becoming an assistant to Whistler. A visit to Paris in 1883 led to an introduction to Edgar Degas (1834–1917), of whose work Sickert became a fervent admirer. As Whistler's assistant, Sickert had worked from nature, but as his admiration for Degas supplanted that for the American painter, he emulated him in both subject matter and technique. Sickert chose to paint London's unsalubrious music-halls and the world of the stage, brilliantly conjuring the dimmed lights, the excitement and the heckling from the gods – in sharp contrast to accepted behaviour and to the genteel and picturesque civility of the NEAC, which he joined in 1887–8. He worked up his paintings in the studio from sketches and memory, in direct contradiction to Whistler's teaching, but his insistence on any subject matter, however ordinary, as ripe for painting was in effect an extension of Whistler's Aesthetic sympathies. From 1895 he wintered in Venice, and his architectural studies and cityscapes began to emerge around 1900.

The years 1899–1905 saw Sickert living in Dieppe; on returning to London, his earlier subject matter of music-halls and the stage was replaced by models in 'real' working-class situations. This is commonly known as his 'Camden Town period', named after an exhibiting society he initiated in 1911 to rival the New English Art Club. Pictures of the female nude were only one aspect of this period, when Sickert was also painting many indoor domestic scenes, usually of a man and a woman. Works such as *Ennui, Off to the Pub* (1912) and *Sunday Afternoon* (1912–13) caught fleeting moments of domestic existence, and often the titles of his paintings recall lines from popular songs heard in the music-halls. *La Hollandaise* is full of ambiguities: it could be dawn or dusk and she could be settling or rising. Although there is a suggestion of event or narrative, the moment is suspended as the light falls on her left thigh, arm and breast, casting the rest of her in sharp relief against the pillow. Although her features are not clearly defined, she emits a strong sense of character as she reclines on the bed. The viewer is forced into an uncompromising appraisal of this 'Dutch girl', and it is the conscious presentation of the female nude as something other than idealised beauty that would cause its audience difficulties.

DAME LAURA KNIGHT *1877–1970*

THE BEACH 1908

Laing Art Gallery, Newcastle upon Tyne / Courtesy of the Bridgeman Art Library

LAURA Knight attended Nottingham College of Art from 1889, then proceeded to teach art professionally. From 1903 she exhibited regularly at the RA and married Harold Knight, also a painter, in the same year. They spent their early married days living in artistic communities in Yorkshire, the Netherlands, and later with the Newlyn group in Cornwall. Laura Knight's reputation was founded on paintings of the ballet and the circus that were narrative and realist in style, and characterised by bright colours. She painted backstage during Diaghilev's ballet season in London, and even went to the lengths of taking lessons at Tiller's Dancing Academy where she also drew. As with the Newlyn School this was the community in which she would immerse herself in order to paint faithfully. In the same spirit she travelled with the Mills and Carmos Circus, and in the 1930s started a series of paintings of horses and gypsies, for example *Gypsy* (1938–9).

In *The Beach* the painter's concern is the effects of sunshine and wind. However, her concern is with light and atmosphere as naturalistic elements rather than as the subject of a methodical enquiry into their nature. Like the work of Clausen and that of the more conservative members of the New English Art Club, this is an example of English Impressionism, as acceptable to the Royal Academy as it was to the more traditional elements of the NEAC.

Knight was the most successful female painter of her generation, and in 1936 only the third female to be elected to the Royal Academy, after Mary Moser and Angelica Kauffmann. Although her most popular paintings at the time were of the circus and the theatre, it is her Cornwall landscapes, in the vein of the Newlyn School, that are favoured now. Knight was an official war artist in the Second World War, and in 1946 she went to Nuremberg to record the War Crimes Tribunal; her subsequent sketches and paintings are in the Imperial War Museum.

SIR LAWRENCE ALMA-TADEMA *1836–1912*

A FAVOURITE CUSTOM 1909

Courtesy of the Tate Gallery, London

WHAT is so interesting about this painting is that it is contemporaneous with Sickert's *La Hollandaise* and yet it could be a product of the mid-nineteenth century, titillation its middle name. The setting is classical, the place the ladies' bath-house. The attention to verisimilitude is evident in the marble flooring and benches, the floor mosaics and tiling, the frieze on the back wall and the vaulted roof. Alma-Tadema was an amateur archaeologist, and possessed a large collection of photographs of archaeological remains, along with his drawings of sites. The scene allows ample depiction of the female nude from various viewpoints and in different stages of undress, as the eye proceeds from the half-curtained-off entrance down to the submerged naked bathers, via the dark-haired lady to the right, who is either removing or replacing her robe.

Alma-Tadema was Dutch by birth, and trained in Belgium before settling in London in 1870 and assuming British citizenship in 1873. His work was immensely popular in the late Victorian period. Knighted in 1899, he received the Order of Merit in 1905. In 1852 he had attended the Antwerp Academy and subsequently developed his taste for historical themes whilst working on the frescoes of Antwerp Town Hall as the assistant to Baron Henri Loy. Alma-Tadema's paintings of this period show a use of sombre colours and overtones of North Europe's Dark Ages. In 1863, his travels to Pompeii turned his attention to the ancient world, and he painted a series of classical subjects set in detailed interiors and rich in deep 'Pompeian' colours. By 1870, his reputation in Britain was founded on paintings such as *Phidias and the Parthenon* (1868) in which he combined an interest in the life of the past, in its human aspects, with accurate settings culled from his study of archaeology.

Success came quickly, and he was elected a member of the RA by 1879. The palette of his pictures lightened markedly in the 1890s, the settings became more generalised, and hints of narrative and of the mildly erotic crept into his work. *Unconscious Rivals* (1893) shows two richly dressed young women on a balcony overlooking the sea. The vaulted ceiling suggests a wealthy Roman villa on the coast, the title a narrative of desire, confirmed by the marble statue of Cupid and the languid posture of the women as they gaze over the balcony. To the right, the feet of a statue, based on the *Seated Gladiator* in the Lateran Museum, Rome, suggests that the object of these ladies' affections, according to the custom amongst wealthy Romans, was a suitably virile young gladiator.

SPENCER GORE *1878–1914*

THE CINDER PATH 1912

Courtesy of the Tate Gallery, London

GORE was at the core of Sickert's Camden Town Group, of which he was President. He had met Walter Sickert in Dieppe in 1904, having trained at the Slade from 1896 to 1899, where he became friendly with another future Camden Town Group member, Wyndham Lewis. The Francophile nature of British art during the radical years of the NEAC had given way by the 1890s to an isolation that would last until 1905. Gore and some of his contemporaries began to look to France again at around this time. As with many artists' groupings, their styles varied enormously, but in choice of subject matter Gore was not dissimilar to Sickert, painting figures in interiors as well as window views of Camden Town and theatrical performances such as *Rule Britannia* (1910). But unlike Sickert, it was not the audience that interested Gore so much as the performers and the stage spectacle. Between 1905 and 1911 he frequently painted the Alhambra Theatre in London's Leicester Square; *Rule Britannia* features a scene from the ballet *Our Flag* which was performed there on 20 December 1909. The emphasis is on the backdrop which has been built up into a concentrated mosaic pattern of colour, blue, green and pink applied in separate brushstrokes and harshly lit by the stage lights.

Roger Fry organised the first exhibition in London of the French Post-Impressionists, works by Cézanne, Gauguin and van Gogh in 1910, and another in 1912/13 which included work by Matisse and Picasso. The effect of these exhibitions was to encourage the British artist to experiment with form and colour and bold painting techniques. Whilst the Impressionists produced visual accounts of passing moments and perfected the technique of painting outdoors, the Post-Impressionists moved away from Impressionism with their emphasis on formal means of painting which would eventually lead to experiments with abstraction.

The Cinder Path was painted while Gore and his wife were guests of Harold Gilman, a fellow member of the Fitzroy Street and Camden Town coterie, at Letchworth. The vivid, unusual use of colour and the geometric blocking of tree shapes and clouds suggest an interest in going beyond naturalistic landscape painting, with objects defined by colour rather than tone. Gore's experimentation with colour was far-reaching. His use of undiluted pigment and touches of pure colour in *Harold Gilman's House, Letchworth* (1912) expresses a desire to respond conceptually rather than simply to record the appearance of the form in the landscape.

HENRY LAMB *1883–1960*

LYTTON STRACHEY 1914

Courtesy of the Tate Gallery, London

THIS is a large canvas, reminiscent of the English tradition of portraiture of Gainsborough and Reynolds. The viewer is struck by the mournful, elongated expression of the sitter, the biographer Lytton Strachey. Verticals and horizontals dominate the portrait, the crossing of the window panes echoed in the patterned cloth draped over the wicker chair, itself a series of crosses and squares. The verticals of the window frame are complemented by the umbrella, the chair legs and the fence seen outside. Tension is rife between the flatness of the window and the curving path. The crisscrossing of lines in the curve of the chair-back, the tree trunk beyond and the furled umbrella reveals a delight in the observation of line. The only thing that draws the sitter into centre stage is the length of his elegant legs, almost perpendicular to the floorboards and bent on a pronounced diagonal.

Lamb was born in Adelaide, Australia, and attended the Chelsea Art School in London until 1907. He moved to Paris in 1908 where he enrolled in art school, and he worked for several months in Brittany from 1908 to 1911. In *Breton Cowherd* (1910) Lamb painted a cowherd seated in the shade in the open countryside, with one of his cattle in the background. The landscape is flattened and translated into essential components of line and colour. In *Death of a Peasant* (1911) he evokes the bitter tenderness of the deathbed scene, abolishing peripheral detail to better close in on the scene; the dead woman's triangular face is sharp and sunken, contrasting with the serried semicircle of her grieving relatives.

As well as the New English Art Club, Lamb was closely associated with the Bloomsbury Group and its emphasis on the formal values in art over and above subject matter. The group consisted of influential figures in the arts – Vanessa Bell, Virginia Woolf, Lytton Strachey, Duncan Grant, Clive Bell and Roger Fry. Clive Bell, husband of Vanessa and brother-in-law of Woolf, coined the phrase 'significant form' to encapsulate what the Bloomsbury Group believed to be the essence of art. Painting was to be understood in terms of forms and the relationships of forms to each other: the narrative or subject of a painting was secondary to its formal properties.

SIR STANLEY SPENCER *1891–1959*

CHRIST CARRYING THE CROSS 1920

Courtesy of the Tate Gallery, London

RAISED in Cookham, Berkshire, a village to which he would remain deeply attached all his life, Spencer studied at the Slade from 1908 to 1912, while still living at Cookham, which had taken on paradisical properties for him. The First World War interrupted this homely existence; Spencer served first at the Beaufort War Hospital in Bristol, and subsequently as an official war artist in Macedonia.

In his work, Spencer linked the everyday and events in his own life with the mystical. A little girl peeping over the fence sees the biblical story of Zacharias and Elizabeth enacted (*Zacharias and Elizabeth*, 1913–14), and the site of *The Christian Resurrection* is the local churchyard in Cookham. *The Resurrection, Cookham* (1924–7) is perhaps his most famous work and in it he combines infinite painstaking detail with a marked freedom of form. Christ sits in the doorway to the church with children in his arms. God leans over the back of Christ's throne and a row of prophets, including Moses with the Ten Commandments, are seen along the side of the church. Figures rise from their graves and the picture contains many autobiographical references – his new wife Hilda Carline appears three times.

The return to traditional representation that swept the British art scene after the war was a climate in which Stanley Spencer flourished. The setting of *Christ Carrying the Cross* is recognisably English and simultaneously rife with references to Spencer's own life. The red-brick house is 'Fernlea', in which Spencer was born, and the ivy-clad cottage, 'The Nest', belonged to his grandmother. The railings swell into shields and spears, and the ladders recall the Cross as they intersect. People lean out of their windows, their shapes distorted – a precursor, perhaps, of the excessive distortion in his work which would alienate the critics in the 1930s. Traditionally, in Christian art since the Middle Ages, this event in Christ's life is portrayed with a sense of mourning, but Spencer has filled the scene with sunlight and vital energy. For him, Christ's life and death were to be celebrated and his crucifixion had, in Spencer's mind, given dignity and worth to human life and deeds, which goes some way to explaining why he saw the everyday as special and sacred. Christ is just visible in the background carrying the Cross and followed by carpenters carrying ladders, who were modelled on employees of the local building firm. Spencer was adamant that the title should be *Christ Carrying the Cross* and not *Christ Bearing a Cross*. Not only was there only one Cross, but Spencer wished to convey his own sense of joy in the crucifixion; instead of being a burden to bear, it was Christ's sole and unregrettable purpose.

CHARLES GINNER *1878–1952*

PLYMOUTH PIER FROM THE HOE 1923

City of Plymouth Museums & Art Gallery

BORN in Cannes, Ginner worked in an architect's studio in Paris from 1899 to 1904 before training as a painter with the Spaniard Anglada y Camarasa and at the École des Beaux-Arts. He worked first as a magazine illustrator, in the manner of Beardsley, then settled in London at the encouragement of Sickert in 1910. He became a key figure in the Camden Town Group, which he joined when it began in 1911. He had learnt in Paris to use thickly encrusted oil paint and this would remain his hallmark: a limerick of the time began: 'There was a young artist called Ginner/Who never used any thinner.' His earliest surviving oil painting, *Tache Décorative – Tulipes* (1908), combines the use of rich impasto with swirling brilliant colour, and his mature style would retain loaded paint applied with greater control and characterised by small, tight deposits and a strong sense of pattern, as if creating a mosaic. Sharp high tones were contained in a dense network of brushstrokes of various sizes, as seen in *Victoria Station, the Sunlit Square* (1913).

By 1914 he and Harold Gilman, another member, had begun to distance themselves from the group. Calling themselves Neo-Realists, they looked for patterns and shapes in their surroundings and embarked on a plastic interpretation of life, whilst maintaining the possibility of decorativeness. Shapes relating to reality that provoked emotional responses were encouraged, naturalism condemned as dull and lacking in personal vision. In *The Fruit Stall* (1914) Ginner made a study of lines and circles, playing off the uprights of the packing cases, the ovals of the barrels, the roundness of the fruit and the market stall awnings gathered like sails. He was an enthusiast for van Gogh's work, and his paintings depended on strict contours and sections of closely related tones. He usually painted conventionally unattractive urban structures, including the unpopular Albert Memorial and a cityscape of Leeds canal, to which he gave a sense of solidity and resonance through his ordered brushstrokes.

In *Snow in Bloomsbury* (1929) Ginner created an elaborate system of reflected light. The warm browns and ochres are balanced by the softening greys and blues, and the combination of strong recessionals and upright format makes the experience of the work intense and direct. The thickness of the paint is overwhelming, with trails of snow atop bare dark tree branches that crawl across the ochre-grey of the brick buildings behind. The logical structure is clear and the texture is such that the scene appears to the imagination as it would to the eye in reality: the vividness of nature – reality, not the illusion of representation – runs through Ginner's work.

After serving in the First World War he joined the NEAC in 1920, and was an official war artist in the Second World War. He became an associate of the RA in 1942, a member of the Royal Watercolour Society in 1945, and was awarded a CBE in 1950.

PAUL NASH *1889–1946*

TOTES MEER (DEAD SEA) 1940–41

Courtesy of the Tate Gallery, London

NASH was born in London, but his mother's illness encouraged the family to move to Iver Heath in Buckinghamshire. His first artistic training was in the graphic arts, as a book illustrator and engraver in the vein of Blake, Rossetti and Beardsley. He attended the Slade School of Fine Art before the outbreak of the First World War, and developed an intense visionary style of landscape painting which looked back to Samuel Palmer (see page 128) but also anticipated the Surrealist influence of the 1920s and early 1930s. His early work consisted of landscape drawings and watercolours in which traditional form combined with imagination.

Nash experienced the devastation of the First World War in terms of the landscape, while artists such as Mark Gertler (1891–1939) expressed the futility and pessimism in terms of the machine age where figures are locked into a perpetual spin, as in *Merry-Go-Round* (1916). Nash was wounded but returned to the front as a war artist; *We Are Making a New World* (1918) dates from the end of the war and is both bitterly ironic and achingly wistful.

The aftermath of war saw many artists, including those most closely associated with Futurism and Vorticism, returning to the landscape: Nash had never left it. In the 1920s and 1930s, he combined his love of landscape with an interest in the international vogue for abstraction and Surrealism. In his immediate postwar paintings of the coast at Dymchurch, the conflictual point where land and sea meet is the subject of *The Shore* (1923), whilst in *Harbour and Room* (1932–6) he blurs the border between interior and exterior. Unit One, a short-lived group established in 1934 by Nash with Henry Moore, Ben Nicholson and Barbara Hepworth, embraced abstraction and structural design, only to founder as Nash moved towards Surrealism. With Graham Sutherland he absorbed Surrealism into the British landscape tradition, uncovering associative meanings in landscape and a heightened sense of presence. Nash was again an official war artist during the Second World War, and further explored the tension between the natural and industrial worlds and the fusion between object and imagination. In *Totes Meer (Dead Sea)* a pile of smashed German aircraft in a field near Cowley, Oxfordshire, suggests the crashing moonlit sea: the sustained imaginative effort of Nash's work gives it a quality of quiet intensity.

JOHN NASH *1893–1977*

THE CORNFIELD 1918

Courtesy of the Tate Gallery, London

JOHN Nash spent the first half of his life in Buckinghamshire, and the latter part in the Stour valley. He had little formal artistic training and taught himself to paint, as he did music and botany. He and his elder brother Paul held their first joint exhibition in London in 1913 and became overnight successes, invited to join the Camden Town Group and the London Group. He fought in the First World War, then was demobbed in 1918 and appointed an official war artist, as he would be again in the Second World War. A series of his war art is in the Imperial War Museum; probably his most famous pieces are *Oppy Wood*, painted in the same year as *The Cornfield*, and *Over the Top* (also 1918), depicting a wintry landscape as the 1st Artists' Rifles clamber out of the trenches. After the war he returned to Buckinghamshire with his wife Christine Khulenthal, then taught first at the Ruskin School of Art (1924–9) and from 1934 to 1957 at the Royal College of Art. Like his brother he illustrated a number of publications, and was a founder member of the Society of Wood Engravers, with whom he exhibited from 1920 to 1935. The society was formed to raise the status of wood engraving to that of other graphic arts, and provided a forum for debate about the techniques and destinations of wood engravings – to hang on the wall or to reproduce in books. The English Wood Engraving Society, a less book-minded breakaway organisation, was formed in 1925.

In his landscapes, both oils and watercolour, Nash's colour, texture and pattern combine to create a vivid representation of something seen and something experienced. *Gloucestershire Landscape* (1914) announces something of the spirit that he achieves in *The Cornfield*, a sense of calm plenitude and mellow light at the end of the war. The structure of the landscape imitates that of the stacks, a shaft of light diagonally crosses the arc of the field, and the sensation of rising and falling arches is reiterated throughout the landscape. The two stacks on the left of the picture create a V shape, encouraging the eye to travel up the path seen in the distance into the melting afternoon light in the sky and the hills behind. A landscape artist and magnificent illustrator, Nash made a number of cartoons, outwardly gentle spoofs on everyday life such as *A Game of Croquet* (1913). He also painted exquisite botanical watercolours and wood engravings for publications such as *Poisonous Plants – Deadly, Dangerous and Suspect* (1927), and the *Shell Buckinghamshire Guide*, published in 1937. His books on plants and the natural world include *Wild Flowers of Britain* and, for Duckworth in 1948, *English Garden Flowers*. Nash was awarded the CBE in 1964.

EDWARD MCKNIGHT KAUFFER *1890–1954*

EARLY BIRD 1918–19

Victoria & Albert Museum, London

KAUFFER came to London, via Paris, from the USA in 1914, where he had studied at the Art Institute of Chicago and in San Francisco. He became a top poster and graphic designer; and his clients included London Underground Railways, Shell UK Ltd, the *Daily Herald* and British Petroleum. Influenced by the Japanese eye for surface line and decoration, Kauffer also leaned towards Vorticism, with its fascination with technology and speed, and joined Group X as a founder member with Wyndham Lewis in 1920. During the time he spent living in Britain, he produced 250 posters as well as doing other types of freelance design work and paintings; Paul Nash credited him with radically changing attitudes to commercial art in Britain in a way that was crucial to the development of the twentieth-century poster. Publicity and advertising had burgeoned at the turn of the century: McKnight Kauffer, the Beggarstaffs (see page 156) and others largely credited Toulouse-Lautrec with the evolution of entertainment poster design.

This poster for the *Daily Herald* was one of Kauffer's most acclaimed designs, produced in the aftermath of the First World War. He was also a book illustrator – he illustrated T. S. Eliot's *Ariel Poems* in the late 1920s – as well as designing theatre and ballet costumes and sets for various London productions. In 1940, Kauffer returned to the USA, where he designed posters for war relief agencies, the UN and American Airlines, as well as maintaining his interest in book illustration.

In the aftermath of the First World War, direct methods of government propaganda such as 'What did you do in the Great War, Daddy?' were considered as approaches to be avoided – 'propaganda' had become a dirty word. The Empire Marketing Board commissioned a series of posters from McKnight Kauffer, the Nash brothers, Clare Leighton and Mark Gertler to promote the foodstuffs and produce of the Empire and, by extension, imperialism itself. Clive Gardiner designed *Motor Manufacturing* as part of a six-part series with the theme of 'Empire Buying Makes Busy Factories'.

Frank Pick of the London Underground Railways was instrumental in early moves towards combining art with commerce – it was his enthusiasm for design that led to the commissioning of McKnight Kauffer. In the 1930s Kauffer's most modernist work was completed for BP. In *BP Ethyl Controls Horse-Power* (1933) he employed photomontage – using his own photograph of a statue of horses in the Place de la Concorde – dynamic rectangles and asymmetrical lettering to emphasize power and movement. Touring exhibitions of the Victoria and Albert Museum collection of posters, after his return to the USA, included much of his work, held up as examples of graphic art and design.

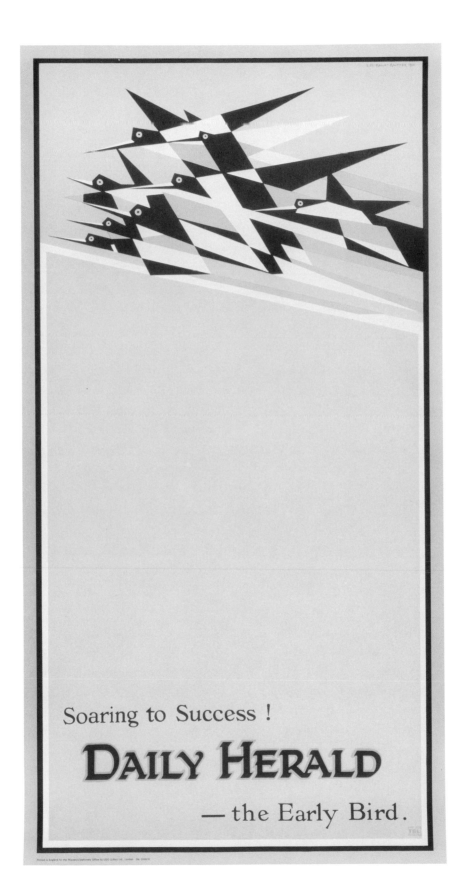

HENRY MOORE *1898–1986*

MAQUETTE FOR FAMILY GROUP 1944

Courtesy of the Tate Gallery, London

THE son of a Yorkshire coalmining engineer, after serving in the First World War, Moore studied at Leeds School of Art and the Royal College in London, where he would also teach. He rejected the classical sculpture inheritance with its canon of beauty and representation, choosing instead to raid the British Museum collection of Pre-Columbian, Etruscan, Sumerian, Egyptian and ancient Greek sculpture. Like Nicholson, Hepworth, Piper and others, from 1930 Moore was a member of the Seven and Five Society – so called because it originally had seven painters and five sculptors as members – and was part of its drive towards abstract art. He was also involved in Unit One with Paul Nash and the British Surrealist movement, exhibiting with them in 1936 and in Amsterdam in 1938. Distancing themselves from the illusion of representation was a prime concern of the British avant-garde in painting, in response to international influence. In sculpture this translated into an emphasis on the material and a push towards responding directly to the texture and density of the stone, rather than falsifying it to give the illusion of the human figure, as seen in Rodin's sculpture, where fingers press marble as if it were flesh.

Although Moore experimented with semi-geometrical forms and abstraction, his recurrent form has been human. The reclining figure is one of the most important themes in his sculpture; and he emphasised the kinship between landscape and the female form, which he repeatedly sculpted in a variety of stones and metals throughout his life. He is most widely known for his *Shelter Sketchbooks*, created in 1940–42 when he was an official war artist. Poignant drawings of people sheltering in Underground stations during air-raids, and miners working at the coalface as part of the war effort, combine in a commentary on the dignity and suffering of humanity. He also represented Britain at the 1948 Venice Biennale, where he won the international sculpture prize.

Early on, Moore underlined the importance of carving without resorting to preparatory maquettes, as a means of engaging directly with the material, its density and texture; but later in his career modelling took precedence, and he produced more angular, elongated forms as if in response to postwar emotional fragility and economic austerity. The male form makes few appearances in Moore's sculpture, but this family group is a trinity. Mother and father sit side by side with their child in their midst, a cloth draped over their knees in the manner of archaic Greek drapery.

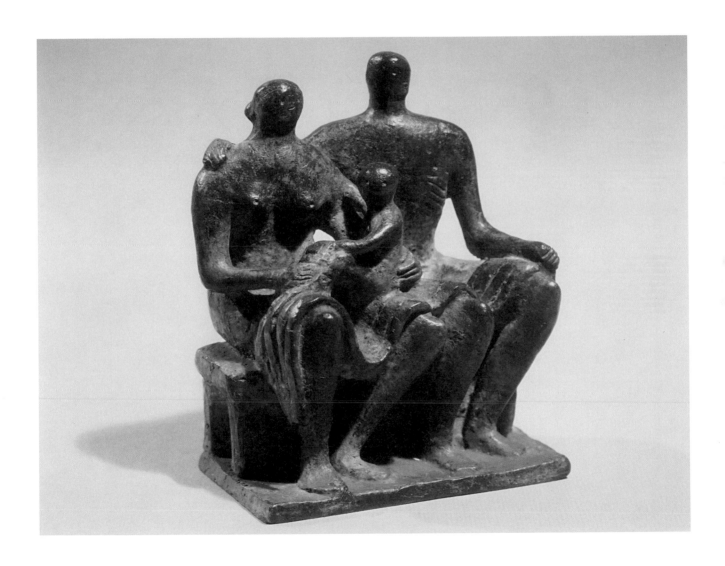

HENRY MOORE *1898–1986*

RECLINING FIGURE 1951

Courtesy of the Tate Gallery, London

THE Arts Council of Great Britain commissioned a number of works from contemporary artists in 1951 for the Festival of Britain, a government initiative to stimulate national optimism after the Second World War. This is the plaster mould from which Moore cast his bronze sculpture, the string creating grooves and lines in the bronze. Other sculptors invited to submit work for the site on the South Bank were Epstein, Hepworth, Lynn Chadwick, Reg Butler and Eduardo Paolozzi.

Moore had been experimenting with the recumbent form, first separating it into individual components of organic shapes. His early works had provoked mixed reactions as they appeared to distort human, and specifically female, form. His *Reclining Figure* of 1929, in which he fused body and terrain, conveying hills and valleys in the female mass, rebutted classical tradition. In the 1930s he took this further, reducing the female body to shapes associated with pebbles, bones, cliffs and caves. In *Four-Piece Composition: Reclining Figure* (1934) the pieces suggest a bent leg and a head as well as elements of landscape – again, human and territory merge. *Composition* (1931) is also made out of Cumberland alabaster, a material quarried in the area since the Middle Ages. Grooved lines suggest fingers, two circular dug-outs the eyes. The form is one undulating motherly mass, expressing vitality and the fertile power seen in Cycladic figures.

In this *Reclining Figure* Moore weds form and space into one composition, where the space has as much weight as the mass. Both Moore and Hepworth have been credited with piercing the first hole in sculpture in a desire to bring the interior of sculpted form on to the same plane as the exterior, as if this were the only way of expressing sculpture's three-dimensional character. Holes have shape, and as much potential to convey meaning as solid mass; space is no longer the negative of the solid in sculpture. Mass and space are united on an equal basis, each dependent on the other, interacting as if fused in one whole. Along with the introduction of the hole came the idea that no two points of view are alike in sculpture.

Viewed from one side, the female figure here appears grounded and rhythmic, a sweeping line and a measured mass, whilst from the other, the figure appears edgy and sinister.

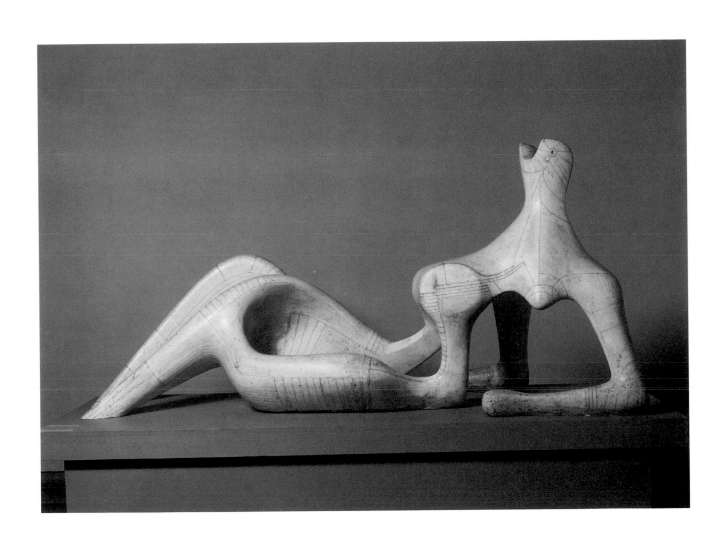

GWEN JOHN *1876–1939*

YOUNG WOMAN HOLDING A BLACK CAT C. 1920–25

Courtesy of the Tate Gallery, London

GWEN John has finally emerged from the shadow cast by her brother, Augustus John, and his reputation, and is now regarded as one of Britain's finest twentieth-century painters. Born and educated in Wales, she left the Slade to study with Whistler in Paris around1898, where, apart from a brief period in London, she would spend the remainder of her life, becoming the model and lover of Auguste Rodin, the French sculptor. Her colleagues at the Slade between 1895 and 1898 included Gwen Salmond and Edna Waugh, and John exhibited at the New English Art Club and jointly with her brother before departing for France.

She developed a method of numbered tones which was partly scientific and partly imaginative, as if to express the strangeness of form. Her subject matter was restricted to lone figures of women, her cats and her studio interior, which were obsessively painted in subtle tones. The women in her paintings appear immersed in their solitude. In *Young Woman in a Red Shawl* (1922–5) the girl's isolation seems to protect her and challenge the viewer, whilst in *Nude Girl* (1909–10) the uncompromising way in which the model is painted and her stare give an impression of harsh discomfort. John's early work revealed a tightness and exactitude in her methods that would be relaxed in the 1920s. She abandoned her brown and red tonalities, adopting blues, pinks and greys, and her handling of paint and texture became looser and broken, creating a less finished effect to her work.

As her brother was extroverted, so she was introverted, and her paintings suggest a sometimes excruciating austerity and heightened sensibility. Her self-portrait in the Tate evokes the impression of an underlying strength of purpose, so perhaps it is not surprising to learn that she set out in 1903 to walk to Rome with a friend, Doriella McNeill. She painted mostly still lifes and portraits, and her later work features single figures – most often women and sometimes nuns, as John had converted to Catholicism in 1913. As if in response to her spirituality, the subject of *Mère Poussepin* (1913–21) is partially dissolved in light on her left-hand side, merging into the background. In *Young Woman Holding a Black Cat* the lid is kept tight on a palette ranging from white to darkest brown, through the orangeness of the lips and the pink and pale blue in the floor and wall. The sitter and cat are outlined; the passivity in the former's hands belies the intensity in her face.

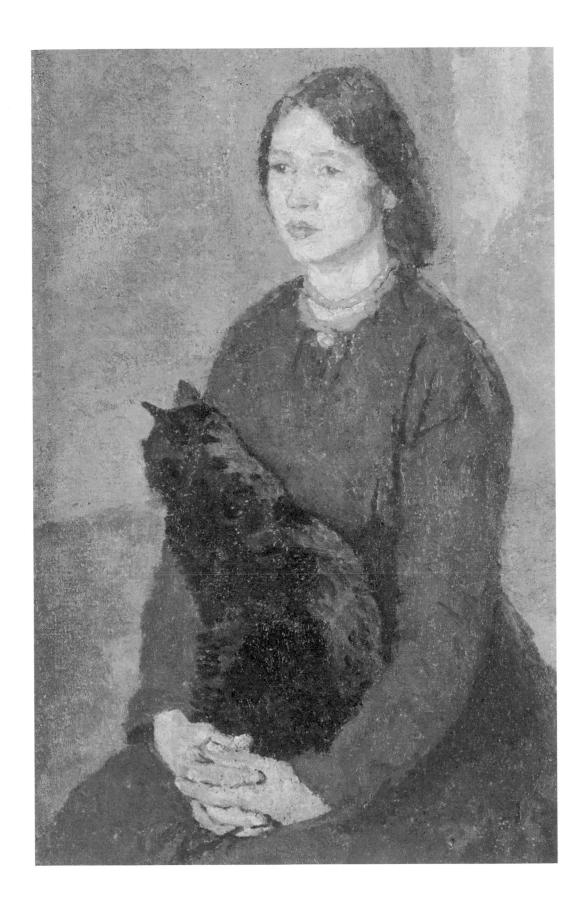

BEN NICHOLSON *1894–1982*

CORTIVALLO, LUGANO 1921–C.1923

Courtesy of the Tate Gallery, London

NICHOLSON was the son of Sir William Nicholson, the acclaimed painter and graphic artist. His attendance at the Slade School of Art, for a term, brought him into contact with Paul Nash, David Bomberg, Stanley Spencer and other artists of his generation. He subsequently travelled in Europe, encountering the work of the Cubists during his visit to Paris. In 1920 he married Winifred Roberts, who was also an artist, and they made their home in Cumberland. Because of his poor health they used to winter in Lugano, Switzerland, and the Ticino in Italy, and his work of these years reveals his growing interest in Cubism and in the potential of abstract art. Running through his early work, mainly still lifes and landscapes, is a strong sense of pattern, shape and colour, as if the traditional components of still lifes were the forerunners of Nicholson's abstract thought. His landscapes are in the same vein, rooted in the Neo-Romantic tradition of the interwar years in England, finding truth in the matter of stone and earth, life in the curve of a hill. This rare oil dates from this period, the white light bouncing off the snow-filled sky and the mountains, with streaks of rock showing through the snow.

Friendly with Christopher Wood, with whom he came across Alfred Wallis the naif Cornish painter, Nicholson also liked to paint with Paul Nash. They worked together in Dymchurch on the Kentish coast, and Nicholson's *Dymchurch* (1923) catches the glimmer of the light on the sand in semi-abstract horizontal strips of colour. As seen in the work of Wallis, who painted clustered coastal scenes on different shapes of card, Nicholson was aiming for pictorial immediacy, bypassing the traditional concepts of naturalistic painting.

Abstraction fascinated Nicholson, who, along with Winifred, became a member (and later chairman) of the Seven and Five Society. He pulled the society, initially conservative in approach, in the direction of abstraction, to rival the structures of natural form. The last exhibition of their work was organised by Ben in 1935. He visited Paris in 1934–5 with Barbara Hepworth, his second wife, and the influence of Mondrian and Modernism is plain in his white relief works dating from this period. Working in relief allowed the artist to abandon the illusion of representation and recognisable imagery and to create tensions between shapes, the truth of natural form.

HERBERT H. HARRIS

BOVRIL PREVENTS THAT SINKING FEELING C. 1920

Courtesy of the Victoria & Albert Museum, London

SIGNIFICANT innovations were made in the process of poster production at the end of the nineteenth century, particularly in France, where the 'artistic poster' had its heyday. Jules Chéret, working in Paris, was honoured in France in 1889 for combining principles of 'high art' with the commercial and industrial process of printing – a debate had been raging since the 1860s about the elevation of the fine arts above the decorative and applied arts. The growth in manufacturing in England also saw a marked increase in the advertising poster, as did new developments in the technique of chromolithography.

The most famous example in Britain was the conversion of an oil painting by Millais into an advertisement for Pears Soap. T. J. Barratt, the soap baron, bought the picture *Bubbles* in 1886. The image was of a young boy making bubbles from suds: Barratt made it into a chromolithographic poster, with the added copy of a bar of soap and the company name. The ensuing debate revealed that the hierarchies of what constituted art were still firmly in place. The Beggarstaffs (William Nicholson and James Pryde), as well as painters and poster designers Dudley Hardy and John Hassall, often created their designs speculatively: the coordination between client and creative design was a hit-and-miss affair. By the turn of the century agencies such as Samuel Herbert Benson had introduced the concept of total campaign management, from design to distribution. Benson published a series of articles and books on advertising, analysing the organisation of the ideal agency departmental structure and the need for a sense of brand. By 1912 he had created the first market research company in any agency.

Bovril was one of the advertising guru's first accounts. He used posters as part of a wider marketing offensive, organising events and competitions, and press as well as outdoor advertising. The early campaign posters, such as *Alas! My Poor Brother* (1905) which pictured a bull looking longingly at a pot of Bovril, were bought in from printers, but S. H. Benson also developed a collaborative approach, choosing specialist commercial poster designers. In addition, he identified the need for the customer to identify with the product, which produced one of the most memorable characters for Bovril, and the catchphrase would become as much a household saying as 'Guinness is good for you'. The copy 'Bovril prevents that sinking feeling' was written by Oswald Green, who took it from a Bovril pamphlet that advised golfers not to go without nourishment. Both the phrase and the pyjama-clad man would crop up regularly in advertising over the next twenty years.

L. S. LOWRY *1887–1976*

COMING OUT OF SCHOOL 1927

Courtesy of the Tate Gallery, London

LOWRY spent his working life as a rent-collector, chief cashier and clerk in Manchester and Salford (the site of the new Lowry Centre), attending art school on and off from 1905 to 1925. Despite a decidedly bleak outlook, he created one of the most popular portrayals of industrial working life in northern England. People amount to little more than automatons in his work, dehumanised against vast industrial cityscapes. He began painting before the First World War, and his style had matured by the 1930s. On artificially white backgrounds, Lowry painted heavily outlined human forms. His use of colour is restricted and shadows are rejected. There is little narrative or naturalistic detail in his work. His self-portrait *Head of a Man with Red Eyes* (1936) depicts a man slowly slipping into madness, a spirit of defiant questioning expressed in his red-rimmed eyes. He continued painting until his death – over 10,000 works by Lowry are known, amongst which are some seascapes of Lytham St Anne's, landscapes and portraits. Lowry worked full-time until he was sixty-five, and would paint in the evenings and at weekends; his subject matter was drawn from his immediate Lancashire environment.

A relatively early work of Lowry's is *Peel Park, Salford* (1927). Topographically accurate with the public library looming on the left, this painting shows the sky casting an ethereal light on three small figures at its centre. *Coming Out of School* shows the end of the school day, children piling out of the school gates into a smoggy white haze. Dwarfed by buildings and belching chimneys, the group is seen to splinter and pull apart in all directions, physically and psychologically, the children detaching themselves in dribs and drabs to return home. As the figures head off, alone, the monumentality of the buildings grows.

Lowry is renowned for his crowds and his instantaneously recognisable sticklike figures, portrayed against cities and chimneys billowing smoke. Occasionally a bow-legged dog can be spotted. Although he remained apart from all the trends of twentieth-century art and his own style did not evolve significantly after the 1930s, various attempts have been made to link him with Impressionism and Expressionism – the latter on account of the movement and gestures of his figures. The importance of composition on the one hand and psychological intensity on the other, as well as the comic and bizarre in human life, have also been highlighted as possible zones of influence. The existence of a Lowry school of painting in the North has also been suggested, represented by artists such as Theodore Magor, Roger Hampson, William Turner, all industrial painters.

Winifred Nicholson *1893–1981*

Flower Table 1928–9

Courtesy of the Tate Gallery, London

NÉE Roberts, Winifred was born into a well-to-do family and her childhood was spent at Castle Howard and Naworth Castle. From an early age her artistic ambitions were encouraged and she later attended Byam Shaw's School of Art in Campden Hill, London. Byam Shaw had frequented the Pre-Raphaelites, and he taught his students to manipulate space tonally and formally. As his star student, Nicholson found it hard to emerge from his artistic theories.

She married Ben Nicholson in 1920 and they had their first joint show in 1923 in London, greatly praised by Paul Nash, where she exhibited 27 paintings of Cumbrian and Swiss landscapes and flower paintings. Her flower-pieces in particular were a new departure, the vases often placed on a windowsill to create a dynamic between interior and exterior. As in her domestic interiors and landscapes, she experimented with the visual properties of colour, and in many of her flower-pieces the foreground and exterior background are held together by colour harmonies. Indeed, by the late 1920s her depiction of objects was in terms of their colour, as if trying to record the reality of the things seen and the act of human perception. Her compositions became increasingly flattened, as in *Rock Roses in Shell* (1936) where the outer undulating texture of the shell and the flowers consists of strokes of colour more pictorially immediate than naturalistic representation.

Nicholson is best known for her flower paintings, but she also painted portraits and abstract art, as well as landscapes. The Seven and Five Society, to which she, her husband Ben, Moore, Hepworth, Piper, Hitchens and others belonged, was formed in 1919. Nicholson joined in 1926, two years after her husband. Although the priority of this loose grouping of painters was to create an outlet for sales of their works, its manifesto, published in the 1920 exhibition catalogue, was a sign of the times, urging upon the reader a need to react against theory and innovation and to return to more traditional modes of representation. Still lifes and landscapes featured heavily in early exhibitions at the Seven and Five Society, but the influence of Ben Nicholson would take the group in a new direction.

After her separation from her husband and the death of their friend Christopher Wood, Nicholson moved to Paris in 1931 and split her time between Paris, Cannes and Cumberland, studying the grey silver light of Paris and the tonal contrasts of the open rural views around Cannes. Her Parisian circle included the artists Giacometti, Mondrian and Brancusi, and her art moved more towards an overt abstraction in which she still expressed a lyricism, as in *Quarante-Huit Quai d'Auteuil* (1935).

EDWARD BURRA *1905–76*

THE SNACK BAR 1930

Courtesy of the Tate Gallery, London

BORN in Rye, Sussex, Burra was to live there most of his life with his parents as he suffered from chronic arthritis and anaemia. He trained at various art schools, including the Royal College, where he developed a sense of the grotesque. When well enough to travel he visited France and America in the late 1920s and 1930s. He went to France with Cocteau and Paul Nash in 1929–30, relishing the reckless seedy life in the cafés and music-halls and of Marseilles. In 1933 he went to New York where he discovered the nightspots of Harlem, then continued on to Boston. The Surrealist shows in London and New York in 1934 and 1936 exhibited his work, although his approach to Surrealism was more decorative and illustrative, with little apparent concern for form. Although he kept his distance from artists' groups, Burra did belong to Nash's Unit One. After the Second World War he returned to New York and in 1955 painted *Silver Dollar Bar*, perhaps one of his greatest nightclub scenes. *Opium Den* (1933) features an unearthly yellow, worn by the doyenne of the establishment, who is wrapped in Japanese robes. Dragons perch on her head. Scattered around the room, which throbs with red and green, three men smoke their opium. Out of their pipes flow sensual genies, owls, the ace of clubs and revolvers.

The outbreak of the Spanish Civil War in 1936 had a profound effect on Burra's paintings; works such as *Destiny* (1937) are laced with sadistic violence. *The Three Fates* (1937) is a ghoulish black and white watercolour, almost grotesque in its sense of the macabre. After the Second World War Burra designed costumes and sets for several ballets and produced numerous book illustrations. In the late 1950s he worked on still lifes and landscape painting. The body of his work recalls that of Georg Grosz, except in one important respect, namely the wicked sardonic humour that pervades much of it; for most of his life Burra was regarded more as a satirist and caricaturist than as a painter.

Although he worked mostly in watercolour, *The Snack Bar* is one of his rare oils. The bar is probably in Soho, a part of London Burra enjoyed. The woman at the counter is most likely a prostitute, and the sexual overtones are clear, from her exaggerated open mouth as she bites down on her sandwich, an action echoed by the man in the background, to the fall of the furling slices of sausage. The carnal, both human and other, is recurrent: the watercolour *Saturday Market* (1932) juxtaposes a prostitute and a vegetable stall owner, both selling their wares.

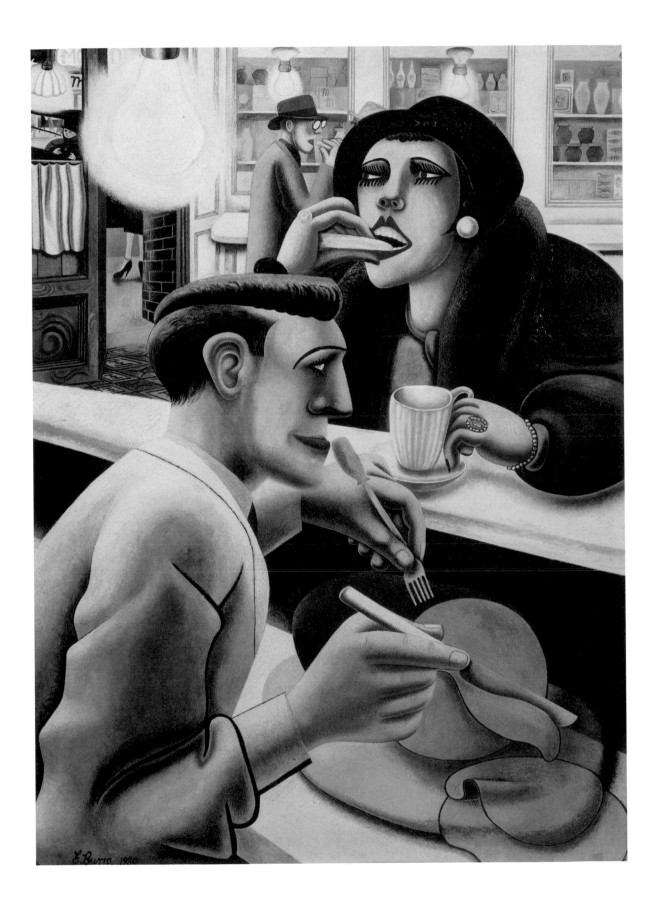

Eric Ravilious *1903–42*

The Greenhouse: Cyclamen and Tomatoes 1935

Courtesy of the Tate Gallery, London

RAVILIOUS was one of the foremost wood engravers and watercolourists of interwar Britain. He had been taught design with Edward Bawden at the Royal College of Art, where one of his tutors was Paul Nash. The wood engravings of Thomas Bewick were very much admired at this time, and Ravilious emulated him, while adding a tautness and angularity that were also to be seen in his watercolours. He produced a wide range of work, including murals, lithographs, and pottery designs for Wedgwood, as well as his watercolours and wood engravings. He was an official war artist in the Second World War; when his plane went down near Iceland while on patrol in 1942, he was presumed dead.

Most of Ravilious's work was small in scale and supportive either of text or of manufactured object. Broadly traditional in outlook, he did not openly adhere to either Surrealism or abstract art, the two main currents running through Britain between the periods of isolation during the two world wars. However, the width of his panoramas and the intensity of his designs communicate a tension between the immediacy of the object and its existence as part of a greater whole. On closer study, the spontaneity and actuality of his watercolours allow the imagination to roam far, and the mystery of time, place and object inherent in his art has direct links with Nash and the Neo-Romantics as well as roots in the work of Samuel Palmer. In many of Ravilious's works, the viewer is led down a path to a broader mental perspective. The timeless cycle of the seasons, the waxing and waning of the moon, and zodiacal signs all recur in his watercolours and engravings, often entering the denoted physical space in the picture, as if to recall a greater reality. The absence of the human figure from his work is striking; sometimes modern objects are juxtaposed with prehistoric, or traces of human activity are suggested by lone rusting farm implements.

From inside the greenhouse, the viewer is invited to look down its length, following the line of drainage tiling, to the final closed door. On either side are rows of pink cyclamen on planks. Those further down look admirably straight, but there is a delightful curve to right and left in the foreground, the only indication of a human hand or presence in what is an entirely manmade construct. The tomatoes, yet to ripen, climb along the roof, through which chinks of sky can be spotted. This is a wonderful play on perspective, the pattern of straight and diagonal lines repeating itself as they recede into the distance.

JACOB EPSTEIN *1880–1959*

JACOB AND AN ANGEL 1940–41

Courtesy of the Tate Gallery, London

BORN in New York of Polish parents, Epstein studied art in Paris and arrived in London in 1905, acquiring British citizenship in 1910. He was equally at ease with carving as with modelling techniques, and amongst his influences counted everything from contemporary life to non-European traditions. His subject matter was equally wide-ranging, encompassing religious, mystical and symbolic themes alongside which he created portrait busts of the famous men and women of his time, perhaps the most famous being those of Albert Einstein and Winston Churchill. His busts always met with success, because of his ability to portray his sitters with psychological insight and an expressiveness of surface. From 1910 Epstein was concerned with the impact of the machine and of violence, both modernistic themes that would also be explored by Wyndham Lewis and the Vorticist painters. A study for *The Rock Drill* drawn before the outbreak of the First World War shows a celebration of mechanisation. Man and machine are one, triumphant and confident. The bronze sculpture *Torso in Metal from The Rock Drill* (1913–14) tells a different story; mutilated and sunken, it speaks of the ambivalence towards the machine in the light of the oncoming war. *Doves* (1914–15), one of three sculptures of mating birds, is one of several of Epstein's earlier works that address procreation, sex and birth. Its sparsity of form and its geometric ovoid shape anticipate the currents of abstraction and Cubism, whilst its subject seems to be an expression of universal fertility, a recognition of the influence of African tribal art which Epstein collected all his life.

The architect Charles Holden gave him his first public commission in 1907, eighteen figures for the British Medical Association building exterior in the Strand. Here Epstein created male and female figures in a triumphant celebration of nudity and primal existence; the scandal was such that the National Vigilance Society almost succeeded in having them removed. His *Tomb of Oscar Wilde*, which he worked on in 1911, caused similar dissent when it was installed in the Père Lachaise cemetery in Paris. Public commissions in Britain ceased for twenty years after the completion of *Night* and *Day* for the Underground headquarters at St James's Park in London. His large bronze groups of the 1950s were all on religious themes.

This large group shows an episode from the Bible, Genesis chapter 32, verses 24–32, in which Jacob fights throughout the night with an unknown opponent who in the morning is revealed to be an angel. This is an image of spiritual strength and perseverance, and is one of several monumental carvings by Epstein on religious subjects for which he used a primitivist and erotic style, shocking many.

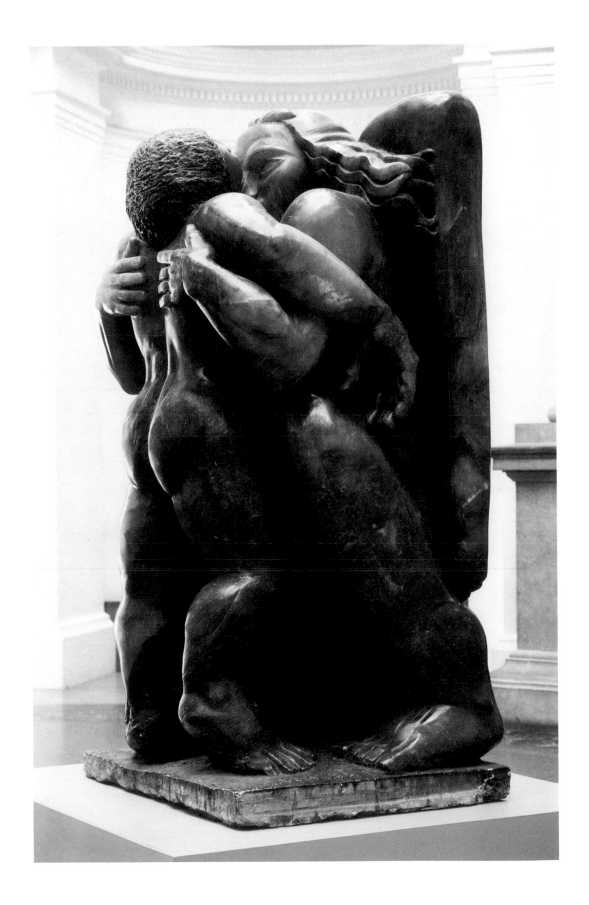

JOHN PIPER *1903–92*

ST MARY LE PORT, BRISTOL 1940

Courtesy of the Tate Gallery, London

PIPER reluctantly worked as a clerk in the firm of his father, who was a solicitor, from 1921 to 1926, during which time he privately published two volumes of poetry. When his father died in 1926, he enrolled at the Richmond College of Art, from where he moved to the Royal College of Art a year later. He became a member of the Seven and Five Society and later secretary to the group, with whom he exhibited abstract constructions in 1935, such as *Abstract I* (1935). He also contributed to *Axis*, a review of abstract art with links to the French abstract group Abstraction-Création. The review was edited by Myfanwy Evans, whom Piper married in 1937. Concurrently with his experimentation with abstraction, he created collages made from torn paper, and in 1937 would contribute an article, 'Lost, a valuable object', to an anthology edited by Myfanwy entitled *The Painter's Object*. Eight issues of *Axis* were published, and whilst it began adamant in its abstract ardour, it wavered towards the end, calling instead for individualism and for the object to be set in its context.

From an early age Piper had been interested in topography, and he had visited every church in Surrey by the age of fourteen. He worked with his friend, the poet John Betjeman, on the *Shell Guide to Shropshire*, having previously sketched and contributed articles and photographs from all over Britain for the *Architectural Review*, edited by J. M. Richards. No doubt the threat of war was a factor in his renewed interest in landscape and English traditions, distracting him from the abstract art he practised in the 1930s – his painting of Seaton Delaval, a country house designed by Sir John Vanbrugh and gutted by fire in 1822, is filled with notions of past glory and impending doom. Artists such as Tristram Hillier had shown country houses to be timeless and unreal, whereas Piper filled his pictures with nostalgic romanticism. Black backgrounds often show through in his oils at points where he has scratched the picture's surface to create effects of wind, light or texture.

This dramatic picture of the remains of a church in Bristol is curiously flat – Piper was later to broaden his interests in set design. Along with Graham Sutherland and many others, he was appointed an official war artist to record the effects of bombing on cities, and his pictures of damaged buildings and decaying country houses testify to his architectural draughtsmanship. In the1950s, he worked as a book illustrator and prolific print–maker, and wrote *British Romantic Artists*.

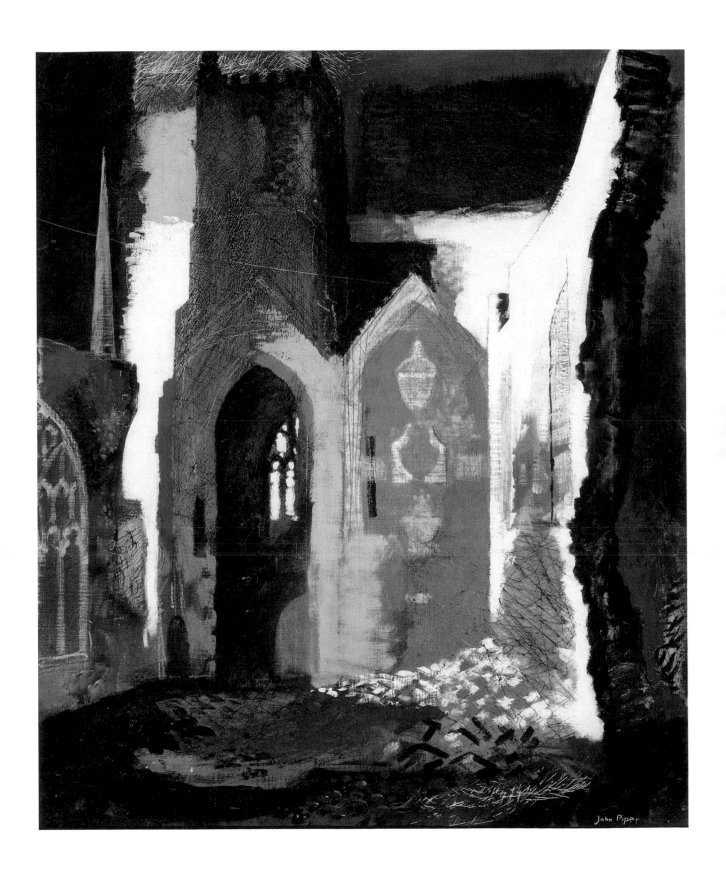

GRAHAM SUTHERLAND *1903–80*

SOMERSET MAUGHAM 1949

Courtesy of the Tate Gallery, London

GIVING up an apprenticeship as a railway engineer, Sutherland studied print-making from 1920 to 1925, and worked exclusively as a graphic artist until 1930 as well as teaching engraving. He began his career as an etcher during the print revival of the 1920s, and complemented it with poster design and tea-service decoration. He took up oil painting in the 1930s, and in 1934 made the first of several trips to Wales where his landscapes took on a degree of abstraction, as seen in *Black Landscape* (1939–40). With Nash he exhibited at the International Surrealist Exhibition in London in 1936, and the two artists became emblematic of English landscape Surrealism. Impending war, and a conscious revival of the influences of the English nineteenth-century Romantic landscape tradition, resulted in a combined sense of foreboding and elation. Sutherland's Welsh landscape pictures are intense in colour and focused on one aspect, such as a road snaking through the landscape, rocks, or an overhanging tree. The colours he employs are of an imaginary world, intense and emotionally evocative of an extra-reality. He painted the elements and elemental forms not directly from nature, but once they had passed through his imagination. His selection of parts of a landscape, his style of condensing, created what he referred to as 'paraphrases of the whole'.

Along with John Piper, Sutherland was an official war artist and painted scenes of urban destruction. His tendency to melodrama lent itself well to pictures of devastation, devoid of narrative incident. *Tin-mine: Emerging Miner* (1944) depicts a miner appearing as if from the womb of the earth, enveloped in such a way as to lend the lone figure added significance. After the war, Piper continued landscape painting, but also took up portraiture and religious painting, the best-known example of which is *Christ in Glory in the Tetramorph*, an altar tapestry in Coventry Cathedral. The Gothic cathedral having been destroyed during an air raid in 1940, Sutherland created a design that revelled in God's glory and power, with little emphasis on his suffering, and attempted to put across the vital mystery of creation, both forceful and timeless.

This portrait of the novelist Somerset Maugham established Sutherland as a portrait painter, and gave the traditional pose a modern twist. He would go on to paint Winston Churchill (who destroyed the result), Lord Beaverbrook and the American collector and Hanover Gallery director Arthur Jeffres, who launched Francis Bacon's career.

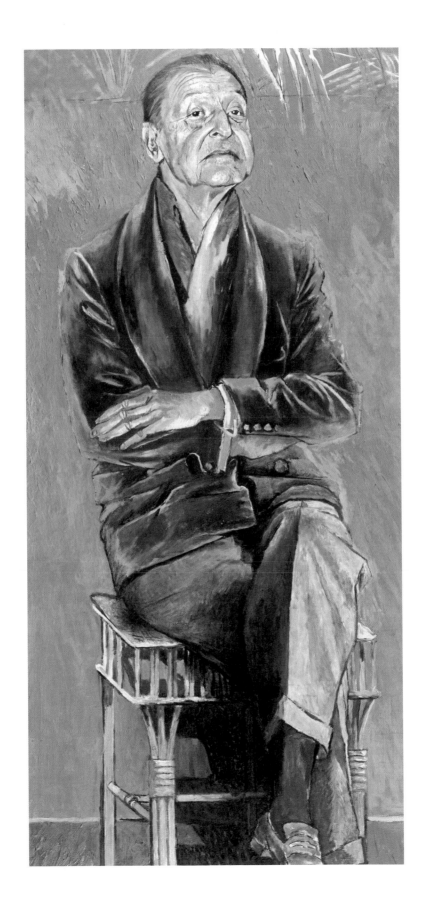

BARBARA HEPWORTH *1903–75*

SINGLE FORM (SEPTEMBER) 1961

Courtesy of the Tate Gallery, London

HEPWORTH'S work is characterised by a great sensitivity to materials and abstract organic form. In 1932 she travelled in France with Ben Nicholson and visited the studios of Braque, Brancusi, Picasso and Jean Arp. She moved to St Ives with Nicholson at the outbreak of the Second World War, where her sculpture took on heightened associations with landscape. A forerunner of the international abstract movement, she executed a number of figurative works in the aftermath of the war, but her dominant style was sensual, non-figurative and harmonious.

Much of her work refers to the beach at St Ives, and many of her sculptures recall the waves, the sand and the sounds of the ocean. Hepworth developed the use of the hole in sculpture, an interplay between mass and space and between the interior and exterior. Yet whereas Moore (see page 190), who also pierced holes in his sculpture, was trying to give equal significance to mass and space, Hepworth also emphasised construction rather than observation, as if to become one with the Cornish landscape through her sculpture. Her earlier work appealed to the emotions evoked on the contemplation of form, rhythm, plasticity and texture, and spoke universally, moving away from the direct political, social or religious commentary that had been seen in postwar sculpture. Like Henry Moore, she was indebted to the Yorkshire landscape she grew up in.

Hepworth attended Leeds College of Art and the Royal College of Art, after which she travelled in Italy. Like Moore, she absorbed influences of both European and non-European traditions, and stressed the importance of direct carving as opposed to moulding – the former being necessary for direct interaction with the material, from which would evolve the form. Moore would prove to be more concerned with mass and interior, whereas Hepworth considered surface, direction and rhythm to be paramount.

Two Forms (1934) is an example of the connection between masses. Two solids, an egg and a rectangular form, share the same base, the sharp delineation of the latter contrasting with the eternal smoothness of the former. Although the egg is grounded and balanced, the shadow that it casts makes it float above the base, and the rectangular form rises too, lightened by its interaction with the ovoid mass.

SIR CEDRIC MORRIS *1889–1982*

IRIS SEEDLINGS 1943

Courtesy of the Tate Gallery, London

CEDRIC Morris was born in Swansea into a family of prosperous industrialists with at one time a staple collection of Romneys, Gainsboroughs, Hogarths and Reynoldses. A baronetcy had been created in 1806 for his great-great-grandfather, a copper and coal magnate, and Morris was to assume the title in 1947. After an undistinguished school career, he spent a couple of years in a series of odd jobs in the USA and Canada before enrolling at the Royal College of Music. He moved to Paris in 1914 and attended art school, although his stay was cut short by the outbreak of the First World War. He returned to England and enrolled in the Artists' Rifles, but ill health would result in his discharge. After the war he moved to Newlyn in Cornwall, where he was friendly with Laura Knight, Dod Procter and other 'Post-Raphaelites', whilst also frequenting the remnants of Wyndham Lewis's Vorticist fraternity, Group X.

Morris's art emphasised the primacy of the subject, but he merged it often with a style that bordered on abstraction. Art was the synthesis of reality rather than its representation, and different natural forms merged accordingly. In *Experiment with Textures* (1923) the abstraction of observed textural effects is married to recognisable organic forms. Much of the 1920s was spent in France, Germany, Italy and North Africa, and in parallel with his experiments with semi-abstraction he painted a series of café scenes and figurative works. He had joined the Seven and Five Society in 1926 but would resign in 1932, probably in reaction to Ben Nicholson's drive to move the group towards pure abstraction. His paintings of this period share characteristics with those of Nicholson and his wife Winifred. In Morris's work, whether his portraits or his pictures of birds and flowers, traditional representational concerns combine with modernism.

With Arthur Lett-Haines he established and taught at the East Anglian School of Art and Drawing, which placed heavy emphasis on the creative impulses of the students and on a freedom to express their own ideas. The approach, keenly based on observation, was decidedly non-academic.

Before the Second World War, Morris was known as a breeder of irises as well as a painter. In 1940, he moved to Suffolk and created a garden inspired by Monet's at Giverny, filling it with over a thousand iris seedlings each year. More a plantsman than a gardener, he shared his interest with John Nash, creating a long list of 'Benton' irises and seedlings which were passed to the British Iris Society on his death. Morris admired Chinese painting, particularly flowers, in which the essence was communicated in deft, rapid brushstrokes. He reduced the motif to its essentials and rejoiced in the sheer existence of the flowers he painted – it was not so much their beauty or colour that he wished to convey with his direct style as the near-ferocity of their life.

EDUARDO PAOLOZZI *1924–*

I WAS A RICH MAN'S PLAYTHING 1947

Courtesy of the Tate Gallery, London

PAOLOZZI was born in Edinburgh of Italian parents who owned an ice-cream parlour. Interred during the Second World War, he travelled to Paris in 1947 after completing his studies both at the Edinburgh School of Art and at the Slade. On his return he was commissioned to design a fountain for the 1951 Festival of Britain, and in 1952 he set up the Independent Group with Richard Hamilton, Reyner Banham and Lawrence Alloway. Paolozzi and Hamilton are considered the founders of British Pop Art: art based on imagery taken from popular culture, predominantly American, intent on exploring the mass media and modern technology.

Since the 1950s Paolozzi has produced two bodies of work, sculpture and collage. His sculpture is mostly robotic-looking, which conflicts with the material from which it is made, bronze. *Large Frog Version II* (1958) is one of a series of three bronze sculptures on the theme of the frog despoiled and disfigured by a mass of manufactured parts. Similarly *The Philosopher* (1957) presents an emaciated and elongated figure swamped by his modern non-organic attributes. Paolozzi is an ambivalent figure for, whilst his sculpture decries the modern capacity for human destruction, he reveals an obsession with mass production.

This collage plays with the format of the women's magazine. A generic sexy brunette looks out from the cover, promising kiss-'n'-tell 'true stories'. But the reality of her existence and the truth of the contents are called into question, not least because this magazine, of course, does not exist – the cover is fictitious. A gun points at her head, but it is a toy gun that recalls action cartoons with their sound bubbles. The picture of the toy gun hides the strapline to the magazine, which would no doubt read 'True Stories', if only we could see it. In among the dazzle of popular culture, other Americana can be spotted – the world-famous Coca-Cola bottle, as curvy as the brunette, cherry pie and Real Gold.

ALLAN GWYNNE-JONES *1892–1982*

PEACHES IN A BASKET 1948

Courtesy of the Tate Gallery, London

ALLAN Gwynne-Jones was born in Richmond, Surrey, and he began his professional career far away from the art world, by training and then qualifying as a solicitor. However, his artistic development moved in parallel with this more conventional route, and he had already begun painting, mainly with watercolour, in 1912. It was at this stage, at the age of just twenty, that art and artistic scholarship became necessary to him, and all thoughts of a staid if secure legal career were abandoned. This change of direction led him to study intermittently, from 1912, at the Slade School of Art in London. Here his studies were interrupted by the First World War, in which he served in the Welsh Guards. Having already proved himself as both a scholar and an artist, Allan Gwynne-Jones showed himself to be an exemplary soldier as well and was awarded a Distinguished Service Order for bravery in 1916.

Seven years later, having returned to academia, Gwynne-Jones was made Professor of Painting at the Royal College of Art, before returning to teach at his old training ground the Slade in 1930. For most of the 1920s he concentrated on etchings of rural subjects. Despite having started off as a painter specialising in watercolours, he is best known for his oil paintings, in the main portraits and still lifes, of which *Peaches in a Basket* is a familiar example. Other works of his held at the Tate Gallery are *A Fair by Night* (1938), *The Mantelpiece* (1939) and *Self-Portrait* (1926).

Victor Pasmore *1908–*

The Park 1947

Courtesy of the Tate Gallery, London

PASMORE began to paint as a child, but the death of his father at a young age led him into the Civil Service in search of a steady income, although he was able to attend evening classes at the Central School. In 1932 he met William Coldstream and Claude Rogers and the three set up the School of Drawing and Painting. The artists of what became known as the Euston Road School adopted a realist style, with the emphasis on observation and freedom of expression. Graham Bell also taught at the school, although Pasmore steered a wide berth in terms of Bell's art politics. The aims of the Euston Road Group were to take painting beyond the confines of the avant-garde, through their choice of subject matter. Scenes of everyday London life were staple – café interiors such as *Parisian Café* (1936–7) – as they had been for the Camden Town Group, but Pasmore's paintings have a delicacy about them that lifts them above gloomy realism.

His marriage in 1940 to Wendy Blood coincided with a series of naturalistic landscapes, often of the Thames. *The Quiet River: The Thames at Chiswick* (1943–4) is a typical example: highly poetic, its atmosphere and light are so ephemeral that it appears a semi-abstract study of mist. *The Hanging Gardens of Hammersmith No. 1* (1944–7) and *The Park* are abbreviated observed concentrates in a similar manner to *Chiswick*, but the lyricism and intensity, marked by the legacy of Whistler's nocturnes at the turn of the twentieth century, are all the more striking. These paintings were also preludes to Pasmore's embracing of abstract art.

In the late 1940s, influenced by Klee and an exhibition of the work of Picasso and Matisse in London, Pasmore underwent a conversion and experimented with Constructivism. He was featured by Laurence Alloway in a 1945 publication, *Nine Abstract Artists*, along with Mary Martin and Roger Hilton who provided a link with the St Ives-based group. Pasmore's 'conversion' to geometric Constructivism was a dramatic event in postwar British art, all the more so since his earlier lyricism had received such praise. Pasmore had been studying the work of the Post-Impressionists as well as the bases for mathematical and geometric principles in art. He produced abstract geometrical pieces in the 1950s using transparent perspex and colour, such as *Abstract in White, Black and Maroon* (1956–7), and later introduced the space-creating spiral into his pieces. He went on to introduce Bauhaus-inspired methods of teaching at the Central School and from 1955 to 1957 would explore architectural space in environmental exhibitions, culminating in the design of part of Peterlee New Town, County Durham.

LUCIAN FREUD *1922–*

GIRL WITH A WHITE DOG 1950–51

Courtesy of the Tate Gallery, London

BORN in Berlin, a grandson of Sigmund and son of the architect Ernst, Freud came to England with his parents in 1931, acquiring British nationality in 1939. Invalided out of the Merchant Navy in 1942, he worked as an artist full-time, having studied at the East Anglian School of Painting and Drawing run by Arthur Lett-Haines and Cedric Morris (see page 214), who favoured an emotive, as opposed to an academic, approach to painting. Since the Festival of Britain in 1951, where he won a prize for *Interior at Paddington*, Freud has been acclaimed as one of Britain's leading portrait and figurative painters, but his drawing and non-figurative works deserve equal attention. Until the late 1950s Freud worked in a Surrealist-Existentialist manner, flattening planes as in the pen-and-ink drawing *Narcissus* (1947–8) and *Boy with a Pigeon* (1944). Linear description, employed as if to withhold himself from engaging with the subject, dominated his early work. Like Bacon, Freud painted only portraits of friends – portraiture otherwise was merely the act of passing by and not engaging with the subject. Stripping his sitters of their character, his portraits sought not a likeness but a portrayal of them, skin, hair and flesh. Unlike Bacon, Freud painted only direct from life rather than from photographs, and his portraits are produced over an intense and lengthy period of time.

Man's Head (Self-portrait I) (1963) is a study of the contrasts between the plasticity of the head and that of the forearm. The latter, fleshy and smooth, is relatively uniform, whilst the face is an exercise in skin stretched over a frame. *Standing by the Rags* (1988–9), one of Freud's nudes, is unremitting in its analysis of flesh on bone under very bright light. The absence of idealisation in his treatment of the body is one of Freud's ways of revealing the truth of his subject, as well as the fact. Awkward poses, uncomfortable gazes and lack of pictorial depth further bring the viewer on to an intimate level with the subject.

This is the last portrait Freud painted of his first wife, Kitty Garman. The towelling robe, the smooth undulations of the bedspread with its piping and the compactness of the dog are mesmerising. The sitter's face challenges this scrutiny; her features seem to be exaggerated in their proportions and her direct gaze out at the onlooker fearful. The use of a pallid range of colours brings a chill to the interior, contributing to a sense of isolation amid rigorous observation. Subsequent portraits would forgo the smooth pale finish and emotive intensity of this portrait in favour of a more relentless, detailed observation of physical existence.

Francis Bacon *1909–92*

Study for a Portrait of van Gogh IV 1957

Courtesy of the Tate Gallery, London

BACON, who had no formal artistic training, was born and grew up in Dublin with his British parents – his father was a racehorse trainer. He came to London in 1925 and worked there and in Berlin, mostly as an interior decorator and designer. He painted sporadically until the exhibition of *Three Studies for Figures at the Base of a Crucifixion* in London in 1945; the uniform shock and even disgust that greeted it put him on the map permanently. Most of Bacon's works are imbued with a sense of violence, although they are never depictions of violence itself. He experimented with the triptych, reminiscent of Christian art and Greek classical tragedy, as a means of bringing together more than one figure whilst avoiding any narrational overtones. In *Three Studies for Figures at the Base of a Crucifixion* (1944) three indeterminate beings, part human, part beast or wingless fowl, twist and strain. The dominant feature is the mouth, gaping wide and taut, the roaring colour of the background hinting at the force of the cries emitted, the contorted necks lending a bestial air to humanity. The work of the photographer Eadweard Muybridge (1830–1904), who published his photographic studies of animals and humans in motion at the end of the nineteenth century, was also to influence Bacon's work.

Many of his works take the triptych as their format, and the Crucifixion recurs, more as an emblem of man's innate cruelty than for its religious message. His later portraits – of Lucian Freud, among others – are contorted, as he sought to convey changes in personality and pose. He destroys the likeness to his sitters in order to reassemble the elements and make a likeness, neither abstract nor the illusion of representation. Although he used photographs in his work, preferring to paint from them than from his subject, Bacon strives to create an image that is as far removed from a perception of the intelligence as possible. The contortion evident in his portraits is not to do violence to his subject so much as to convey the person and presence in his or her totality, above and beyond likeness.

Study for a Portrait of van Gogh is one of eight paintings he made in 1956–7 inspired by a photographic reproduction of a self-portrait by the Dutch artist. Bacon was also to use reproductions for his series based on Velázquez's portrait of Pope Innocent X, perhaps as a distancing tool allowing him to assimilate the original and then create his own piece, both in homage and as an expression of his own painterly ideas.

RICHARD HAMILTON *1922–*

SWINGEING LONDON 67 1968–9

Courtesy of the Tate Gallery, London

HAMILTON studied at the Royal Academy Schools and the Slade, as did Paolozzi. The two formed the Independent Group of the Institute of Contemporary Arts, and Paolozzi's ground-breaking collages of the late 1940s would inspire Hamilton. Their interest in mass media and science and technology led them to address objects of consumerism, from the depiction of women in advertising to the beauty of the mass-produced Chrysler fin-tail. In so doing they questioned the accepted boundaries of taste and convention and opposed aesthetic restrictions.

Hamilton's subject matter is the celebration of mass production and consumer goods, and his work is a homage to sophisticated applied art and industrial design. He welcomes the reality of his own period and sees consumerism and design as part of a continuous evolution. In his early works he used allusion and even abstraction rather than the direct representational techniques that he has employed in his more recent work. In his archetypal Pop art work *$he* (1958–61) he addresses the presentation of women in advertisements. The image suggests a female figure standing in front of an open fridge, with a toaster that doubles as a Hoover nearby; the contents of the fridge seem to be a Coca-Cola bottle and a pint of milk. He has airbrushed the woman's breast and shoulder, a technique used in magazine advertising, and has diagrammatic dots trace the path of the flying toast.

In *Swingeing London* he evokes media photography while recording the judge's call for a 'swingeing sentence' to be passed on Mick Jagger and Hamilton's own art dealer, Robert Fraser, after a drugs bust. The source of this image is the *Daily Mail* photograph of Jagger and Fraser, handcuffed in the back of a police van. Hamilton enlarged and retouched it, removing the outside of the van and extending the interior depth. He produced six versions: the photographic image was silkscreened in black over conventional coloured oil paint. In this version, the canvas has been primed in white and the oil paint applied on top of the black silk-screened picture. Collage has also been added to conjure views through both the window and the handcuffs, and the mixture of media calls into question the nature of the object and questions the truth of representation. Photography and traditional art forms are placed within the same frame; human figures are juxtaposed with machines again, this time enclosed in a motor vehicle. The blurred quality and slanting angle of the van window create sensations of speed and emphasise the coexistence of different spaces and varieties of focus.

GERARD HOFFNUNG *1925–59*

THE TUBULAR BELLS C. 1955

Courtesy of the Hoffnung Partnership

HOFFNUNG was born in Berlin to Jewish parents. The family left for Florence in 1938; he and his mother moved to London in 1939, while his father went to Palestine. After school and art studies in London, he left for New York in 1950 to pursue magazine commissions, but returned in 1952 to work on BBC Radio and also to marry. He would become a regular contributor to *Punch* and a weekly illustrator on the *Daily Express*. Hoffnung played the tuba in amateur orchestras throughout his life, and from this pastime sprang a series of caricatures on an orchestral theme. His first illustrated book, *The Right Playmate* (words by James Broughton, 1952), is typical of Hoffnung – wise, hilarious and off the wall. It tells the tale of a lonely boy growing up in circumstances both typical and odd: the first caption, in which the boy introduces himself, is accompanied by a drawing of a boy skipping with a rope: the rope is made out of barbed wire. So it continues. In 1949 he illustrated *The Boy and the Magic*, based on Ravel's opera *L'Enfant et les Sortilèges*, with a libretto written by Colette, and in the 1950s published a series of six Hoffnung Little Music Books, *The Hoffnung Symphony Orchestra*, *The Hoffnung Music Festival*, *The Hoffnung Companion to Music*, *Hoffnung's Musical Chairs*, *Ho Ho Hoffnung* and *Hoffnung's Acoustics*.

Caricatures of a political nature first appeared in England during the eighteenth century – the origin of the word 'caricature' is the Italian *caricare* meaning 'to load' or 'to surcharge' – and between 1790 and 1820 there was a surge in the number of satirical prints available, some of which were tinged with a sense of moral purpose.

In the work of the following generation of political cartoonists, in particular James Gillray, the finish and high quality of their drawings contrasted with the vulgarity of their subject matter. Conventions such as captions, speech bubbles and the antecedent of the comic strip – namely, frames without narrative links – began to make appearances during this period. Changes in print reproduction techniques wrought changes to the style. In France the lithograph in particular created a caricature that was more fluid and expressive than previously, as the artist drew directly on to the stone from which the impressions were taken. Periodicals such as *Punch* still used wood-engraving techniques until the 1880s, and the caricatures were more restrained and conventional in style. *Punch* first explored the possibilities of the cartoon when it parodied the preparatory sketches, also known as 'cartoons', for the frescos that were to decorate the new House of Commons in 1843.

Commentary on contemporary events, social and political, was aided by developments in other printing techniques in the 1880s which made illustrative material cheap enough to become obligatory in daily newspapers, and in 1888 the first staff cartoonist was employed on a newspaper. As the photographic process faithfully reproduced the cartoonist's drawing, artists such as Toulouse-Lautrec, Whistler and Georg Grosz began to blur the boundaries between art and the cartoon. A revival of the cartoon's fortunes in the mid-twentieth century in Britain can be attributed to geniuses such as Gerard Hoffnung, Ronald Searle and Gerald Scarfe.

SIR ANTHONY CARO *1924–*

EARLY ONE MORNING 1962

Courtesy of the Tate Gallery, London

CARO had a traditional art training at the Royal Academy Schools after completing studies in engineering at Cambridge and serving in the Navy in the Second World War. His encounter with the American art critic Clement Greenberg, and his trip to the USA in 1959 where he met the sculptor David Smith and the painter Kenneth Noland, were to have a radical influence on his work. In 1954 Caro took up a teaching post at St Martin's School of Art in London, from which a group of sculptors was to emerge that became known as the New Generation. Among them was Phillip King, current President of the Royal Academy.

Caro abandoned the lessons of art history and the traditional materials of the sculptor, including the pedestal. He started making works out of steel sheets, girders and other prefabricated elements found in scrapyards, which he then painted and linked together. The horizontal nature of *Early One Morning* is reminiscent of Henry Moore; Caro was his assistant between 1951 and 1953. The material of the sculpture is indistinguishable – a whole legacy of classical marble and bronze has been shrugged off. And instead of creating the sculpture by chiselling, Caro has built up forms by adding the various elements to each other. The title is not descriptive; it evokes associations, echoed in the lightness and grace of the curved pieces. In *Prairie* (1967) the horizontal plane is again evident as individual shapes are added together and united by the application of yellow paint. Caro has created an arrangement of horizontals, verticals and fault planes in an almost abstract painterly fashion; the air that circulates around and through the sculpture removes any lingering impressions of monolithic monumentality. The horizontal rods are anchored at one end only and their impressive length means that they often tremble gently. This, coupled with the colour and flatness of the piece, contributes to a vivid suggestion of winds blowing across a prairie. Caro's work of the 1970s explored the possibilities of working with malleable raw metals. Two visits to the steel mill in Veduggio, Italy, produced a series of sculptures that are united by their unfinished quality. The edges are jagged and raw, the joins between the pieces obvious, and there is an emphasis on the machine-age origins of the materials.

In reaction to the New Generation, sculptors like Barry Flanagan began using common-or-garden materials such as sand, cloth and rope, whilst Tony Cragg's work (see page 252) has featured modern manufactured objects often retrieved from the scrapheap.

ROGER HILTON *1911–75*

OI YOI YOI 1963

Courtesy of the Tate Gallery, London

HILTON was of German extraction (the art historian Aby Warburg was a cousin) and his family name, Hildesheim, was changed in 1916. He studied first at the Slade and subsequently in Paris in the 1930s; he was a prisoner of war from 1942 to 1945. Following travels to Paris and Amsterdam to look at Mondrian's work, his first abstract works, dating from the 1950s, feature flat blacks and whites with the occasional flash of colour. Although he did not adopt Mondrian's strict geometric style, Hilton's abstraction was as severe in its directness. Abstraction for him was a reaction to illusionary representation; he intended to paint space-creating pictures, rather than pictures of space.

He taught at the Central School of Art in London from 1954 to 1956, and it was around this time that he first visited Patrick Heron in St Ives. Many artists had gone there after the war, following in the footsteps of Ben Nicholson, Barbara Hepworth, Terry Frost and others. Frost's *Green, Black and White Movement* is archetypal of what became known as the St Ives School; it is an abstraction that actively acknowledges the artist's response to the Cornish landscape. Inspired by the bobbing of boats in St Ives harbour, Frost depicted an arrangement that through colour and the suggestion of movement was to express his emotions rather than the reality of what he saw.

Hilton settled in St Ives in 1965; he had spent long periods there since the late 1950s, having rented a studio at Newlyn, and his work began to reflect his experience of the shapes of the Cornish coastline and landscape. When he exhibited at the abstract show at the Institute of Contemporary Arts in 1957, Heron referred to his work as evidence of the creative artist's struggle, his thought processes and stance. More intuitive than mathematical in outlook, Hilton was not part of the move towards Constructivism in the late 1950s/1960s. His pictures became steadily more representational in style – figures, boats and landscapes can be discerned in his work of the mid- to late-1960s, although there was no attempt to make them seem 'real'.

In *Oi Yoi Yoi* Hilton conveys a sense of vital joy and colour, a reality of experience as opposed to a vision. *Large Orange, Newlyn, June 1959* is rich and vibrant in both texture and colour, whereas *March, 1961* is more restrained in tone. *Untitled* (1971), one of his last works, still vibrates with his exuberance and force of life.

BRIDGET RILEY *1931–*

NATARAJA 1993

Courtesy of the Tate Gallery, London

RILEY is a leading British exponent of op art (an abbreviation of 'optical art', just as Pop art is an abbreviation of 'popular art'). It is a type of abstract art that plays on the human ability to create and perceive illusory visual effects, making an artwork appear to pulsate and move, and draws attention to the limits of the painterly surface. As a technique it demands geometrical precision and relies upon optical tricks – as found in most perception psychology books, such as the drawing of the old woman's profile which when stared at for long enough becomes that of a young woman, or the outline of a vase that becomes two profiles facing in opposite directions. The eye can switch between the two perceptions, but cannot see them simultaneously.

Riley was born in London and trained at Goldsmiths' College of Art and at the Royal College of Art. One of her first influences was the work of the Neo-Impressionist Georges Seurat, who irrevocably separated perception from the painterly mark: in 1960 she painted *Pink Landscape*, in which the dots are so large that they become independent units. The impossibility of the fixed image permeates her art; a trip to Italy had introduced her to the work of Italian Futurists and their desire to paint the movement, sound and speed of modern existence. Riley's work was initially predominantly in black and white, although she subsequently worked with shades of grey, shapes radiating from a central point or systematically crossing the picture on a horizontal or vertical axis. If stared at for long enough, hallucinatory colours can be perceived in her black and white works such as *Fall* (1963). In 1968 she won the International Painting Prize at the Venice Biennale: her success was such that a clothing company designed dresses along the lines of her paintings after a sell-out one-woman show in New York in 1965.

As in Caro's additive sculpture, Riley builds up her paintings, which she creates with emulsion and acrylic paint, into a sequence of actions, a series of perceptions that she sets in motion. She also uses colour, experimenting with intensity and hue, as here. She has travelled extensively in the Far East, India and Egypt – the underground tomb paintings at Luxor inspired her scheme for the Royal Liverpool Hospital in 1983, the same year in which the Ballet Rambert performed *Colour Moves* at the Edinburgh Festival with a set designed by Riley. Like *Nataraja*, *Achaian* (1981) resonates with the experience of North African travel.

MARY MARTIN *1907–69*

CROSS 1968

*Courtesy of the Board of Trustees of the National Museums and
Galleries on Merseyside (Walker Art Gallery)*

A leading member of the British Constructivist movement in the 1950s and 1960s, with her husband Kenneth Martin as well as Victor Pasmore and Anthony Hill, Mary Martin (née Balmford) attended Goldsmiths' College and the Royal College of Art. Much of her pre-war work was centred on landscape and still life painting, but after the First World War she became increasingly interested in abstract art, producing her first abstract painting in 1950. This swiftly led to non-figurative, constructed art, characterised by geometric forms. The British Constructivists were not at the heart of the European modern mainstream, and their approach evolved more out of home-grown experimentation with abstraction from nature, as exemplified by Ben Nicholson's work and Victor Pasmore's moves away from the representational.

Mary Martin's constructions are self-generating and repetitive exercises in logic, based on systems and ratios of her own devising. Mathematical processes, by analogy, emulate the art of natural form, and it is the creativity and infinity of nature that are encapsulated in these configurations. Her prime concerns are the interplay of sequence and rhythm, repetition and light, and she experiments with these by a variety of methods involving sequence, colour, different materials, orientation and folding.

In *Cross*, by covering the sliced cube faces with stainless steel Martin makes a mirrored surface that contributes a further dimension to the sequential permutations, disrupting the pattern of the arrangement that has been constructed along mathematical or sequential lines. The question of human intervention and physical space is thrown open as the viewer passes in front of the object. The complexities of the reflected patterns become evident, due to the shifting fall of light, and the construction takes on the colours of its surroundings and those of the viewers that pass before it.

DAVID HOCKNEY *1937–*

A BIGGER SPLASH 1967

Courtesy of the Tate Gallery, London

BRADFORD-born, and a prize-winning student at the Royal College of Art, Hockney quickly came to success and critical acclaim. He and Peter Blake are considered the stars of London's swinging sixties and of the Pop art scene, in the wake of Paolozzi and Hamilton; as is often the case, these artists who have been bracketed together have produced strikingly different work.

Hockney has retained in his repertoire figurative painting and the human body, rather than moving into abstract or other non-representational forms of art. As with R. B. Kitaj (see page 244), his early work was overtly linked with his personal concerns: one of his RCA pieces of 1961 was entitled *We Two Boys Together Clinging* (1961), taken from a Walt Whitman poem. His early style consisted of a combination of scratchy brushstrokes and scrawled writing, but his use of acrylic rather than oils in the late 1960s and 1970s resulted in a different style. He also produced a series of etchings in 1961 entitled *A Rake's Progress*, a conflation of Hogarth's series and his own experiences in New York. In 1964 he moved to Los Angeles and began a series of swimming-pool views, painted in acrylic. Acrylic allowed the painter to achieve a flat, poster-like effect, and Hockney chose bold, clean forms and an ahistorical presentation, perhaps in homage to the artistic freedom he sensed in California. In *A Bigger Splash* the Californian light flattens the design and brings out the bold blandness of colours and space, perturbed only by the splash in the water. Hockney's interest in photography – the Hayward Gallery in London held an exhibition of his photographic works in 1985 – accounts for the element of well defined photorealism in some of his swimming-pool pieces. The overall style in this series wavers between the naturalistic and the photorealistic.

During the years 1968–71 Hockney painted a series of double portraits of his friends. In *Mr and Mrs Clark and Percy* (1970–71) the tension between art forms is evident in the strong verticals and horizontals of the room and the shutters, the flatness of the figures and the formal treatment of the book on the table. The male sitter's leg, stretched on a diagonal, the naturalistic depiction of the lilies and the fullness of the sitters' faces contrast with the near-abstract treatment of the interior.

Hockney's most recent paintings have been vast highly coloured landscape canvases such as *The Road to the Studio*. He is also a skilled graphic artist: he etched illustrations to *Six Fairy Tales of the Brothers Grimm* in 1969 and his *Travels with Pen, Pencil and Ink* was published in 1978. From 1975 he enjoyed success in stage and costume design for productions at Glyndebourne, such as Mozart's *The Magic Flute*.

DAME ELISABETH FRINK *1930–93*

HORSE AND RIDER VI 1970

Courtesy of the Tate Gallery, London

FRINK'S early influences were Henry Moore, through the work of Bernard Meadows, whose pupil she was, and Alberto Giacometti. Giacometti's anguished view of man was a dominant force in postwar Europe. Critical attention was being focused on minimal and conceptual art, on the art of isolation, loneliness, existence in a universe without given meaning. Figurative sculpture was regarded as old-fashioned at the time and lacking in spiked existential menace – it was not considered part of the contemporary sculptural scene. The human figure in postwar art could no longer represent what was good or noble: on the contrary, it came to stand for all that was momentary and angst-ridden, to be realised only in reduced form, as if seen on the horizon from afar. Kenneth Armitage's groups of figures merged into each other as if the human figure could not stand alone: *Figure Lying on Its Side (No. 5)* (1957) shows a swollen figure, with spindly arms and legs unable to support it. However, his *People in the Wind* was not solely the expression of apprehension and anxiety; and although Meadows's abstractions of a crab's menacing scuttle summed up for many the atmosphere of unpredictability, much of the sculpture of the 1950s was part of the Expressionist tradition, with roots in the painting of van Gogh and Munch.

Influenced by Meadows's crab, Frink's early work consisted of wingless dead birds. Her sculptures embody feeling and represent her search for a way to express emotion, with minimal concern for formal manipulation for its own sake. She modelled, cast and carved in plaster, to give the bronze a more textured surface, as did Moore. Frink spent some time in Ireland, where her French husband Michel Jameet lived. She became interested in the ancient Celtic cult of the head, and works such as *Helmeted Head with Goggles* (1968) and *Tribute IV* (1975), representing part oracle and part godhead, express facets of her fascination with this cult. Her sculptures of birds, dogs and horses have always been very popular, but there is a sense of isolation in these figures. Not intended as likenesses of particular animals or breeds, they express the spirit of animal existence, the nature of non-domesticated horsiness or dogginess and the relation of the creatures to man. Although famous as a sculptor, Frink was also an accomplished print-maker and painter, and her illustrations for Chaucer's *Canterbury Tales* and Aesop's *Fables* are in the Tate's collection. She was awarded the CBE in 1969 and made a Dame of the British Empire in 1982.

IAN HAMILTON FINLAY *1925–*

HOMAGE TO MODERN ART
(COLLABORATION WITH JIM NICHOLSON) 1972

Courtesy of the Tate Gallery, London

A Scottish poet, Finlay was born in the Bahamas, and after a brief period at the Glasgow School of Art made his reputation first as a writer. After serving in the Second World War he worked as a rural labourer in the Orkneys and wrote his first short stories and plays, which were published in the *Glasgow Herald* and broadcast by the BBC. Most of his protagonists were rural dwellers, and seemed to create a native Scottish pastoral idyll. In 1961 Finlay founded the Wild Hawthorn Press with Jessie McGuffie, and within a few years was Britain's leading practitioner of concrete poetry, the arrangement of words to create an image fitting to the subject. He developed this poetic form in the late 1960s, extending it to three dimensions, where words, materials and images interact in space and time. *Starlit Waters* (1967) is one of a series of pieces based on the names of fishing boats (the sea has always been a source of inspiration). In this work the words become physical objects made from wood, measuring 31.1 **x** 240 **x** 13.3 cm. The letters are fixed to a flat support and arranged on a display shelf, covered in a nylon fishing net. His sculpture embraces a vast array of materials, including neon lighting.

With his wife, Finlay has created a garden at his home in Lanarkshire, Little Sparta, for which he is best known. They have created temples from farm buildings, and distributed plaques, fountains and architectural fragments throughout the property, where the juxtaposition of neoclassical and modern symbols and contexts invites reflection. In 1987 he completed an outdoor installation in America, *Unda* (the Latin word for 'wave'). Five stone blocks each bear the carved letters U-N-D-A in various sequences, and an S-like mark to indicate the transposition of two letters. The result is that each block ultimately spells out UNDA, and the transpositional marks roll sinuously and repetitively across the installation.

Finlay questions through contrast and collaboration. *Homage to Modern Art*, a screenprint, is one of a series of poem/prints he produced with Jim Nicholson in the 1970s. A technique of commercial mass reproduction and minimum artistic participation has been consciously chosen, yet there are signs of human intervention, such as the two signatures and the curious leakage of one of the foresails, as if to draw attention to the artistic process. The boat's shape is archaic, the yellow triangle vibrant; the frame results in a constant struggle between illusion and the flat surface.

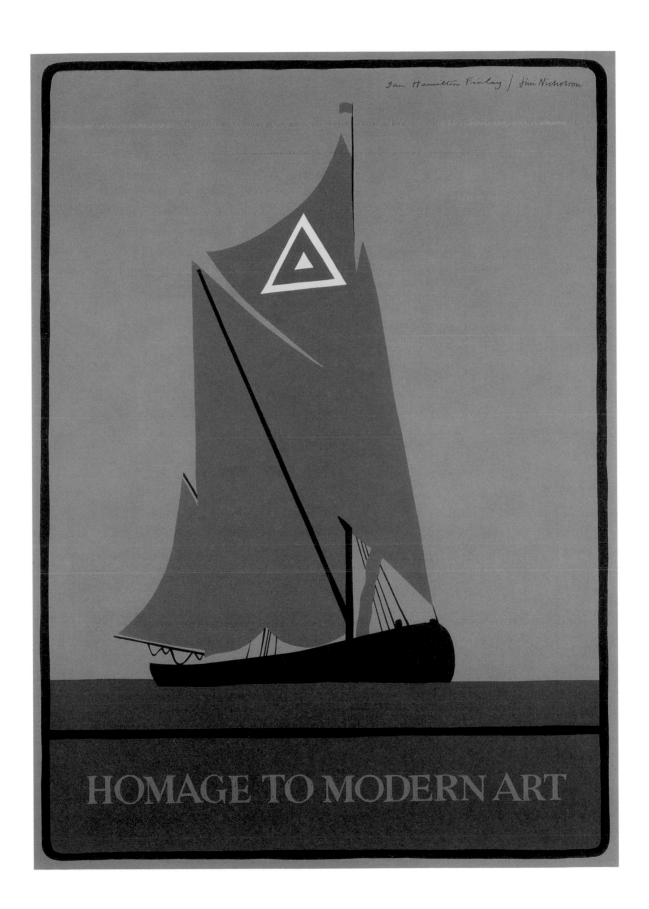

R. B. KITAJ *1932–*

IF NOT, NOT 1975

Scottish National Gallery of Modern Art, Edinburgh /
Courtesy of the Bridgeman Art Library

BORN in Cleveland, Ohio, Kitaj settled in Britain after arriving on a GI scholarship in 1958. After studies at Cooper Union and Vienna, where he learnt in the manner of the Expressionist Egon Schiele, he attended the Royal College of Art. He was part of the RCA generation of Pop artists, although he showed relatively little interest in mass media, but his work has always contained associations and juxtapositions of personal and political imagery, and has upheld the figurative against the prevailing abstraction. Perhaps because he is American, Kitaj did not leave the RCA seduced by America and the popular arts to the same extent as did his contemporaries Richard Hamilton, Peter Blake and David Hockney. He produced a large number of screenprints at Kelpra Studios in the 1970s, and has collaborated with the poets Robert Creeley and Jonathan Williams as well as experimenting with pastel.

The work Kitaj has produced whilst in the UK has been of wide-ranging influence on the British art scene. One of his main concerns has been the subject of works of art – namely, art itself – and many of his pieces have borrowed from earlier art to establish a link and a grounding, almost a notion of solidarity, between his own work and the past. There is a division between the formal aspects of his work and its subjects; the structure and layout of the components can be discussed independently of his paintings – form is no longer his artistic priority.

His preoccupation with his own Jewish identity emerged in his work during the 1970s and has been a dominant feature ever since, an identity that inherits many different traditions and yet is always on the move and always displaced. Kitaj pulls disparate elements together – free to do so because of his peripatetic inheritance – to create a highly individual style with which to comment on humanity's condition and oppression. In *If Not, Not* the gates of Auschwitz are seen in the top left of the picture, bodies are strewn along a river bank, reminiscent of Conrad's *Heart of Darkness*, and the pool of water stagnates – usually the source of life, it sits in a wasteland which has little to do with renewal.

The poetry of T. S. Eliot has been another source for Kitaj, one of allusion and fragmentation, of juxtaposition of the colloquial with the lyrical. Until the mid-1970s his work has been disparate and disjointed, containing a variety of pictorial and literary allusions that have been unclassifiable; a mix of collage and painterly style disposed on a single canvas, and influenced by the free associations of Surrealism. The commentaries accompanying his art have further emphasised the importance of the idea behind each work as well as its image and form.

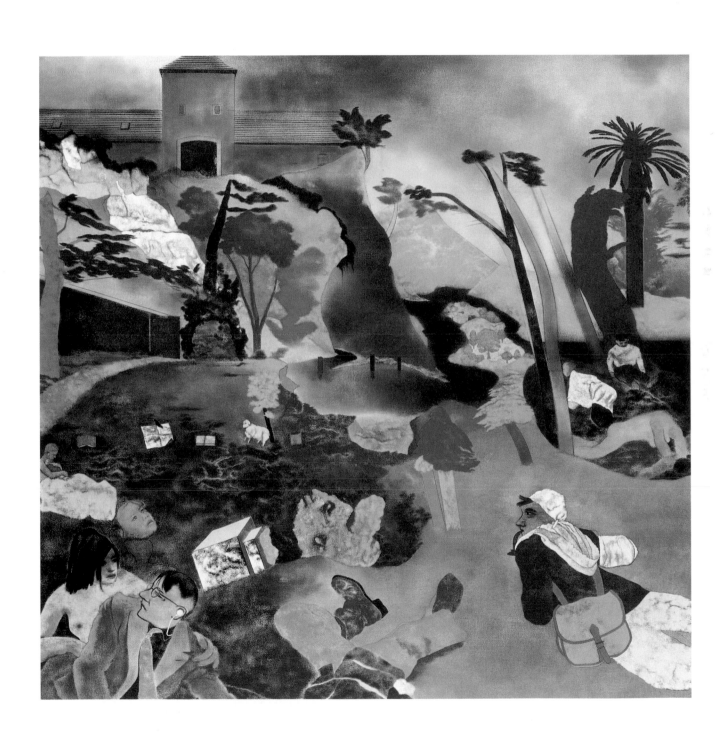

BARRIE COOK *1929–*

CONTINUUM I 1975

Courtesy of the National Museum of Wales

COOK was born in Birmingham, where he studied and later taught. In 1977 he was elected Gregynog Fellow of the University of Wales, having previously been Senior Fellow in Fine Art at the Cardiff College of Art. His move to Cornwall in 1992, leaving behind the urban environments in which he had always lived, coincided with the introduction of colour into his works.

Inspired by international American modernity, he has maintained the use of traditional media and techniques, oil paints and glazes and well defined areas on the canvas. His range of work is impressive, from the large abstracts that cover the gallery wall to the smallest figurative drawings with apparent autobiographical relevance. His work of the 1970s, typified by *Untitled* (1971), evolved from the experimental optical black and white pictures of the time. Since the 1960s Cook has used spray paint in a unique manner, building up layer upon layer to create repetitive, rhythmic stripes that appear to move, in a never-ending search for space and light. The spray gun was the technique of the American advertisement as well as of the contemporary art scene, but Cook invented a series of processes that were consciously artificial and laborious to execute, in line with the spray gun's mechanical uses and industrial origins. He experimented with the distances from which the canvas could be sprayed, and in doing so he highlighted the lack of physical intervention by the artist on the canvas.

The aloofness and large scale of his work gave a sense of autonomy to his abstraction, but it was in a move away from remote gesture that Cook started to apply paint in numerous coats. *Morning Glory* (1976–7) has over a thousand coats of acrylic and spray paint, and its surface is rough and heavily textured with multiple flecks and granules of paint. The bars of *Continuum I* and other works of the 1970s swell and pulsate. The fluidity of *Continuum I* seems to express a sense of continual renewal and regeneration, and the abstract qualities of the work go beyond the principles of design alone. The gradual introduction of colour provided additional resonance to the work that Cook produced in the 1970s, and by the 1980s there is a notable return to the depiction of subject matter: *Roath Park II* (1985) strongly evokes the park on a misty morning, seen through the railings.

Cook abandoned acrylic and the spray gun in the 1980s and took up more traditional media and methods, but throughout his large paintings the conflict between the abstract and the material is evident. By contrast, his drawings are figurative and autobiographical – the *Coal* series (1984–5) expresses his frustration with the years of industrial decline in the North.

DAVID INSHAW *1943–*

THE BADMINTON GAME 1972–3

Courtesy of the Tate Gallery, London

INSHAW was born in Staffordshire and studied at the RA Schools before going to Paris on a French government scholarship. His first one-man show was in Bristol and he moved to Devizes in Wiltshire in 1971. From 1975 (until his move to Wales in 1983) he was a member of the Brotherhood of Ruralists with Peter Blake, amongst others. This assemblage of painters, in a conscious evocation of nineteenth-century artistic groupings, exhibited together and worked together in the countryside in an attempt to return to its spirit. Fairy paintings and illustrations, such as the jackets of the New Arden edition of Shakespeare, are emblematic of their work.

There is a hallucinatory feeling to this picture: the English countryside in late summer is shown with uneasy clarity. Inshaw depicts a classic English scene, a game of badminton on the lawn. The shadows are long; it is afternoon or early evening and the moon can be seen in the sky. The only movement is that of the girls, and there is uncanny silence – no wind in the trees or sign of life from the house, which has windows visible only on the top two floors and is slowly being engulfed by ivy. The yew trees tower over the players; the shuttlecock is a tiny white pinpoint against the dark green foliage, in suspended animation before the next whisk of the racquet or breath of breeze amongst the trees. The tension is one between timelessness and the single moment – the shuttlecock will never fall yet will always be on the point of falling.

This suspension of the momentary recurs in Inshaw's later work: *Figures in a Wiltshire Landscape: A Moment* (1985/7) eternally captures the fall of an object, just as in *Jumping Horse* (1989) the horse and rider are frozen in mid-jump beneath a towering tree. The landscape of Wiltshire, its burial mounds, prehistoric stone monuments and stone circles provide Inshaw with the ideal backdrop against which to set his questioning of time. The lightness of his earlier works gives way to a darker, more brooding landscape in which the cone of Silbury Hill is a recurring motif. In one of his works, a cricket game is played in the shadow of this ancient manmade earthwork. Inshaw juxtaposes motion, whether that of the shuttlecock or the cricket match, with immutability and a larger grasp of time.

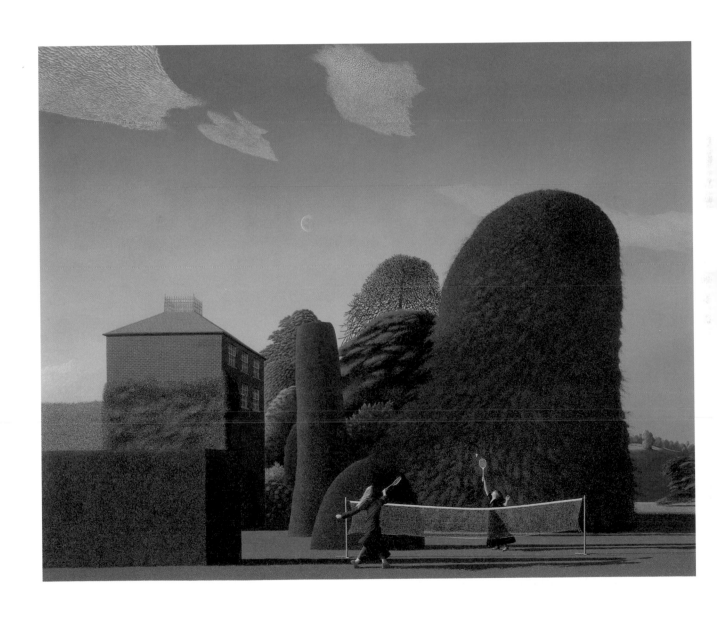

RICHARD LONG *1945–*

SMALL WHITE PEBBLE CIRCLES, MARBLE PEBBLES 1987

Courtesy of the Tate Gallery, London

BORN in Bristol, Long studied first at the West of England College of Art and then at St Martin's School of Art in London, where he sought to extend the traditional boundaries of sculpture. Along with Gilbert and George, Barry Flanagan and others, he challenged the New Generation of sculptors that had emerged under Caro's influence questioning the narrow remit given to sculpture. He opposed the industrial materials and essentially urban outlook of much of contemporary sculpture and moved outside the gallery in order to create his work. His first pieces of land art date from the mid-1960s, and he soon added the dimension of time, recording sculptures of walks through the use of photography, maps and topographical notation. Sticks and stones, items found on his walks, provide him with his materials, and the countryside is his context – his sculptures are both objects and places, intrinsically linked. Circles and lines are the most common shapes in his work, representing the passing of time, and eternity: *A Line in Ireland* (1974) is made up of an assembled line of local stone and flint, like a spine running along the ground towards the cliff edge; part of the natural habitat, it merges with the landscape, but can only be a temporary arrangement. *From Tree to Tree: A Walk in Avon, England* (1986) lists in green lettering fifteen different types of tree passed and the corresponding mileage covered, but there is no fixed vantage point, and the words are the result of travel through the landscape rather than of static observation.

As well as the geometric sculptures using natural materials and sites discovered while walking, the 'walking sculpture' is a feature of his work: this is produced by repeatedly walking a straight line in a field – the result, the trace left behind that is doomed to disappear. In *England*, a monoprint he made in 1968, the field is filled with wild flowers – buttercups and daisies, the archetypal 'English' flowers. The trace he has made is that of a cross, the cross of St George, patron saint of England since at least the fourteenth century. *A Hundred-Mile Walk* (1971–2) is a copy of the Ordnance Survey map for Dartmoor, an area of which the artist has ringed with a geometric precision. Long recorded his experience of the walk, particularly the sound he heard that presaged a river, and the gullies, pockets into which sound would temporarily disappear. Movement, sight, sound, touch, taste – all inform the artist's work, conveying a heightened sense of awareness.

Long represented Britain at the 1976 Venice Biennale and has produced works in landscape in Peru, the Himalayas, Iceland, Japan, Morocco, the Arctic Circle and elsewhere. He has also published a large number of books, mostly concerned with recording his walks, including *Mountains and Waters* (1992).

TONY CRAGG *1949–*

BRITAIN SEEN FROM THE NORTH 1981

Courtesy of the Tate Gallery, London

CRAGG was born in Liverpool and attended Wimbledon College of Art and the Royal College of Art in London. He came to the fore in the 1980s, along with sculptors such as Anish Kapoor and Bill Woodrow. The nature and the processes of sculpture, and the materials and methods of display, have been questioned by two generations of artists since the 1960s. Antony Gormley's lead casts of his own body give expression to human experience, and Cragg defines humanity in terms of its relation to its own environment, both organic and inorganic. Confronting matter is a basic requirement of existence, and man orders matter into schemata that give coherence and order to the environment and, by extension, to the world.

This encounter is a mixture of sensual reaction and intellectual reckoning: the eye perceives the material and translates it in terms of surface, texture and colour, whilst the brain registers this sensual thought against a range of learnt information and responses. Cragg takes this process and debates in his work the eternal relation of an object, its material and the image. In this concern with the materials beneath every surface lies a world of physical structures and conditions, imperceivable laws and chemical constructs. Molecular models of sugar and alcohol atoms are incorporated into *The Worm Returns* (1986), whilst the repetitive nature of structure is emphasised in *Aqueduct* (1986) and *Echo* (1984) carries references to the earth's geological layering. Man is similarly considered as an animate object within the environment, by which he is defined and knows himself.

In *Britain Seen from the North* Cragg has arranged on the gallery wall an assortment of plastics, bits of manufactured objects and other fragments recovered from rubbish dumps. The arrangement takes on the recognisable forms of Britain, seen from a bird's-eye perspective, and of a human figure. Pieces that have been discarded have been recovered to form a new object. The manufacturing industries, particularly rooted in the north of the country, have been discarded and, until the recent devolution, power in Britain was centred in the south. Cragg invites you to challenge established views by tweaking traditional representation and to see unity in past discarded material and heritage. His message is not nostalgic – he is not romanticising a past epoch. Tools and vessels such as the pestle and mortar, the axehead and the canoe, recur in his work, but there is no sense of regret; rather, a recognition of a past environment where man had fewer tools and methods of manufacture at his disposal. Improvement in man's condition of existence is not to be found in the past – Cragg suggests a different way of looking at Britain, of reacting to the present, with the aim of finding routes to a more meaningful relationship with the environment.

GLOSSARY

abstract art Art that is either completely non-figurative, or that transforms things observed into patterns whose significance is independent of their source.

Aestheticism Movement whose beliefs were based on the notion of 'art for art's sake' – art should serve no moral purpose – and that flourished in the second half of the 19th century.

the antique Ancient Greek and Roman art which inspired painting and sculpture of the Renaissance and later.

Art Nouveau Late-19th-century decorative style, drawing influences from sinuous shapes in nature.

baroque A bold and exuberant style in architecture, sculpture and painting, that flourished in the 17th century.

Bloomsbury Group 20th-century group characterised by painting in which 'significant form' was paramount, two of its most influential members being Vanessa Bell and Roger Fry.

Camden Town Group Exhibitors at the Post-Impressionist exhibition of 1910–11, led by Sickert and including Gilman and Gore.

Constructivism Abstract art movement of the 1920s in which construction, line and colour were the main concerns.

conversation piece Group portrait with several figures shown engaged in everyday activities; popular in 18th-century England.

Cubism Movement that attemped to express fully on a flat surface, often geometrically, all aspects of what the artist saw in three dimensions.

East Anglian illumination Comprising manuscripts made in the dioceses of Norwich, Ely and the Fens in the early 14th century.

Expressionism Movement originally characterised by its opposition to Impressionism; today, art in which distortion overrides realism.

Futurism Movement characterised by violent departure from traditional forms so as to express movement and growth.

genre painting Art showing scenes from everyday life, exemplified by the work of such painters as Wilkie and Wright of Derby.

Grand Manner An elevated style typified by classical robes and idealised poses, and advocated by such leading 18th-century art theorists as Reynolds in his *Discourses*.

history painting Art illustrating heroic classical or biblical subjects, or historic events.

the Ideal That which art unites when seeking to depict the best in nature, as filitered through the artist's own idea of perfection.

Impressionism Style of painting, originating in France in the late 19th century, aiming to give a visual impression of a subject rather than its detail.

Independent Group Group of 1950s British artists and critics, including Paolozzi and Hamilton,

considered to be the founders of British Pop art.

marine painting A genre emerging in England in the 1730s as exemplified by Samuel Scott, and reaching its apogee with de Loutherbourg and Turner.

miniature Usually a portrait, in watercolour or gouache, painted on a very small scale.

Modernism Any or all of the avant-garde styles that dominated art in the 20th century.

naturalism A tendency prevailing in the second half of the 19th century and characterised by the depiction of ordinary life.

New English Art Club (NEAC) Society of artists such as Clausen and Sargent founded in 1886 in reaction to the restrictive selection policy of the Royal Academy.

Newlyn School Community of artists founded by Stanhope Forbes in 1885 and influenced by the French fashion for open-air paintings and for depicting rural communities in their own setting.

Norwich School School of painters founded by John Crome in the 1830s and specialising in East Anglian landscapes.

op art Abstract 1960s art, exemplified by the work of Bridget Riley, that explored optical effects in painting.

panel painting A painting on wood, used in medieval times before canvas became prevalent.

Pop art Art based on imagery derived from mass media and consumerism, and exemplified in Britain by Richard Hamilton and Allen Jones.

Pre-Raphaelites 19th-century English artists including Rossetti, Millais and Hunt, whose work combined romantic medievalism with a realistic depiction of nature and a moral as well as an aesthetic aim.

Rococo Suggesting, in painting, an emphasis on frivolous subject matter combined with extravagant colours.

Romanticism Late-18th- and early-19th-century style marked by feeling, individuality and passion rather than by classical form and order.

St Ives School Community of painters, such as Terry Frost, who lived and worked in St Ives, Cornwall, from the early 1940s.

Shoreham painters 1830s group whose main exponent was Samuel Palmer, and whose members shared a pantheistic attitude towards nature and painted landscape with religious overtones.

sporting painting Depiction of rural sports such as hunting, dating from the early 18th century.

Surrealism Movement seeking to express the unconscious by techniques such as the apparently random juxtaposition of images; founded by André Breton in 1924 but established in Britain only in 1936.

Vorticism A British avant-garde movement influenced by Cubism and Futurism, and founded in 1914 by Wyndham Lewis.

Further reading

Auerbach, E. *Tudor Artists* (Athlone Press, 1954).

Blayney Brown, David *Romantic Landscape: The Norwich School of Painters* (Tate Gallery Publishing Ltd., 2000).

British Council, *Lucian Freud: Paintings* (British Council, 1987).

Brown, Christopher (ed.) & Vlieghe, Hans (ed.) *Van Dyck, 1599–1641* (Royal Academy of Arts, 1999).

Cormack, Malcolm *The Paintings of Thomas Gainsborough* (Cambridge University Press, 1991).

Egerton, Judy *Turner: The Fighting Temeraire* (National Gallery Publications Ltd., 1995).

Graham-Dixon, Andrew *A History of British Art* (BBC Worldwide Ltd., 1999).

Jenkins, Simon *England's Thousand Best Churches* (Penguin Books, 2000).

Mercer, E. *The Oxford History of English Art, vol. 7* (Oxford University Press, 1962).

Myrone, Martin *Representing Britain 1500–2000* (Tate Gallery Publishing Ltd., 2000).

Noakes, Vivien *The Painter Edward Lear* (David & Charles, 1991).

Parry, Linda (ed.) *William Morris* (V&A/Phillip Wilson Publishers, 1996).

Pevsner, Nikolaus *The Englishness of English Art* (Penguin Books, 1993, 1997).

Piper, David (ed.) *The Genius of British Painting* (Weidenfeld and Nicholson, 1975).

Royal Academy of Arts *1900: Art at the Crossroads* (Royal Academy of Arts, 2000).

Royal Academy of Arts *Art Treasures of England: The Regional Collections* (Royal Academy of Arts, 1998).

Saumarez Smith, Charles *The National Portrait Gallery* (National Portrait Gallery Publications Ltd., 1997).

Snodgrass, C. *Aubrey Beardsley: Dandy of the Grotesque* (Oxford University Press, 1995).

Spalding, Frances *British Art Since 1900* (Thames and Hudson Ltd., 1986, 1996).

Strong, Roy *The Artist and the Garden* (Yale University Press, 2000).

Tate Gallery Collections *British Painting* (Tate Gallery Publishing Ltd., 1984).

Tate Gallery *Turner 1775–1851* (Tate Gallery Publishing Ltd., 1974).

Vaughan, William *Romanticism and Art* (Thames and Hudson Ltd., 1978, 1995).

Wilson, Simon *Tate Gallery: An Illustrated Companion* (Tate Gallery Publishing Ltd., 1990, 1997).

Wilton, Andrew (ed.) *The Great Age of British Watercolours 1750–1880* (Prestel Verlag, 1993).